ROCKWELL KENT THE ART OF THE BOOKPLATE

ROCKWELL KENT

THE ART OF THE BOOKPLATE

DON ROBERTS

Foreword by Will Ross

FAIR OAKS PRESS / SAN FRANCISCO

To David Garst and Gary Jones

FAIR OAKS PRESS, SAN FRANCISCO

Copyright © 2003 by Don Roberts
Foreword copyright © 2002 by Will Ross
Writings by Rockwell Kent are the property of the Plattsburgh State
University Art Museum, Rockwell Kent Gallery and Collection, and
are extracted with their permission.

The bookplates shown are from the collections of the Plattsburgh
State University Art Museum and the Antioch Publishing Co. Sketches
of Rockwell Kent's bookplate art are the property of the Rare Book
and Manuscript Library, Columbia University, and the Rare Books and
Special Collections of the Firestone Library, Princeton University.

LIBRARY OF CONGRESS CONTROL NUMBER 2002114622

ISBN 0-9658811-2-1

Copy Editor Taylor Teegarden
Proofreader Sharilyn Hovind
Image Production and Layout Julie Churchill

A limited edition of five hundred with a bookplate designed by
Christopher Kent, a grandson of Rockwell Kent, was also published.

Printed in the United States of America on acid-free paper.

10 9 8 7 6 5 4 3 2 1

First Edition, May 2003

Contents

Foreword

That day will mark a precedent,
Which brings no news of Rockwell Kent.

WHEN THIS "DITTY" WAS PUBLISHED, IN THE NOVEMBER 20, 1937, ISSUE OF the *New Yorker,* Rockwell Kent was arguably the most famous artist in America. He was talented, charming and charismatic. A brilliant speaker, ladies' man and gentleman adventurer. He was also opinionated, outspoken, hot tempered and intolerant of fools. And it was these attributes, in addition to his artistry, that brought him fame.

Now, you may wonder: If this man was so famous, why have I never heard of him? The reasons are varied, and have to do with the times he lived through, with the kind of man he was, with his art and with the nature of celebrity itself.

I became interested in Rockwell Kent partially because of his art, but also because of the man himself. He was not one of those artists who sit in studios and paint lovely portraits; he was the artist as adventurer. Kent traveled to Alaska, Greenland and Tierra del Fuego. Not only traveled to them, but explored them, and then wrote and illustrated books about his exploits. Not dry travelogues, but tales of derring-do: of storms, shipwrecks and treks over unexplored territory. Books that were peopled by crooks, sailors, ranchers and Eskimos. Books filled with his wonderful illustrations of exotic people and places. The fascination with Kent and his escapades was enough to make them best-sellers.

During the twenties and thirties, his illustrations in the popular magazines *Scribner's, Punch, Life* and *Vanity Fair* brought his art before the American public. On the pages of *Vanity Fair,* high society was regularly discussed, pictured, parodied and applauded—a coup for celebrities as diverse as the pioneer radio manufacturer Atwater Kent and the silent-screen actress Pola Negri. Rockwell Kent would appear in its "Hall of Fame" column on more than one occasion. In the June 1923 issue, he was listed with the theatrical

designer and filmmaker Samuel Rothafel, the literary critic Havelock Ellis and the actress Eleanor Robson Belmont. None of them is a household name today, for fame is a fleeting gift. In 1936, Kent described it thus:

> *On Being Famous—not, I hasten to say—for these are autobiographical reflections—famous like Greta Garbo, Bernard Shaw, or Haile Selassie, but on having your name more or less familiar to the stranger that you run across, having it conjure up something or other however indefinite to his mind, having a name that he has seen or heard. More strictly: "On Having Your Name in the Papers"—for that, it seems, is fame to the tens of millions whose names have never been there. It is their question—put I am sure to every bearer of a printed name they meet—the question "What does it feel like to be famous?" that I want to answer. Yet let me make my meaning still more clear—clear up, I mean, what being famous is: It is not famous to have people ask one of my name, and they do all the time, if I am any relation to Atwater Kent. It is being famous to have a charming debutante gush to Mr. Atwater Kent, as I am told one did, "Oh, Mr. Kent! I think your mountain pictures are so wonderful!"*

Rockwell Kent and his fellow artist Norman Rockwell would find the confusion over the similarity of their names a continuing problem from the thirties into the fifties. They maintained a cordial correspondence based partially upon this confusion, as well as a mutual affection for each other's work. On one occasion, Kent was accosted by a man who, presuming him to be Rockwell, reminisced about the time they spent together in the Army during World War I. In a letter to Norman Rockwell, Kent recounted the incident and the man's request that he complete a portrait begun in 1917: "I hate to burden you with this, buddy, but such is the reward of fame."

Fame does, however, have its rewards, including forgiveness for one's transgressions. In 1936, Kent was commissioned by the Treasury Department to paint two murals depicting mail service in Alaska and Puerto Rico. Ever the practical joker, and a believer in Puerto Rican independence, he found a way to insert a liberation message into the mural. After it made the newspapers (leaked to the press by Kent) official Washington was outraged. Shortly after the turmoil ended, Kent was invited to a White House dinner by Eleanor Roosevelt. In his autobiography, Kent described his pardon:

> *The names of most of the many distinguished guests I have forgotten, but not that of the beautiful and charming woman who, at dinner, sat at my right.*

She was Mrs. Morgenthau, the wife of the chief of the department that, through its Procurement Division, had commissioned the controversial mural. Hardly had we been seated than Mrs. Morgenthau turned to me and said: "Mr. Kent, you have a priceless sense of humor!" And she literally shook with laughter. And after dinner the Secretary and I had a long and most friendly chat over our coffee and liqueur.

But fame also exacts a toll, as Kent would discover. The notorious imposter Michael Romanoff, after working as a hired hand at Kent's upstate New York farm in 1931, stole the artist's identity and went around the country as Rockwell Kent, making speeches, eating free meals and making promises to illustrate books. Kent fulfilled one of the illustration contracts, for *A Yankee in Patagonia* by Robert and Katharine Barrett. He was amused by Romanoff's gall, intrigued by the book about a part of the world he had visited and sympathetic to the predicament the authors and publisher had found themselves in, through no fault of their own.

Kent would also take advantage of his fame to promote the causes he held dear, supporting the Loyalist side in the Spanish Civil War, the organized labor movement, and many left-wing and so-called Communist-front associations. Such actions, while tolerated in the 1930s, lost their acceptability as the United States entered the Cold War in the late 1940s, and the vehemence of his convictions made him a lightning rod and, to many, a reviled figure. Unlike other politically-minded artists, such as Pablo Picasso, he made his beliefs a central point of his character and public persona.

Of course, there were other reasons than Kent's infamy behind his loss of celebrity. There is a valid argument to be made that his success in so many different fields diminished his reputation in any one of them. His recognition, as opposed to Norman Rockwell's, ran shallow rather than deep, and was less able to withstand the vicissitudes of changing times and tastes. At the height of his influence on the graphic arts, in the twenties and thirties, Kent was called "the most-copied artist in America." His move to upstate New York would eventually separate him from the art scene and contribute to his disappearance. By the fifties, the growing influence of abstract expressionism made his defiant belief in realism anachronistic. Ironically, Kent was caught between a public that was more conservative than he and an art world that viewed him as too conservative. His paintings stopped selling, and museums seldom displayed the works they had collected at the height of his visibility.

By 1960, that day did come when there was no news of Rockwell Kent.

At the time of his death a decade later, he was not famous, or even infamous; he had become unfamous. Still known, subject of a front-page obituary in the *New York Times,* he was no longer the important, notorious, exciting figure he once was. He had become a has-been.

For almost forty years, Rockwell Kent and his art have been largely ignored. However, the first years of the twenty-first century bring a profound resurgence of interest in this most American of artists, through exhibitions and new and exciting scholarship, including the book in your hands. The bookplates he designed speak volumes about his genius as a graphic artist.

I believe the passage of time allows his art to be viewed today in balance with his life and politics, and its beauty and technical perfection can be seen and appreciated anew. Rockwell Kent's personal motto was "Be yourself as an artist, be yourself as a man." Take him at his word. Whether famous, unfamous or infamous, he remains one of the most amazing, and controversial, figures in American art.

WILL ROSS
Calabasas, California
Thanksgiving 2002

Preface

ROCKWELL KENT TOLD THE TALE OF A MAN WHO LIVED THE SOLITARY LIFE deep in the woods. The people of the nearest village, knowing nothing of his history, called him the Mad Hermit. In time he died, leaving "nothing that could throw any light upon his identity. And not a book to serve as evidence perhaps, through what he read, of what he was."

The volumes in Kent's library numbered in the thousands. They described a man who was many men: painter, writer, adventurer, book illustrator, peace activist, political reformer, carpenter, dairy farmer... And to underscore his affinity with his books, a bookplate of his own design was carefully pasted in every one of them.

The art of the bookplate is an art of identity, born out of necessity soon after Johannes Gutenberg converted a wine press into a printing press and thieves took up "book-borrowing." A sixteenth-century bookplate, illustrated with gallows, was inscribed with the rhyme "My Master's name above you see, take heed therefore you steal not me. For if you do, without delay your neck for me shall pay." The Latin *ex libris* ("out of the library of") eventually became the standard inscription. By then, one's personal library was regarded as a living entity, and the loss of a single volume was tantamount to dismemberment. In the Victorian era, a bookplate was the only proper way to identify one's books. As one American writer noted, "He who could find it in his heart to write on title pages could surely commit a murder," and by 1900, there were possibly as many bookplate artists as murderers.

Albrecht Dürer, William Hogarth, Paul Revere, Aubrey Beardsley, Kate Greenaway, M. C. Escher and Marc Chagall designed bookplates, but each is remembered for more visible pursuits. The nature of a bookplate precludes glory for the artist. It is, after all, only an artistic slip of paper that serves its purpose by disappearing, sometimes forever, between the covers of a book. The art of the bookplate is an art of obscurity.

Although Rockwell Kent thought of himself first as a painter, his works created for reproduction are his great legacy and contribution to a distinctly

American art. Kent's bookplates were by no means innovative, but represent, in miniature, the progression of his graphic-design career from the first wood engravings through his masterworks of illustration and beyond.

He believed that if a shelf of books, "with all they hold of life," furnished clues to their owner's identity, then the label pasted inside the books should be the epitome of its owner or, at the least, a flattering symbol. Between 1912 and 1968, he designed more than one hundred sixty bookplates—the earliest as gifts for the people he loved. That he made a career of it must be attributed to Carl Zigrosser and Elmer Adler, the gallery manager and the printing impresario who prodded him to make bookplates for people he rarely met face to face. Even so, the design process was always "a personal matter" between himself and the client. Whether a bookplate served an heir to the Pulitzer fortune or a student with a bank account of ninety-five dollars, Kent was stimulated by its intimate nature.

In the 1940s, when an entrepreneur proposed that stationery stores offer his design services to their patrons, Kent replied in jest, "The store should get the fullest information as to the client's wishes, should have the client psychoanalyzed if possible and a complete psychiatrist's report sent to me." In fact, he came to rely on the exchange of letters to gather the essential information: "the story of your life, your likes, your aspirations."

The story of Kent's own life is a tangled tale of love and longing. Intent on being its lone hero, he was Crusoe and Casanova and Quixote. "I am not going to do any fool, little thing," he said. "I am…reaching to the stars." A hand stretched forth into the night sky is a universal image of aspiration that appears frequently in his bookplates, and more often there than anywhere else in his art.

Bookplates are fancy, trifling little papers. Even so, Kent called them a blessing. "The theft of a book," he said, "is more nearly homicide than larceny. Books are not things, they're people multiplied.…The possession of books is both the promise of a richer life and, in degree, the sign of its fulfillment." The bookplates he made expressed two people's passion for books: the artist's as well as the client's. In Kent's hands, the art of the bookplate became the art of empathy.

ROCKWELL KENT THE ART OF THE BOOKPLATE

One / The Region of Feeling

1882 to 1907

"I BEGAN, LIKE EVERY OTHER PERSON GIVEN THE LEAST ENCOURAGEMENT, to draw pictures as soon as my hand could hold a pencil," Rockwell Kent said of his childhood. The eldest of Rockwell and Sara Holgate Kent's three children, he was born in Tarrytown, New York, a distant suburb of New York City, on the first day of summer, 1882.

It was an off year, notable at the time for nothing much except optimism. Having recovered from its Civil War, the enterprising nation had begun to draw attention to itself in the wider world. A writer for the *New York Times* noted the "wiser and higher demand" for imported artworks, and when circus owner P. T. Barnum purchased Jumbo, the London Zoological Gardens' twelve-foot elephant, relations with the British Empire were put to the test. In 1882, *jumbo* was the word for American aspirations: John D. Rockefeller cornered the market on lamp oil, while the Edison Electric Illuminating Company brought light to lower Manhattan. On the waterfront nearby, the Statue of Liberty and Brooklyn Bridge were close to completion. The deaths of Ralph Waldo Emerson, Henry Wadsworth Longfellow, Charles Darwin and Jesse James seemed to signal the passage of an era, and in the long shadow cast by its setting sun, the significance of 1882 would be revealed in the next century, a century that America would call its own.

The senior Rockwell, a gentle, warm-hearted attorney, died of typhoid fever five years later, leaving Sara to raise their children in the Victorian manner. Although her embroidery and baking brought in a bit of income, she was dependent on her wealthy widowed aunt for the family's livelihood. In young Rockwell's memory, his great-aunt was "a niggardly patroness of poor relations" who made it possible for the family to live on the periphery of prosperity without enjoying the security of it. Suppressing her emotions, Sara practiced frugality and governed her children with a firm hand, instilling discipline and a rigid sense of right and wrong. "I was brought up to get up early in the morning, get to work and keep busy," Kent recalled. "I had the example of an indefatigably energetic mother." The fortunate addition of

The twentieth-century artists Edward Hopper, James Joyce, A. A. Milne, Virginia Woolf, Georges Braque, Igor Stravinsky, Eric Gill, N. C. Wyeth and George Bellows were also born that year. (Pablo Picasso had arrived in late 1881.)

Josephine Holgate, Sara's spirited younger sister, to what he described as a "widow's household," completed the family:

> *Besides being a strikingly beautiful woman and, if a small boy's impressions are to be trusted, graced with rarer charm, she had such initiative and ability in practical matters as must have been rare among women of her class in the period of the Gay Nineties. She could do things, do anything and everything, it seemed to us. Having studied art in the schools of New York and Paris, she had won herself some reputation as a water-colorist and something of the earnings that good reputations sometimes bring. A woman of strong character, of practical ingenuity and manual skill, she proved a veritable godsend to us all through all the years she lived with us.*

Kent's only enduring memories of his father were his "square-bearded silhouette as he sat reading at his desk window" and the sound of the silver flute he played. Reading and music would be his legacy, and Kent described Sara's house as "a species of Academy of Fine and Liberal Arts" where reading was mandatory. He began with the fables and fairy tales of Aesop, Andersen and the brothers Grimm, and proceeded through his father's boyhood library:

> *Since in all the books…the heroes were invariably youths or men of incorruptible virtue and dauntless courage, and their villains uniformly bad, the notions of good and evil, which my elders at home had been at unremitting pains to implant, assumed corporeal form; what had been mere moral abstractions were now transmuted into the flesh and blood of heroes, heroes to worship and to emulate, and bad men to detest. To be like them, my heroes: how deeply I aspired to!*

Even so, he was a stubborn, troublesome boy, whose slight stature only seemed to magnify his willfulness. Drawn to adventure stories, he confessed, "That, upon reading *Robinson Crusoe* and *The Swiss Family Robinson,* I did not run away to sea in the fond hope of being shipwrecked on a lonely island, can only have been that my then tender years—and my elders—prevented it." Tarrytown's wooded hillsides, just beginning to be dotted with palatial homes, overlooked a broad swath of the Hudson River known as the Tappan Zee. There, at high tide, the steady stream that flowed from the Adirondacks, three hundred miles due north, met the salty waters of the Atlantic Ocean. To an imaginative boy growing up on the river, the masted ships and steamers that navigated its currents afforded passage to the heroic

life. Seafaring was in his blood and bones. In 1895, Rockwell made his first ocean voyage:

Quite obviously, a boy of thirteen would not of choice embark alone upon an extended, four months' vacation in Europe. It is even possible that his mother would not allow him to. But such conjectures are beside the point in the matter of my trip, for it was my mother's sister, Auntie Jo, who—for no conceivable reason but sheer goodness of heart and unexplainable love for a somewhat unmanageable little boy—invited me.

In the years following the Civil War, Americans had begun to venture abroad in increasing number. Their cosmopolitanism was a final declaration of independence from the English cultural model of two centuries, and with Paris the ultimate destination, they became the early patrons and students of the Impressionist painters.

Josephine Holgate was one of the small number of women of her day who dared to make a career of what was for respectable young women a pastime. Those who did study art with serious intent were taught apart from their male counterparts and restricted to sketching the human anatomy from plaster casts rather than from life. As a result, women's careers tended toward portraiture and domestic art. In her early thirties, the unmarried Josephine paid little heed to the conventions of society.

She and Rockwell sailed to London, then traveled to Dresden, where she studied painting on china. Their visit to the Dresden Museum marked his introduction to fine art, from which he would carry away little more than the memory of Raphael's *Madonna Sistina* and recall that "the two little cherubs leaning on their elbows were kind of silly." It was not art treasures, but the limitless horizon of the ocean that excited his imagination.

He had drawn from as early as he could remember, encouraged by the example of an artist in the household, but his first recognition had been an award for penmanship at age nine:

I have no doubt that the hand that won its medal for Spencerian penmanship was one already exercised in making pen and pencil do the things its master wanted. My ability to write well and to embellish what I wrote with fanciful initial letters and decorative borders was quickly recognized.

The books he read were so richly illustrated that it was only natural for him to associate art with print. He first applied his drawing talent to illustrating

small, handwritten books for family members, then bookmarks and letter-heads for his schoolmates.

At age fifteen, he received his first professional commissions from the family's Tarrytown neighbors. Having studied family crests and heraldry, he was hired to draw coats of arms for the town's "scions of nobility, if not of royalty." At home, he could not avoid assisting Josephine on the production line of her pseudo-delft china painting. (Dutch windmills and English cottages brushed in blue were his specialty.) But it was in mechanical draw-ing classes at New York's innovative Horace Mann School that his hand would gain discipline in serving his eye.

His obvious intellect, however, was always at the mercy of his stubborn-ness, and he had yet to prove himself a scholar. Ultimately, the inevitability of his becoming some sort of an artist led his mother and aunt to steer him toward architecture: "a career at once compatible with my talent and with that social and financial success which every family desires for its sons."

As the new century began, he entered Columbia University on scholar-ship: "There, remote from college life, we sat on high stools, bent over our drawing boards, grinding out projects of Roman baths and stadiums, while our brothers of the Arts and Sciences disported, if it pleased them to, in the swimming pool and track of the university. We were a group apart, unknown to our fellow classmates." With his natural aptitude for the sub-jects of study, including English composition, he excelled. His enthusiasm, however, was muted by what he considered the absence of "originality and initiative" in turn-of-the-century architecture. When he was singled out from the other students, it would be for his failure "to conform to the habits of respectable society in the lecture rooms and draughting rooms." In the summers, he studied painting with William Merritt Chase at his Shinnecock Art Village on Long Island, and after visiting a Philadelphia art exhibition in 1903, he abruptly decided to trade the restrictions of architecture for the freedom of painting. At the New York School of Art, better known as the Chase School, he enrolled in a night class. The teacher was Robert Henri.

Henri's father was a professional gambler. After a dispute resulted in his shooting a man to death, in self-defense, the Cozad family fled Nebraska. Fearing for their safety, they had adopted new names.

BORN ROBERT HENRY COZAD, HENRI HAD GROWN UP ON THE PLAINS OF THE Midwest. The hardships of the frontier, where self-reliance was a necessity, had shaped his character and given him an expansive sense of the country. As a student and, later, teacher at the Academy of the Fine Arts in Philadel-phia—then the country's most prestigious art institution—he took pride in his role as a "revolutioniser" and painted subjects drawn from the everyday world. He admired the art of Thomas Eakins especially, but his heroes were

the American writers Walt Whitman, Henry David Thoreau and Ralph Waldo Emerson. Emerson's belief that the artist should be true only to himself became his credo.

Like so many young artists of his generation, Henri completed his studies only to realize America's cultural limitations. In 1888 he made his first pilgrimage to Paris, following the lead of Eakins, Louis Comfort Tiffany, John Singer Sargent, Childe Hassam and Mary Cassatt. At the Louvre, he was drawn to the works of Rembrandt and Velàzquez, but in time he would warm to the liberating influence of the contemporary French painters and their revolutionary vision.

Influenced by the immediacy of photography, they had begun leaving the studio twenty years earlier to paint in the open air, capturing the fleeting impressions of the moment with a quick, free brush. This was Impressionism, an altogether new approach to painting, and one powerful enough to polarize critics, academics and patrons as never before. The history of art had culminated in the Romantic ideal with its implied superiority of art over nature, encouraging painters to prettify whatever they saw. But the Impressionists, through their uncontrived landscapes and images of contemporary life, identified themselves as nature's servants. Upon seeing Monet's *Haystacks*, Henri said, "All will be affected by the new light he has cast on the art of painting, and painting will be better for it."

Although he won recognition in Paris and reveled in the freedom of its bohemian life, Henri was an American through and through. Disliking pretension of any sort, he had even corrected the French pronunciation of his name, in favor of the American *Hen-rye*. In 1900, he returned to America and settled in New York City with the other European-trained artists. But Henri had come home with a mission: to lead a revolt against the genteel aesthetics of the past by translating the freedom of Impressionism into a distinctive American idiom. It was, however, as a teacher at the New York School of Art, not as a painter, that he would wield his greatest influence, and he was that rare teacher with the power to quietly electrify a young man like Rockwell Kent.

Henri advocated "direct painting," quickly executed without the use of a preliminary sketch, and introduced his students to the work of the old masters as well as the moderns. But his teaching went beyond the brush and easel: As his students painted, he read aloud from the poetry of Walt Whitman in order to instill what he called "the American idea" in an art for the new century. Believing it should be characterized by subject matter as much as style, he sent them out to sketch the gritty humanity of New York's

tenderloin. "If he showed a greater interest in labor, underprivilege and dilapidation as the subject or background for a picture," Kent said, "it was merely because, to him, man at this level was most revealing of his own humanity." While the distinguished William Merritt Chase continued to teach art as "a commodity that must find a market," Robert Henri declared it "a means of speech and not of picture making" and urged each student to make his work a revelation of what he alone *felt* about the subject, not merely what his eyes saw.

At age twenty-one, Rockwell Kent was beginning to look inward and discovering the feelings that would shape him. Through Henri, he decided early on that an artist's work was a reflection of whatever integrity he brought to it, and his teacher's integrity was indisputable. "Henri was in a very deep and true sense a man of the people," he would later write. "His people were mankind. To them—their joys and sorrows, their hopes and their despairs, their world in its physical and emotional entirety—art should give utterance.

The confinement of Columbia's school of architecture and its concentration on the building arts had sharpened Kent's drafting and drawing skills, but it had failed to stimulate his intellect or ambition. In Henri's studio, he sketched alongside George Bellows, Edward Hopper, Guy Pène du Bois and Vachel Lindsay. "They lived for art," he said, but also found time to organize an unbeatable sandlot baseball team. It was during their discussions of European literature that Kent realized that despite the best education money could buy, he had barely read beyond Sir Walter Scott.

Henri counseled Lindsay to give up painting in favor of poetry. One of the major "jazz poets" of the 1920s, Lindsay nevertheless applied his talent to the illustration of a number of his published works.

Making the rounds among them was the translation of a book by Leo Tolstoy. Titled *What Is Art?*, it was a diatribe against Western culture (or as he put it, "Christian art"), an attack on art for art's sake. The elderly Russian writer even went so far as to denounce his own work. While the other students ridiculed Tolstoy's questioning the value of art in society, Kent took his words to heart and marked the closing passage. He would return to it again and again throughout his life:

The destiny of art in our times is to transmit from the region of reason to the region of feeling the truth that well-being for men consists in being united, and to substitute for the present reign of force, the kingdom of heaven, that is, love, which we all recognize to be the highest aim of human life.

It may be that in the future, science will discover new and higher ideals for art, and that art will realize them; but in our time, the destiny of art is clear and definite. The task for Christian art is to establish brotherly union among men.

"Books began to open up a whole new world to me," Kent wrote, "and, sadly, to give my family its first vague premonitions that I was leaving theirs." After reading the poetry of Coleridge and Wordsworth, he felt compelled to become a vegetarian, which provoked ridicule and hostility at his mother's dinner table: "It's funny, I thought, that people get just as mad at you if you try to be a little better than they are as they do if you are worse." Having grown up in a nominally religious, liberal-minded household, he was amazed that he had never heard mention of Darwin's forty-year-old theory of evolution. And so he read *The Origin of Species*:

> *I was as tinder to that match; as tinder heated to the near combustion point. A touch of flame, and I exploded. How far I read, I don't recall. Not far. "Of course!" I cried; for suddenly it was as though a great light, a new sun, had risen on a world of darkness.*

Sara Kent had greeted the news of his departure from Columbia with the expected disappointment and "dire warnings of a life of poverty." Always status conscious, she had struggled to make ends meet most of her adult life. To confer her sense of self-importance on the children—all now approaching adulthood—she had sent them to the best schools and shielded them from contact with their middle-class neighbors. The prospect of Rockwell's architectural career had served her unyielding claim to lost respectability. Fortunate for him, her disapproval of his painting was mollified by the death of her wealthy aunt. A beneficiary of the estate, Sara found herself in a position to have everything she had gone without. She wasted no time in purchasing four acres in Tarrytown Heights and hiring Charles Ewing, the architect brother of one of Rockwell's few childhood friends, to design a house that would be their first permanent address. The inheritance was also a windfall for Rockwell: She bought him the saddle horse he had always wanted and saw that a painter's studio was included in the house plans. And to her satisfaction, the Ewing and Chappell firm hired the former architecture student to help draft the working drawings.

Josephine was more sympathetic to her nephew's determination to paint and arranged for Rockwell to spend the summer of 1905 as an apprentice to Abbott Thayer, the European-trained master painter with whom she had studied. Thayer's popular depictions of angels hovering protectively over the landscape reflected the influence of French Impressionism as well as his interest in New England transcendentalism. A nature-lover and amateur naturalist, he had fled New York in 1901, at the peak of his career, to live in

Thayer and his writer son, Gerald, were then at work on a book that documented his theory that the colors and markings of animals serve solely as protection from predators. After *Concealing-Coloration in the Animal Kingdom* was published in 1909, he promoted the idea of camouflage for military uniforms and battleships. During World War I, his theories were tested successfully by both the Allied and German armies.

the woods of Dublin, New Hampshire, where he could study and paint the protective coloration of birds and animals. Although he owned a house that, without heat or running water, was certainly rustic enough, the eccentricities of his back-to-nature agenda dictated that he, his wife and three children sleep year-round in individual lean-tos scattered through the forest.

It was Thayer's custom to have his students paint copies of his own works in progress, which then provided canvases for his experimentation without risk to the original. Kent was to sleep in a tent and assist with *Copperhead Snake on Dead Leaves,* a painting in which the subject is concealed by the leafy background. But three days into his stay, Thayer declared Kent too good a painter to waste his time as a copyist and freed him to spend the summer painting on his own.

While Kent's independent nature resisted the cultic discipleship that Thayer craved from his assistants, he did learn to respect his instincts over the prescribed rules of painting. With Thayer, he rambled the tall-forest trails of Mount Monadnock, captivated by its wildness. At summer's end, having lived in harmony with nature for the first time, Kent departed with a number of completed paintings and a growing awareness of how sheltered his upbringing had been. Months later, the prestigious National Academy of Design accepted two of these canvases for its juried winter exhibition. That in itself was a remarkable accomplishment for a student, but within days after the opening, both had sold: *Dublin Pond* to Smith College and *Monadnock* to Charles Ewing, his mother's architect. Rockwell Kent could then call himself a painter, although more than a decade would pass before he sold another painting.

HE HAD GROWN UP WITH ONE FOOT IN HIS MOTHER'S MODEST HOUSE and the other in his great-aunt's mansion. Taken altogether, it was a world of privilege. Through his exposure to Henri, Kent began to observe and feel the reality of ordinary lives. Questioning why those who performed the hardest work received the least reward and how poverty could exist in the face of prosperity, he made a discovery: the foolish conceit and ugly existence of class distinctions:

> *The time had been when I would feel a little troubled, now and then, at our having less money than a lot of other people; and now, believe it or not, I began to be troubled at having more. We now had servants, and their lot began to trouble me....I knew I must accept my share of blame. But what I didn't know—not yet—was what to do.*

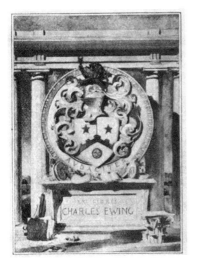

*Bookplate for
Charles Ewing, date
unknown.*

Rockwell Kent was
employed, off and on,
by Charles Ewing's
architectural firm
from 1903 to 1917.
Attributed to Kent,
this is most likely
the first bookplate he
designed.

*Sketch for a bookplate for
E. Josephine Holgate.*
(Rare Book and Manuscript
Library, Columbia University)

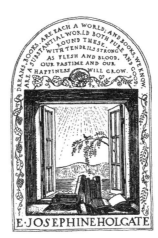

*Bookplate for
E. Josephine Holgate,
1923.*

For his Auntie Jo's
bookplate, Kent selected
a passage from "Personal
Talk," an 1807 poem by
William Wordsworth:

*Dreams, books, are
each a world; and
books, we know, are
a substantial world
both pure and good:
Round these, with
tendrils strong as flesh
and blood, our pastime
and our happiness
will grow.*

In 1904, increasingly isolated in his questioning, Kent sought what he described as "the active companionship of a mind cut closely to the pattern of my own." He found that camaraderie in Rufus Weeks, a well-to-do Tarrytown business leader in his late fifties. Weeks invited Kent to a meeting of the local Socialist Party, where he met others dedicated to righting the injustices of society. Concerned with unemployment, women's suffrage, child-labor laws and the questioned freedom of workers to form unions, the socialists he met were hardly radical firebrands. They were good-hearted citizens, working people for the most part, who believed that socialism was simply the realization of basic Christian tenets. In response to the lingering question of what to do, Kent became a Socialist just in time to cast his first vote for Eugene Debs, the party's perennial candidate for the presidency.

MONHEGAN ISLAND, A SQUARE MILE OF PARTIALLY FORESTED ROCK, RISES from the Atlantic ten miles off the coast of Maine. For almost three centuries, it had been home to generations of fishermen and lobstermen who harvested its winter waters. The island harbor faced southeast, a village of simple wooden structures stood scattered over barren hills, and a lighthouse crowned its highest point. Artists had discovered its surf-battered cliffs in the 1850s, and in time boats from Boothbay Harbor began ferrying summer visitors over to fill the two hotels. In the summer of 1903, Henri spent six weeks there, later describing the island as "a wonderful place to paint—so much in so small a place one could hardly believe it." At his urging, Kent made the same journey in June 1905: "Probably for no better reason than that I was born in Westchester County, which has practically no sea coast, I wanted more than anything in the world to live on the ocean; so I went to Monhegan Island." As Henri's student, he had taken little interest in painting the urban scene and had resisted his teacher's limited color palette. Monhegan would be Henri's great gift to Rockwell Kent: "It was enough for me, enough for all my fellow artists, for all of us who sought 'material' for art. It was enough to start me off to such feverish activity in painting as I had never known."

But it was not enough to watch the Monheganers rowing their dories in the surf and pulling their heavy lobster traps from the water, while he "worked hard at nothing." Envious of the strength and skill that come only from hard labor, he chose to remain on Monhegan when the other main-landers left in September. Work was plentiful:

I worked as a lobsterman and fisherman, as a day laborer, as handyman to

clean out privies or do odd jobs at carpentry. I bought a little piece of land and built myself a house—so I learned the trade of building from the ground up. I later became, in a small way, a contractor and, in a thorough-going way, an expert carpenter. Above all I liked the people I was thrown with, the fishermen.

In his bare, one-room house, he relished the simplicity of dining on lentils, onions, potatoes, rice and lima beans "all stewed up together in their own blood," and found contentment in his time alone:

Far the most profitable hours of my spare time were my nights at home. Seated in my rocker, my feet at the oven door, the lamp at my elbow, my curtains drawn to shut out the night's immensity, my purring cat for living company, I'd read. And reading only the books I had sought out as offering companionship in my thoughts and light along the way my thoughts and life had taken, their authors, giving me as all true writers do the utmost of themselves, became as friends of mine, friends in a more intimate and personal sense than any flesh and blood friends I had known. Books, as the living speech of intimates, as, frequently, their most soul-searching utterances, had come to mean too much to me to ever be deserving of so little as to be loved as books. I was too young, too lusty, lustful, lonely, too starved for intimate companionship and love to stoop to book-loving.

We were a choice group who lived together in my little house on Monhegan. We were Tolstoy who, as we know, had been my friend for years; and with him, Jesus. And Turgenev, a new friend but a loved one.

When he was without work or when the wind blew too hard to go to sea, he painted, and in the spring of 1907, his aunt arranged for fourteen of the Monhegan canvases to be shown at a New York gallery. The artist John Sloan, writing in his journal on April 13, noted:

Went over to Ninth Avenue to pay butcher bills and order supplies for this evening. Then to Clausen Galleries where Rockwell Kent, a pupil of Henri's, has an exhibition. These pictures are immense Rocks and Sea in fair weather and in winter. Splendid big thoughts. Some like big prayers to God. I enjoyed them to the utmost and accept them as great. I'd like to buy some of them.

It was by all accounts a critical success, although not one of the paintings sold. At least in Monhegan, he could count on compensation for his labor,

Of his first exhibition, Kent later wrote: "The critics gave columns to it. The pictures were all for sale and were all low priced. Nobody bought one. Nearly all those pictures are now in museums or important private collections. A lot of money was paid for them—but not to me. In a time of great distress several years later, I sold them all, including their costly gold frames, for the sum of $38.46 apiece."

and that summer he was hired to help build a pair of large summer homes for a Boston family. Elaborately designed, the twin houses would be the island's first to have running water.

At twenty-five, he had heedlessly steered clear of amorous entanglement until he met Jennie Sterling. She was a "plain, alluring little girl," one of the few eligible young women on the island. His attraction to her, he realized, had as much to do with her raw musical talent as with her sensitivity and high spirits. Her exposure to music had been limited to hymn singing and organ playing in the island church until Kent introduced her to German lieder and the romantic songs of Schubert and Franz. "Would a girl's weeping as you read to her the verses that you loved not touch your heart?" he wondered. "Would you not want her desperately? Should not one's actions suit one's thoughts?" But his uprightness, what he called his "better self," forbade intimacy outside of marriage.

The islanders began to regard the two as a couple, which made his odd ways and ideas somewhat more tolerable, if only for a while:

This Sunday night, this fatal Sunday night, they had a preacher, one of those fellows who used to come and spend a week or two preaching and praying and shouting his Hallelujahs until, having collected about all the spare change on the island, he'd move on to greener pastures. Well, there he was, looking no better and no worse than any other man, but carrying on as though he were the twelve apostles rolled in one. With his wife playing soft music on the melodeon he'd preach and pray and plead and shout until with everybody shouting back Praise Be's and Hallelujahs and Amens, and jumping up and testifying and weeping, the whole thing reached a pitch of sacrilegious obscenity that was no longer to be endured.

After expressing his opinion over the lack of reverence in the service, Kent found himself ostracized by the entire community. Even the children were warned to avoid him, and Jenny questioned his singular nature: "Why do you have to be different? Why don't you try to make people like you?"

In the autumn, he departed Monhegan Island with some relief, having weathered what appeared to be the end of his first romance.

Two / The Great Happiness

1908 to 1919

THE CONVIVIALITY OF ABBOTT THAYER'S FAMILY DREW ROCKWELL BACK TO Dublin, New Hampshire. Although he "never won entire acceptance as a member of their most inner circle," he did enjoy the companionship of Thayer's son. Gerald was a writer, and the two bachelors made plans to share a vacant farmhouse outside Dublin that winter of 1908. While Gerald wrote poetry, Rockwell painted, indoors and out. Their concentration, however, was interrupted when Kathleen Whiting, Gerald's cousin from Berkshire, Massachusetts, visited the Thayers:

> *Kathleen, a tall, shy, beautiful girl of barely seventeen, showed in her carriage and her quiet manner all premonitions of the true stateliness that was to grace her later womanhood. Deep-voiced, soft-spoken, gentle, she revealed the depths of her emotional nature only, when overcoming her shyness and her natural modesty, she would sing and play [the piano] for us.*

"Marriage, to someone, it appears, was beginning to enter my mind," he admitted, and his attraction to Kathleen was immediate. She responded in kind, and they became engaged when he visited the Whitings that March. In accordance with her parents' single demand—that they not marry until after her eighteenth birthday—their wedding date was announced for New Year's Eve.

His eagerness to marry stemmed in part from a pressing need to experience physical intimacy with a woman: "Kathleen, however much I loved her, was more to me than just the girl I loved…she was the promise of release and of enduring fulfillment; what a safe harbor is to storm-beset sailors.…" He described her parents as "good people, people finished, inert, done. Kathleen and I were not."

With his mother's guarded approval, Rockwell got to work raising the two hundred fifty dollars he guessed it would take to begin a marriage. That meant returning to Monhegan, where work was waiting and where, he

confessed, he was still "pretty generally disliked." In the summer, he completed the twin houses and built a vacation cottage for his mother. To make his own house a comfortable home for Kathleen, he added a room and a porch, built bookshelves and purchased a good wicker chair.

That October, he returned to Tarrytown to await their wedding date, living for the last time under his mother's roof and attempting to work in the studio she had built for him. "It is almost hopeless to try and accomplish anything in painting here," he wrote to Kathleen. "I feel perfectly helpless and without any ambition." For his growing collection of books, he dabbled at the design of a bookplate, without completing it.

He had seen little of Kathleen after they became engaged, but through frequent correspondence the two became better acquainted. In his letters, he romanced his "darling, darling little Comrade" with his views on socialism and vegetarianism, both of which he considered to be essential steps in mankind's slow ascent toward civilization. He also encouraged her to write to Jennie Sterling, who had taken the news of his upcoming marriage badly. Given the young women's devotion to music, he expected Kathleen and Jennie to become friends.

By then he was aware of what he called "the Whiting family's growing disapproval of the opinions, of the religious faith or faithlessness, of the politics, of the hopes and aims, of, in short, the entire human and divine fabric of their impending son-in-law." After a simple Unitarian wedding ceremony, they spent the winter in Berkshire, a stipulation her parents had added to their consent. Whatever fears they had were eased after the couple settled into a rented house and Rockwell went to work as a draftsman in nearby Pittsfield. "I had never known what home could be," he later wrote, "home as a loving good wife could make it...

George Meredith wrote *The Ordeal of Richard Feverel* in 1859 after the painful collapse of his marriage. In it, the hero and heroine struggle against predatory lords and her dominating father before she loses her sanity and dies.

Our long winter evenings by the stove in our tiny cozy living room: they were good. We'd read aloud. First, I believe, we read a book that I had asked for and received for Christmas: Dostoevsky's Crime and Punishment. *That was a great experience. But then, not knowing what disaster we were courting, we turned to reading* The Ordeal of Richard Feverel, *to find ourselves in the grip of tragedy so merciless as to leave us at its end in such utter sorrow and dejection as only the rapid reading of one Jane Austen after another could relieve.*

WHAT THE COUPLE HAD MOST IN COMMON WAS A LOVE OF MUSIC. AS THE elder son, Rockwell had inherited his father's silver flute, and the square

grand piano they received as a wedding gift had been more gladly welcomed than the investments Sara Kent transferred to her son's name. When he and Kathleen sang or played duets, they were, in his opinion, "not so far from good that others got no pleasure from it." After a trip to New York, where they spent every evening at the opera, he concluded that music summoned "the reverence of life, the love of all mankind….It is not what music *is* that counts, but what the music makes us be. It is not what any of us *are* that counts, but what we do." And he was no good at doing nothing:

> If the enjoyment of life, the enjoyment of each moment of life as you come to it…is wise and right—and I believe it is—Kathleen was far better attuned to happiness than I. No sooner, for example do we finish the good meal that Kathleen in her new role of homemaker has given us, and, one would assume be ready to relax and take things easy for a while, than I, with an eye on the kitchen sink, must say, "Let's get things done," and start at doing them.

In late spring 1909, the Kents and their grand piano moved to Monhegan. Kathleen, already expecting their first child, adjusted easily to island life. As he roamed the headlands with paints and easel, the sounds of her singing and piano playing drifted from their tiny house. It was inevitable, however, that he would encounter Jennie, and when they met on a lonely path, he was unable to resist her. With intimacy no longer a mystery to him, they began an affair. He later wrote that "as my young wife approached that inevitable and most moving metamorphosis of bride or mistress into motherhood, the particular bliss I had so long and fervently awaited was dissolving even as I held it in my arms." Naïvely believing that Kathleen would understand and forgive, he confessed his feelings for Jennie.

Monhegan being no place for an expectant mother and too small an island for two jealous women, the Kents joined a community of socialists near Stamford, Connecticut, in September. Charles Ewing, his first patron, could always find a place in his drafting room for the wandering artist, and Rockwell reluctantly settled into the daily routine of commuting to New York to work as an architectural renderer for the Ewing and Chappell firm. "That most stupendous of all earthly happenings" occurred in late October when Rockwell Kent III, "a big, fine, bouncing boy," was born. They called him Rocky.

Working from an architect's plans and elevations, the renderer makes the idealized perspective drawings of a building as it should look upon completion.

The days Kent spent in the city reunited him with the circle of renegade artists that orbited about Robert Henri. A year earlier, he and seven others, calling themselves The Eight, had organized an exhibition in defiance of the

National Academy of Design. Founded in 1825 "to promote the fine arts in America," the tradition-bound Academy had come to dominate American painting and sculpture. The endorsement that came from being selected for its annual exhibition was essential if an artist was to be exhibited in galleries or receive commissions. In 1908, The Eight had succeeded in loosening the Academy's stranglehold on American art.

John Sloan, one of The Eight, had made his reputation in Philadelphia as a newspaper illustrator before taking up painting in New York. When plans for a second exhibition fell through, he and Henri began organizing what they called the Exhibition of Independent Artists. The month-long event in a three-story loft would be open to any artist willing to pay a small fee, without a committee ruling on which works would be accepted for display. Sloan remembered Kent's work from the Clausen Galleries exhibition, and after the two became acquainted in January 1910, Kent was "in the scheme." As planning progressed, Sloan and his wife Dolly took the young artist under their wings, their friendship strengthened by the socialist views they shared. Many nights found Kent sleeping on the studio couch at their West Twenty-Third Street apartment when he missed the train to Stamford.

The exhibition of more than a hundred artists, known and unknown, opened in April, and the praise and condemnation it received attracted throngs of New Yorkers. Kathleen, whom Sloan described as "a pale willowy young girl," visited on April 5, the day that marked her introduction to this other life her husband led. As Sloan recorded in his daily journal, she returned at the end of the month:

> *The Kents arrived with the baby boy, Rockwell Kent third. Dolly took care of [the] baby while they went to the Independent Exhibition. After the little one had been put to sleep Mrs. Kent played the piano…I like her playing. I made a sketch for a bookplate for Kent.*

Sloan had recently acquired two books of Thomas Bewick's late eighteenth-century wood engravings of English country life. The bookplate he drew for Kent simulated Bewick's vivid style, and Kent reported that Henri "went into raptures" over it. In early May, Sloan noted: "Rockwell Kent wrote to me from Monhegan, Maine, sending me proofs of his bookplate which looks quite well, I think. He is very much pleased with it. Invites us up to spend some of the summer with them."

Rockwell had returned to the island, added a studio to his house and opened the Monhegan Summer School of Art. To Kathleen, Monhegan

George Luks, Arthur B. Davies, Ernest Lawson, William Glackens, Maurice Prendergast and Everett Shinn completed The Eight. They were selected by Henri, who is said to have considered two of his students, George Bellows and Rockwell Kent, but ultimately chose the older artists.

Sloan provided the
scratchboard-and-ink
illustration; Kent most
likely lettered Kathleen's
and his names. Drawn
in the style of a Thomas
Bewick engraving, it was
the first bookplate Kent
is known to have used.

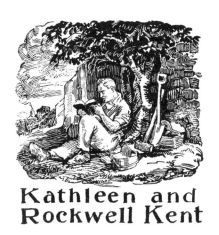

Kathleen and
Rockwell Kent

served only as a reminder of her humiliation, and she and the baby spent that summer with her parents in Berkshire. She took comfort in knowing that Jennie Sterling had left the island to study voice in Boston, but agonized over her husband's divided affection. After several months' separation, she arrived on Monhegan with an ultimatum: If their marriage was to continue, Rockwell would sell the house and cease his correspondence with Jennie. Although he professed love for both women, he agreed to his wife's demands.

John Sloan's journal provides the most accurate record of what followed:

October 6 Rockwell Kent arrived early in the day. He has brought Mrs. Kent to stay in the city for the winter. He is…making a two week trip to Newfoundland to look over the ground up there. He proposes to buy some acres of land and perhaps start a "colony." Wants me to take the Newfoundland trip with him.

Kent had envisioned his Monhegan art school as the genesis of a community of artists similar to the one in Dublin. With Kathleen's refusal to live on the island, he looked northward to Newfoundland, "that rumored, stern and forbidding, sea-encircled rampart of our northeast coast." Eight hundred miles from Maine, it was a self-governing British colony, and with a thousand miles of rocky, deeply indented coastline, it became, in Kent's hopes, Monhegan on a far grander scale. Sloan admired Kent's adventurous spirit, but was unwilling to brave the upper latitudes himself.

Bayard Boyeson had lectured at Kent's summer art school, using it as a platform for preaching his own radical politics. He became an enthusiastic backer of the artist's Newfoundland idea.

October 11 Rockwell Kent still sleeps here at night though we see very little of him, he is so energetic! At request of Boyeson, who is assistant professor of English at Columbia College, Kent went up and gave an informal talk to students in a club of undergraduates of the University.

October 12 We came back to the studio where Mr. and Mrs. Kent were having a quiet last evening together by Dolly's invitation. Mrs. Kent, who with the baby is in Brooklyn with a sister, stayed the night. They sang for Dolly and me.

Expecting to be away for two weeks, Rockwell left the next morning for Gloucester, the Massachusetts seaport where he was to board a fishing boat for Newfoundland. Due to various delays, including a stopover in Boston that returned him to Jennie's arms, it was two weeks before he even reached his destination. By then, Kathleen was anxiously awaiting his homecoming.

On October 28, she visited the Sloans and, thinking Rockwell would show up any day, ended up spending a week with them:

October 30 Mrs. Kent still with us. The baby is a fine beautiful straw white haired boy, a perfect specimen. She is the most curiously quiet woman I ever met, you simply can't make her say more than six words "in a chunk."

November 1 Mrs. Kent still quietly stays on. We are sorry for her but it does get rather tiresome to entertain one who is so unentertaining. And the baby fine and dear as he is [is] a nuisance, in three rooms and bath...and this entertainment adds to our household expenses and keeps us on a vegetable diet for Mrs. Kent is a vegetarian made such by her devotion to Rockwell, of course. So poor Dolly and I have been "on the Nebuchadnezzar" as you might call it ever since she came and will be till she goes.

November 4 Mrs. Kent and Rockwell the baby left to go to Brooklyn and continue their visit with Mr. and Mrs. Grebbs who must be very long suffering people or have musical tastes or something of that sort.

When Kent arrived home after more than a month, he was bursting with plans for the "university" he intended to create from an abandoned factory on Newfoundland's southeastern coast. From there he had written: "Dear wife, dear little son, I love you so! And never, never shall you be unhappy again." It was the assurance Kathleen desperately needed, for she was expecting another child.

Once Kathleen and Rocky were settled in the apartment he rented in the Sloans' building, Rockwell traveled to Monhegan to pack up his canvases. Upon arrival, he received a letter from Jennie with the news that she, too, was pregnant. He replied immediately:

Jennie—all that I can give you is yours—except the one most important thing at this moment—myself. I'll sell all that I have, if necessary, to give you money. But Jennie, it seems to me that unless we want to be plunged into a life of endless tragedy the child must not be born....As I write this I feel like a reptile.

For Jennie, an abortion was out of the question. As reparation, Kent gave her everything he had—the Monhegan house he had intended to sell, as well as the securities his mother had given him as a wedding present—and his Newfoundland venture dissolved in an instant. At age thirty, he still called

On Nov. 16, Sloan wrote in his journal: "He had some interesting experiences, though of a strenuous sort that hardly appeal to me." He seemed dubious that anything would come of Rockwell's plans. After the two couples became neighbors, their friendship rapidly crumbled when the Kents prevailed on the Sloans to baby-sit once too often. Sloan would later write: "Poor Rockwell Kent! Little man with *ideals...*"

himself a painter, but had sold only two canvases in ten years. Architectural rendering was the only way he knew to earn a living in the city, and it was tolerable at best. After a fellow draftsman commented on his cheerlessness, Kent responded, "When five o'clock comes round you're just one day ahead in what you want to do. And I have lost another day from life." Kathleen's baby arrived in April 1911; named for her mother, she was called Katie. Jennie's child, a boy, was born in July and died five months later.

In the flat they rented at 4 Perry Street, Rockwell and Kathleen found contentment through the normalcy of their domestic life. Pinching every penny, they socialized at home with their few friends. One was Marsden Hartley, a painter from Maine, whom Kent called "a constant visitor, dining with us as an accepted member of our little family several times a week." Carl Zigrosser, a twenty-year-old literature student, was another. He had met Kent when the artist addressed Boyeson's student group at Columbia. It was "friendship at first sight," overwhelming Zigrosser's usual reserve and whetting his interest in the New York art world. By Kent's description, Carl was "as angelically beautiful a youth as ever trod our earth, his beauty being eloquent of such unearthly purity of soul as shamed a sinner such as I." He would never forget his first visit to the artist's home:

> Greenwich Village seemed so romantic on that cold snowy night. And the warmth of hospitality inside, music with Kathleen at the grand piano, good talk—Marsden Hartley was there between sojourns in Maine—talk of poetry, art and nature. It was a glimpse of life at its fullest, most glamorous—the artist's life, the creative way.

True to his wandering nature, Kent seized upon an opportunity to move to Winona, Minnesota. There, as the on-site representative of a prestigious New York City architectural firm, he would spend a year superintending the construction of a pair of Georgian mansions. Known as Briarcombe Farm, the suburban estate was owned by two businessmen whose wives were sisters. The Kents arrived in the spring of 1912 and moved into an abandoned schoolhouse near the construction site. When Rockwell found himself with spare time, he began peddling fruit and vegetables from a horse-drawn wagon—a sideline that endeared him to the town's working-class people, if not to his two socially prominent patrons:

> It was…somewhat disconcerting to know, as of course my host and hostess would, that I was on far more familiar terms with their servants than with

The side note reads:

Affiliated with the Alfred Stieglitz circle of artists, Marsden Hartley was five years older than Kent. When they met, Hartley was painting Maine's mountain landscapes, but searching for an individual style. He went on to become one of America's leading avant-garde painters, a development that Kent would bemoan.

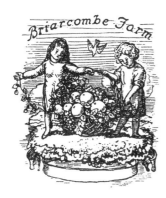

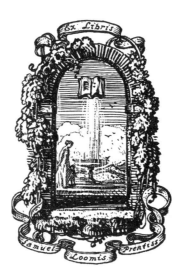

Bookplate for
Briarcombe Farm, 1913.

Bookplate for
Samuel Loomis Prentiss,
1913.

Bookplate for
Margaret Sanger, 1944.
When Sanger donated
her books to the
New York Academy of
Medicine and the
Library of Congress,
she asked Kent to
design a bookplate for
them, using the drawing
he had made for her in
1915. Kent located the
drawing but left the
typography and overall
design to his printer,
Abe Colish.

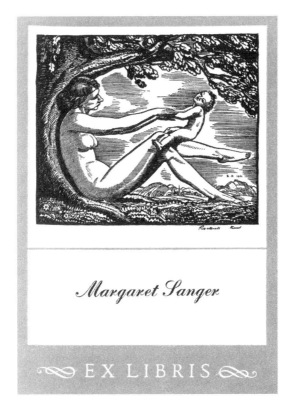

themselves, having as like as not that very morning delivered in their kitchen a good portion of the food my hostess served at dinner.

Later, his successful campaign to raise the construction workers' wages further provoked his patrons' outrage. But Samuel Loomis Prentiss, the more tolerant of the brothers-in-law, arranged an exhibition of the artist's paintings at the local library, and Kent designed bookplates as gifts for him and the estate.

WHILE KENT WAS IN MINNESOTA, THE INTERNATIONAL EXHIBITION OF Modern Art opened at the 69th Regiment Armory building. The culmination of the independent artists' challenges to the authority of the Academy, the Armory Show presented the works of three hundred American and European artists, and attracted more attention than any previous art exhibition. Although the imported works of Matisse, Kandinsky, Picasso and Duchamp received more ridicule than praise, they easily stole the show. A generation ahead of the most adventurous of the American painters, the Europeans represented the future. Kent's absence from what was the pivotal event in the history of American art can only be explained as out of sight, out of mind.

Kathleen gave birth to their third child soon after the family resettled in New York in June 1913. Back on the "chain gang" at Ewing and Chappell, Rockwell became more determined to resurrect his painting career. Other artists could paint the New York street scenes; he remained haunted by his brief visit to Newfoundland three years earlier and dreamed of painting its steep, stark hills. After his mother and an art dealer agreed to provide a monthly allowance, he sailed alone to Newfoundland in February 1914. At Brigus, a thriving outpost of seal hunters and fishermen on Conception Bay, he rented and reconstructed a tumbledown cottage, and awaited the arrival of Kathleen and the three children that summer:

As the steamer neared the wharf and I could see them all, all four along the rail—the baby Clara in her mother's arms—my heart was near to bursting. Before the steamer touched the wharf I leaped aboard—only to be collared by an immigration man and brought ashore again. No matter; in but minutes more we were in each other's arms.

As the people of Brigus welcomed the family into its social circle, he knew he had found his promised land: "Not for a season's sojourn had we come to Newfoundland…we had come to stay." He painted its landscape

Robert Henri and most of his students exhibited at the Armory Show in February and March 1913. Still dedicated to the development of a truly American art, he had objected to the inclusion of foreign artists and was barely involved in organizing the show. Afterwards, his worst fears were realized when many of the American painters began to experiment with Cubism.

during the short summer, while in winter he experimented with canvases freely composed from his imagination. With Kathleen expecting their fourth child, their immigration seemed complete. But as Rockwell later recounted: "A man's clambering about the rocks and hillsides with his paints and canvas, and the very act of painting pictures were, to the general public, activities of so curious a nature as to arouse, at first, some wonderment and, finally, suspicion." In early 1915, England and Germany went to war, and rumors of his being a German spy began to circulate among their neighbors:

What, in fact, could be the purpose of the so-called "studio" I'd built? What but a secret place to finish up the maps that all had seen me painting here and there!...And hadn't Kent (if that was really his name) sung German songs at a church concert? Though it had been at least a year ago, those Schumann songs had been remembered. And how about those seven tons of coal he'd stocked last fall—on that steep hillside fronting on the bay? An easy place, no doubt, for U-boats to refuel!

It was a ludicrous notion to Kent, and his reckless response and admitted admiration for the German culture only made matters worse. The harassment that followed culminated with the family's deportation at the end of July. Penniless and with another mouth to feed—a third daughter, Barbara, was one month old—they were brusquely put on a boat for New York.

There, Rockwell realized that hysteria over a war fought an ocean away had followed him home. Under Woodrow Wilson, the United States had officially adopted a neutral position, while silently favoring England and France. Most Americans had no immediate familial ties to Europe and were disinterested in becoming involved in war, but the German and Irish Americans, the country's two largest immigrant groups, were united by their pro-German and anti-English sentiments. The sharp divisions of opinion were especially pronounced in New York.

Kent's adamant opposition to the United States going to war for either side renewed his interest in political reform. In the radical bohemian culture that flourished in Greenwich Village, he met others who shared his views. Among them was Margaret Sanger. As a nurse helping deliver babies in lower East Side tenements, she realized that poverty propagated childbearing, and vice versa, and had taken up the cause of birth control. It was a crusade that could only be borne by the momentum of the socialist movement, and the shy young mother had gravitated to others who were challenging a political system that seemed to enforce poverty. The warmth of her friendship with

Kent was underscored by the fact that he—unlike Emma Goldman, John Reed and the other firebrands in that community of intellectuals and artists—was a family man. In 1915, he drew the cover for one of her birth-control pamphlets. Upon receiving the image of a happy mother and her one child, she wrote, "I was so overjoyed to receive your drawing that the family think I've quite lost my wits."

Two years would pass before the first American troops landed in France, but when the slowing economy reduced Ewing and Chappell's workload, Kent was laid off. Encouraged by the large number of magazines published in New York, he turned his skill at pen-and-ink rendering to freelance illustration. It was a precarious and, to his way of thinking, frivolous way to earn a living, but his lighthearted drawings began to appear in *Vanity Fair* and *Punch,* signed "Hogarth, Jr." to protect his identity as a serious artist.

His paintings occasionally found buyers, thanks to his association with Marie Sterner, who selected contemporary art for the Knoedler Gallery. Even so, "fortunes reached their all-time low" in June 1917. Ostensibly to reduce expenses, Rockwell moved his family to a borrowed cottage on Monhegan. Kathleen's innate maturity and sense of responsibility had, in truth, become an uncomfortable reminder of his own inadequacies and failed aspirations. He would remain in the city, living and working in his Twelfth Street studio with Hildegarde Hirsch, a dancer with the Ziegfeld Follies. As ever, he believed his confession to Kathleen transcended his transgression. "This last 'affair,'" she wrote, "has left a scar on my life that will not soon disappear."

The family's finances were promptly restored when the Metropolitan Museum purchased *Winter,* a painting from his early days on Monhegan. With city life stifling his need to paint and its Hildegardes imperiling his family's future, a healthy bank account renewed his wanderlust. Time had done nothing to assuage his resentment over having been uprooted from the contentment he and his family had enjoyed in Newfoundland:

> We have searched hard, my Kathleen and I, for the Great Happiness.... Always we seem, at least to ourselves, to gather a little more wisdom along the pathway to some wonderful free land. It is this that we are living for.

IN HIS QUEST FOR A PLACE TO PAINT "WHERE MEN ARE NOT," HE CONSIDERED Iceland and the American Southwest before making Alaska his destination. Kathleen had written from Monhegan, "Do stop for a minute and try to realize how cold and lonely we are here; and if possible come up and take us home." Even so, she promptly dismissed the idea of accompanying him

Of Marie Sterner, Kent later wrote, "It is due entirely to her intelligent and generous management that I am now a professional painter rather than God knows what."

The Kent's fourth child, Barbara, had been given the name Hildegarde at birth. After Kathleen realized that it was the name of her husband's mistress, she renamed their daughter.

without the children. He was ironically more concerned with his loneliness than hers, for the prospect of facing the Alaskan winter alone terrified him. His suggestion that Hildegarde accompany him persuaded Kathleen to allow Rocky, "a husky lad, tall for the age of eight, and strong," to go along.

Rockwell and Rocky arrived in Seward, Alaska, in late August 1918 and made arrangements to share Fox Island, twelve miles across Resurrection Bay, with Lars Olson, an elderly prospector and its sole inhabitant. The log shelter Olson had built for his Angora goats suited Kent's spartan needs. It became what he called an "adventurers' home." Without a clock or calendar, the progression of days was marked in the journal Rockwell mailed to his family and friends:

September 25 [Rocky] and I worked some time with the crosscut saw. I'm constantly surprised by his strength and stamina. [He] read nine pages in his book of the cave dwellers. So nine of Robinson Crusoe *were due him after supper. He undresses and jumps into bed and cuddles close to me as I sit there beside him reading. And* Robinson Crusoe *is a story to grip his young fancy and make this very island a place for adventure.*

The Cave Dwellers and *Robinson Crusoe* were but two of the two dozen books in their library. Others were *The Iliad, The Odyssey, Treasure Island, A Literary History of Ireland* and a biography of Albrecht Dürer.

Torrents of autumn rain kept father and son confined to the cabin for days on end. There, sitting side by side, they drew pictures and wished for word from the outside world.

November 6 Olson returned this evening with news that Peace is at hand! Thank God!

December 5 I don't believe that provincialism is an inevitable evil of far-off communities. The Alaskan is alert, enterprising, adventurous. Men stand on their own feet, and why not? The confusing intricacy of modern society is here lacking. The men's own hands take the pure gold from the rocks; no one is another's master. It's great land—the best by far I have ever known.

December 7 Whew, but it's cold tonight and the wind is rising to a gale. And last night!—what a bitter one. I got up four times to feed the ravenous fire. And even so the water pails froze. We cannot afford to let it freeze much in the cabin for our stores are all exposed. What if the Christmas cider should freeze and burst! I painted out-of-doors today—in sneakers! and stood it just about as long as one would imagine. To love the cold is a sign of youth—and we do love it, the Awakener.

December 13 If I'm out-of-doors busy with the saw or axe I jump at once to my paints when an idea comes. It's a fine life....I painted out-of-doors on two pictures. That's bitterly cold work—to crouch down in the snow; through bent knees the blood goes slowly, feet are numbed, fingers stiffen. But then the warm cabin is near...

In letters to Carl Zigrosser, he confessed the darker side of their adventure: "Paradise is far, very far from complete. I have terrible moments, hours, days of homesick despondency..." He contemplated suicide. Among the books he read was *The Odyssey,* and like Ulysses, he longed for his wife. The letters he wrote to Kathleen were calculated to persuade her to join them, but she again refused to leave their three daughters.

When the Christmas mail arrived in February 1919, Rockwell learned that she had moved from Monhegan to New York. Their bank account having dwindled to nothing, she was dependent on the mercy of sympathetic friends. She begged him to come home.

There was no choice but to leave as soon as passage to Vancouver could be arranged. "I told [Rocky] of this today," he wrote, "and his eyes have scarcely been dry since." As for his own feelings, it marked "the end of a real summer in our lives..." The canvases, in various stages of completion, were carefully rolled, crated and delivered to a shipping firm in Seward, and father and son departed in mid-March without having known an Alaskan summer.

Three / A Light Flashed into Darkness

1919 to 1922

ALTHOUGH THE ALASKAN EXPEDITION LASTED ONLY SEVEN MONTHS, IT had been a productive time. Traveling to New York with a stack of sixty drawings, Kent faced the world "of numbered streets, numbered houses, numbered floors" with dread. If history foretold his immediate future, it seemed inevitable that he would be back where he started, "a ridiculous figure rushing here and there with a portfolio of ideas that nobody wants, ending finally as a comic artist for *Puck*."

The two Rockwells returned to a joyful homecoming—and to the hard reality of accumulated debt. Marie Sterner quickly came to the family's financial rescue; within weeks, she mounted an exhibition of the Alaskan drawings at the Knoedler Gallery. It was not only a critical and financial success beyond Kent's reckoning but also resulted in a publisher's contract for a book, a memoir of his expedition that would include the drawings and excerpts from his letters.

In Alaska he had concluded that "isolation—not from my friends but from an unfriendly world—is the only right life for me." Looking northward to Arlington, Vermont, he bought a farm. "It's more beautiful than any place I've ever seen," he said of the hundred acres known as Egypt. "The verdant valley lies like a map below us." He and Kathleen had been man and wife for a decade, with the piano her only abiding companion. she had tolerated the wandering as well as his absences and lapses; she had raised four happy children and set up some semblance of a household under nine different roofs. If she were ever to feel secure in their marriage, it would begin at Egypt.

Once Rockwell made the old house habitable, he went to work finishing the canvases that had arrived from Seward and editing the manuscript for his first book. He called it *Wilderness: A Journal of Quiet Adventure in Alaska*. When the day-to-day distractions of family life got in the way of his work, he built a studio on a remote ridge. Memories of his one-room house on Monhegan and the cabin on Fox Island determined its design and proportions. Isolated from the farmhouse and with a commanding view of Mount

Arlington, Vermont, was home to the author Dorothy Canfield and her husband John Fisher, who had befriended the Kents upon their arrival in the village.

According to local lore, after a late frost caused crop failures in the countryside, one area was miraculously spared. After its farmers shared the harvest with their neighbors, those acres became known as "Egypt," after the Biblical story of Joseph providing grain to his starving brothers.

Equinox, it was a shack just large enough for the tools of an artist's trade, a wood-burning stove and a small handpress that Carl Zigrosser had procured for him.

AFTER EARNING A DEGREE IN LITERATURE, CARL ZIGROSSER HAD MARRIED and gone to work as a research librarian for a New York dealer in fine prints. It was Kent who had opened his eyes to art, and Zigrosser's association with the maverick artists and hours spent at the Armory Show had galvanized his resolve to find a place for himself in that world. "I was a youthful and uncritical admirer," he later said of Kent. "We were both idealists and we had many interests in common."

Knowing Rockwell's affinity for woodwork and the precision of his draftsmanship, Carl had given him a set of hardwood blocks and engraving tools before he set out for Alaska. Months passed before Rockwell made his first attempt: "Tonight I've made a number of pen-and-ink drawings and have at last drawn a design upon a wood block. It is a wonderful surface to draw upon." He spent the next day cutting the block. The exacting discipline of making a woodcut proved irresistible. A canvas could be painted over, but wood was unforgiving. It allowed no room for error or carelessness, and whatever image he envisioned would have to be cut in reverse. What intrigued him most was the sculptured luminescence of the image: "Into the smooth surface of a wood block—which, if inked and printed, would appear as solid black—the artist cuts those lines and hollows out those surfaces which, like a strong light flashed into darkness, reveal the forms it had concealed." Confined to the cabin during Alaska's rainy autumn, he continued his experiments, and by late November he had completed a crude engraving of a figure with arms outstretched, standing in a boat. Satisfied, he cut his initials into the sky and stamped the image on his stationery. It marked a beginning:

> *Engraving, in my hands, became wonderfully consistent with the eccentricities of my own nature: with my inability to distinguish what are termed the "finer shades"; my preference for fair over foggy days; for clean sharp lines; for clear perception versus mystical imaginings; for stark, uncompromising realism versus unreality. You've got to know your mind to work with steel on wood.*

When Carl visited Egypt, he and Rockwell spent hours experimenting with wood-block printing. By then, he had been hired to open and manage an art gallery in the back of Erhard Weyhe's Lexington Avenue bookstore. Weyhe

A *woodcut* is made on the soft side grain of a plank, whereas a *wood engraving* is cut against the grain on its more durable sawed end. Kent's experimentation with the medium in Alaska is thought to have begun with a woodcut of a Christmas tree decorated with candles. He continued with small wood engravings.

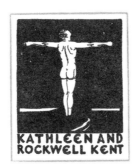

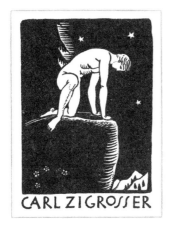

Bookplate for
Kathleen & Rockwell
Kent, ca. 1920.

Bookplate for
Carl Zigrosser, ca. 1920.

Bookplate for
Florence King, ca. 1920.
She and Carl Zigrosser
married in 1915. An
Irish-born feminist, she
kept her surname.

Bookplate for
Nancy Lee, ca. 1920.

Bookplate for
Charles Amiguet,
ca. 1920.

Amiguet was a painter
associated with the
artists' colony at
Woodstock, New York.

Bookplate for
H. C., 1923.

The identity of H. C.
is unknown. In later
years, Kent refrained
from naming the
person for whom it
was designed.

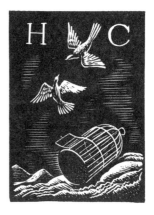

Bookplate for
Elizabeth Miller,
ca. 1923.

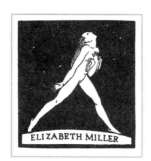

ELIZABETH MILLER

specialized in art books, for which there was a growing demand, and he was agreeable to Zigrosser's vision of a gallery that would offer contemporary prints, mostly imported from Europe, at moderate prices. Zigrosser's ultimate ambition for the E. Weyhe Gallery, however, was less mercenary: "The introduction of graphic art from abroad…was only one part of the gallery's program; the other aim was to become a center for American prints, and to encourage the native artist by creating a market for his work." He began by commissioning prints from twelve American artists, including Kent, in time for the gallery's opening.

Printmaking also appealed to Kent philosophically; he called it "a democratic art." Unlike a painting, each impression was "in every sense the true 'original' of the design." A single picture could be acquired and appreciated by a hundred people of modest means.

His earliest prints—experiments with the blocks Zigrosser had sent with him to Alaska—were limited in size to an inch or two in either direction. To make them useful, he added names or initials to create bookplates. The first was for Kathleen and himself. Replacing the one John Sloan had designed for them, it was a refinement of the letterhead he had made for himself in Alaska. With the addition of Kathleen's name, it signified his recommitment to their marriage.

Rockwell called the bookplate he made for Carl *The Onlooker.* They agreed that it was a psychological portrait. "Often I wish that I were constituted for such Olympian detachment," the artist said of his best friend. Although they were united in their outrage over every form of social injustice, Rockwell was the one to wage battle, while Carl avoided confrontation: "Our differences, such as they were, stemmed from the difference between an active and a reflective temperament." Rockwell fashioned a companion bookplate for Carl's wife, Florence King.

The few bookplates Kent made at Egypt most often served as gifts for friends. Those that were improvised from his small wood engravings were usually identified by the recipient's initials cut into the background. Others, such as his bookplate for Gerald Kelly, were printed from copper plates made from pen-and-ink drawings.

An employee of the Wildenstein Galleries in New York and, like Marsden Hartley, a homosexual, Kelly was a welcome visitor at Egypt:

> Gerald, a man of rare sensitivity, great culture, and most touching humanity, was of that unhappy nature termed, from the standpoint of male chauvinism, feminine; and in compensation for which he quite understandably affected an

intellectual and cultural arrogance that was as much at variance with his sympathetic heart as with his better understanding of himself and others. We soon became great friends; but reminding me, as he occasionally would, that I was not of the inner circle of his friends, he would wave his hand and say, "You are too small to play with us." How proud, superior, aloof he made himself to be! Well, Gerald came to visit us. He saw our family life, and felt its beauty; he loved the children. And suddenly one day it was too much for him. He told me what it meant to him to see such normal happiness, how agonizingly he longed for such a life; how it could never be. He wept. Good God, I thought, if people only understood!

Kent's sketches for Kelly's bookplate were the basis for his 1920 wood engraving *Man under a Waterfall;* the bookplate itself was printed from an ink drawing that the artist later titled *Absolution.* After Kelly received his bookplate, he wrote to Kent, "On the whole I like the rather 'drawn' look it has (like myself after a hectic night)."

THE KNOEDLER GALLERY EXHIBITION OF KENT'S ALASKA PAINTINGS AND THE publication of *Wilderness* were timed to coincide in March 1920. The *New York Sun* heralded the exhibition as "the most interesting event from an American point of view this year." It was, however, *Wilderness* that had the greater impact. One British literary critic called it "the most remarkable book to come out of America since *Leaves of Grass.*" Kent was inevitably described as a modern-day Thoreau. His paintings and writing received acclaim, but the Alaskan adventure they chronicled made him a celebrity in New York. And celebrity demanded that he divide his time between the city and the country.

The family's first year at Egypt had been idyllic in most ways. With Kathleen expecting their fifth child, Rockwell added a room to the house. (A second son, Gordon, was born in October 1920.) The New England village met the family's social needs, but Rockwell was less enchanted by the traditional teaching and curriculum at the district school. Presented with an opportunity for Rocky, Katie and Clara to attend a progressive private school at little expense, he moved Kathleen and the children to Greenwich, Connecticut. The family would reunite at Egypt each summer. It was an arrangement made for the benefit of the children, but it also suited their father, who could more easily partake of his celebrity without Kathleen to answer to.

Reluctant at first to be exploited as a personality, he became surprisingly

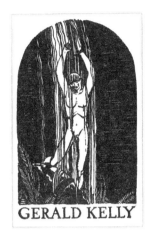

*Sketch for a bookplate
for Gerald Kelly, 1920.*
(Rare Book and Manuscript
Library, Columbia University)

*Bookplate for
Gerald Kelly, 1920.*

*Bookplate for
Katherine Abbott, 1920.*
(Bottom left) Katherine.
and Rockwell met in
1917, and she was most
likely one of the women
with whom he had an
impulsive affair during
his marriage to Kathleen.
It was a friendship that
endured through
Katherine's marriages
to millionaires Gordon
Abbott and Cheever
Cowdin. Rockwell
designed two bookplates
for her, as well as a logo
and brochure for her
personal shopping and
interior decorations
businesses.

*Bookplate for
Katherine Abbott, 1927.*
(Bottom right) Titled
*Life Triumphing over
Learning,* the drawing
for her second bookplate
had been published in
Vanity Fair in 1921.

visible in the realm of "fine houses, pretty people and good food." From his association with Ewing and Chappell, he had learned a lesson: "They had good friends; and friends, I came to realize, are maybe more important to *success* in the profession of architecture than all one's taste and talent put together." One winter lived in a goat shed had ironically catapulted him into the lap of New York society, where his outgoing personality served him well. As Carl Zigrosser recalled, "He often went out with black tie and dinner coat, and moved, in New York or at Long Island estates, in the circle of the Ralph Pulitzers, the Whitneys, and Gordon Abbott and his wife, Katherine."

At Egypt, he had closed the house and moved into the studio, but most weekends found him in residence at Ralph and Fredericka Pulitzer's mansion in Manhasset. There were visits with his family in Greenwich, but it was only a matter of time before he plunged into an affair with another woman. "One didn't look for trouble," he wrote of her, "trouble—garlanded and wreathed in smiles—just came."

By the spring of 1922, the demands of juggling a love affair in New York with his work at Egypt and his family in Greenwich proved impossible. Kent had become frustrated with painting the bucolic Vermont landscape, and there was no future with the other woman, who proved to be as dominating as he. In his words, it had become an "emotional mess." Zigrosser, who usually reserved judgment, had come to the conclusion that the New York social scene, with "its essential mockery and shallowness," had led to his friend's undoing.

Arrangements were hurriedly made for what Rockwell admitted was "a somewhat desperate move toward disentanglement." For years he had talked about traveling to the farthest corner of the world, Tierra del Fuego. Charles Darwin's writings, no doubt, added to the allure of the Patagonian archipelago at South America's southern extremity. In May, Kathleen and Carl saw him off from Brooklyn, where he boarded an ocean liner for Chile, his heart set on sailing a small craft around Cape Horn.

Four / Reaching to the Stars

1922 to 1928

ELMER ADLER HAD ARRIVED IN NEW YORK IN 1922. WITH A PROOFREADER, a pressman and three hand-operated presses, he opened the Pynson Printers above a midtown garage. He was a thirty-eight-year-old bachelor with no experience in workaday printing, but he knew its artistry through his collection of centuries-old works by the master printers. Others found inspiration in the meaning of the printed word, but it was the beauty of each letter of the alphabet and their artful arrangement as words on a page that moved him. That he had never learned to set type or operate a press—and never would—was irrelevant to the objectives laid out in his company's prospectus:

From the 20th of March 1922, the Pynson Printers are at your service for the planning and production of all printing in which quality is the first consideration. We have founded our organization on the belief that the printer should be primarily an artist—a designer and a creator rather than a manufacturer.

Our shop is adequately equipped with presses and a careful selection of typefaces, which will be augmented from time to time with importations and new designs. But we consider the equipment of value only as it serves our ability as designers and creators. And to supplement our efforts we have available in our library the examples of the master printers of five centuries.

We will do no work in which quality must be sacrificed to exigencies of time and cost. On the other hand, we will demonstrate that promptness and economy are not incompatible with high standards of workmanship and that good printing depends on beauty and effectiveness of design, on conscientious craftsmanship, rather than on expensive material or elaborated processes.

We believe that the practice of competitive bidding encourages the awarding of contracts to the bidder most willing to sacrifice quality to cost, consequently we will have no part in this system. However, we will always be ready to prepare, on order, plans and layouts to meet a definite appropriation. We especially solicit orders for books and brochures.

The Pynson Printers was named in honor of Richard Pynson. As printer and stationer to Henry VIII, Pynson had introduced roman type to England in 1509. (Up until then, the printed word in English had been composed in black letter, the heavy script-like typeface known today as Old English.)

Adler's ambitions were well-founded: The optimism and prosperity of the twenties had resulted in a dramatic increase in readers, which in turn fostered a rush to collect high-priced fine editions. Printed in small quantities, these were most often classic works, the text of which became secondary to their handsome illustrations, typography, paper and binding. The demand for limited editions created an unprecedented opportunity for designers, illustrators, typographers and printers to elevate their crafts to the highest level of creativity and visibility.

In the world of Elmer Adler, which was largely the Pynson Printers, there was no place for carelessness or hurry. One colleague described him as "an instigator, a needler, never satisfied with maybe or second best…the most *un*easygoing person I have ever known." Anyone who knew him came to dread the slight lift of his right eyebrow, which unconsciously registered disdain for anything that intruded upon his ideals of quality and good taste. He believed fervently that art and life should be mutually enriching. Fortunate for him, the community of mostly younger writers, artists and publishers who had gravitated to New York after World War I shared his idealism. Their generation would usher in America's golden age of publishing.

Adler easily established himself and his print shop with those who not only respected his impossible standards but also could bear the accompanying cost. Dedicated to the well-written *and* well-made book, the up-and-coming publisher Alfred A. Knopf immediately hired him to design and print four hundred fifty copies of Willa Cather's *April Twilight and Other Poems.* And in 1924, Arthur Hays Sulzberger of the *New York Times* invited the Pynson Printers to move into the Times Annex building, where Adler could advise the newspaper on typography while operating his own printing business with a free rein.

The suite of rooms that Sulzberger offered afforded space for offices, a library, an exhibition area and a small printing plant. With the German designer Lucien Bernhard overseeing its decoration, the result was "the most uncommercial printing plant" imaginable. Despite the rumble and vibrations of newspaper presses from the floors below, it was a place where Adler, habitually dressed in business tweeds, could manage his day-to-day business, lead a roundtable discussion on the art of the book one evening each week and serve afternoon tea to clients and friends. He was a rarity in the New York art and publishing circles, living modestly by a strict set of rules and shunning tobacco and alcohol. *Tea* being a familiar euphemism for bootlegged liquor during the "noble experiment" of prohibition, Rockwell Kent would later describe Pynson Printers as "the last place in New York—

and for all I know, in America—where when people were asked to come to tea, they got TEA."

Kent had returned from Tierra del Fuego after seven months of high adventure, but without reaching his ultimate destination. Within miles of Cape Horn, the waters had ultimately proven too treacherous: "We had to run for it. But I have seen Horn Island; I have seen that region, seen those storm-swept, treeless peaks of the sunken Cordillera. I have seen that 'Sailors Graveyard.' That's enough." In the months it took to secure a seaworthy vessel and an iron-hearted crew, he explored the glacial landscape, recording it in paintings and drawings. That his exploits made headlines only contributed to his reputation as an artist and as "the craziest man alive." To one interviewer he boasted, "I am a colossal egotist…I am not going to do any fool, little thing…I am reaching to the stars."

Kent met Elmer Adler in late 1924, when Pynson Printers produced the program Kent designed for the Fourth Annual American Legion Victory Ball at the Waldorf-Astoria. The timing was perfect. From his experiments with wood engravings, Kent realized that if he were to succeed at printmaking, he would have to work in close association with someone who knew ink, paper and presswork better than he did—if possible, someone with even higher standards than his own. Pleased with every aspect of their initial collaboration, he chose Adler as his printer. Both were equally punctilious, critical and outspoken in all things related to their respective crafts, and Adler's deliberation complemented Kent's abandon.

A YEAR EARLIER, UNDER THE PRETEXT THAT LIVING IN A FOREIGN COUNTRY would be an educational adventure, Rockwell had packed Kathleen and their five children off to the south of France. Their absence freed him to concentrate on writing his second book, *Voyaging: Southward from the Strait of Magellan*—and to indulge in an affair with his typist. Familial duties had provided ballast, but never anchorage, and his marriage of sixteen years was again foundering:

If…I had become unhappy in our marriage, Kathleen, and with good reason, was unhappier. More than once, in the past, I had said to her that she ought to have married a good, sensible, steady fellow, one who would stay at home and work and give her and the family the security that was their due. Kathleen deserved just such a man; she didn't have one. It is possible that few couples are enduringly happy on a plane above that of tacit, mutual endurance; if that is true, mere ordinary common sense, resting upon a

realistic view of life, would dictate its acceptance. I lacked that common sense and, rejecting the premise, persisted in a doubtless juvenile belief in a romantic Absolute.…If I may liken marriage to a piece of cabinet work, I was a stick of raw, unseasoned wood that had been built into it; and I had warped and cracked and sprung to such an extent that the piece was at last coming apart in its joints.

Voyaging was published in late 1924. Kent's daring exemplified America's heroic sense of itself following World War I, and the book's success established him as an adventurer as well as an author. (Two years later, Charles Lindbergh would fly the Atlantic and become the country's ultimate hero.) Following an exhibition of the Tierra del Fuego paintings at the Wildenstein Gallery a few months later, Kent put work aside and sailed to France for a reunion with his displaced family. He traveled without his paints and brushes; it would be a vacation.

He was pleased that the children had adapted so easily to the foreign culture and language, but was dismayed that Kathleen "had come to know few people and, unhappily, but little French." After he sailed for home, she wrote to suggest divorce, her one condition being that they remain together until one of them should marry again. Although Rockwell agreed to their separation, he lamented it:

And now I was alone again—and no one's fault but my own. Sometimes, when I am not *alone, I think I like it; mostly I don't. No, that's putting it too mildly: I find it unendurable. The biologic unit is the pair, and to divide it is to split a personality; to like it so, is to confess to abnormality.*

Freedom, as ever, absolved him of guilt, and he hurried into an affair with Olga Drexel Dahlgren, a twenty-eight-year-old heiress who fancied herself an artist. She was, by his admission, "a problem child," given to irrational, sometimes violent outbursts. Once they decided to marry, he returned to France to make arrangements for what he called "Kathleen's divorce." She would assume title to the Vermont farm and receive alimony; he would take a tiny apartment in New York.

The city became Kent's destination only when he was short on funds, and despite the successes of *Voyaging* and the Wildenstein exhibition, he could hardly afford the expenses of two households. In New York, the postwar prosperity had quickened the growth of its advertising and publishing industries. Aware of the prestige his name carried, magazines and advertising

Bookplate for
Olga Drexel Dahlgren,
1927.

It was commissioned
through Carl Zigrosser
and printed by Elmer
Adler. Olga was the
granddaughter of Joseph
Wilhelm Drexel, a
partner in the banking
house of Drexel, Morgan
& Co. After her affair
with Kent ended, she
gave him a gold key to
her New York house,
which he never used.

Bookplate for
Lucie Rosen, 1922.

She was the wife of
Charles Rosen, an
artist in Woodstock,
New York.

Bookplate for
Mary C. Wheelwright,
ca. 1923.

From her home in
Northeast Harbor,
Maine, she worked to
preserve the spiritual
rituals and culture of
the Navajo people,
eventually founding the
Wheelwright Museum
of the American Indian
in Santa Fe.

Bookplate for
Louise & Gilbert Lang,
1926.

agencies clamored to hire him, and after he began illustrating the national campaigns for Rolls-Royce and the jeweler Marcus & Co., the pseudonym "Hogarth, Jr." was retired forever. Kent welcomed the work—it funded "the luxury of painting pictures"—but the compromising nature of commerce riled him:

> *When a coarse, pot-bellied, garter-snapping vice-president of some gangster corporation begins to find fault with a face I have drawn, no argument is possible. If I consult my own commercial interests, I just say to him promptly, "All right, old boy, just give me a photograph of the tart you're keeping on Riverside Drive, and I'll copy it." And if there is an artist in me I'll add, "But I won't sign my name to the thing." Then is when the trouble starts.*

By comparison, book publishers were respectful of an artist's viewpoint. The successes of his books, as well as the drawings he had recently made for a translation of *The Memoirs of Casanova,* had only whetted his appetite for book illustration:

> *Carl Zigrosser, either knowing of my love for* Moby-Dick *or believing that I ought to love the book and, therefore, ought to illustrate it well, had interested the publisher, Alfred Knopf, in getting me to do it. And Knopf, liking the suggestion, had offered me two hundred dollars for the job. Now, however questionable it may be that an artist should live—and there are those who say artists do their best work starving—no one can well question my obligation to support my wife and five small children; all things considered, two hundred dollars for some months of work was not enough. I told Knopf that I'd need five hundred. But I guess the publisher figured he had to live too—for, so far as I know, no one has ever hinted that men of business thrive on a starvation diet. So Alfred Knopf said no.*

Somewhat to Rockwell's relief, his engagement to the unpredictable Olga Dahlgren came to an abrupt end. "Of all the things in the world," he wrote, "I wanted most to fall head over ears in love, get married, move to the country, and…live happily ever after." Then, in February 1926, at a Sunday luncheon on Long Island, he met a woman who could fulfill his hopes:

This fateful event occurred at the Manhasset home of Gordon and Katherine Abbott.

> *The moment that I first saw Frances Lee I had no eyes, no ears, no thoughts, for any other. I loved her earnestness, I loved her laughter, I loved the sound and sense and manner of her speech. I read her candor in her countenance,*

and felt the warmth and goodness of her heart. I loved her without doubt, or caution, or reserve.

Blue eyed, blond and recently divorced, the twenty-six-year-old was starting over in New York with her four-year-old son. She was a Southerner, a native of Virginia who took enough pride in her Lee ancestry to shed her married name, Higgins. Rockwell's proposal of marriage the next day was met with a surprised laugh. Undaunted, he would propose again, fifteen times over the next fifteen nights, before her laughter became a simple yes. That day he had sent her a token of his resolve: a lifetime supply of fine stationery stamped with a woodcut monogram *FLK* of his own design. They married in April 1926, and Frances soon found herself caught up in the whirlwind of his life.

Years later, Rockwell contacted an authority on the Lee genealogy and learned that Frances was not related to the historic Lees of Virginia.

Plans were already underway for him to spend the summer painting in Ireland, an excursion financed in part by Duncan Phillips of Washington, D.C. The memorial gallery Phillips had opened in his Dupont Circle home five years earlier was well on its way to becoming the country's first museum dedicated to contemporary art, and with a fortune from the family's steel and banking interests at his disposal, he had paid $125,000 for Renoir's *Luncheon of the Boating Party* the previous year. He also made a point of investing in promising American artists. In a letter to Kent, he wrote: "As you know, for our Kent unit we take pride in having a good example of each of your adventures in different parts of the world. The Irish experience should by reason of your happiness be a culmination and I certainly wish to have an example of the work done at that time." Phillips' support was considerable: He had volunteered to pay Kathleen's alimony while Rockwell and Frances were abroad. Before their departure, Rockwell made a bookplate as a gift for Duncan and his wife Marjorie. Upon receiving it, Phillips wrote:

In 1925, the Phillips Collection became the first American art museum to purchase a painting by Georgia O'Keeffe.

Your generous wish to give it to us touched us very much. It has also embarrassed us a bit for, to be perfectly frank, as I am confident you would want us to be, the prints from the woodblock are disappointing. You would be the first to agree that the diminutive size of the picture cannot stand the big forms and the close proximity of three areas of light—the sun, the sunflower and the reflection on the sea. The wedge shape, incidentally, of this reflection and its strong edges create a doubt as to its being a light on a receding plane. Now of course since I approved it I assume full responsibility for my own disappointment with this design. I was thrilled by the symbolism and satisfied with the decorative pattern but I seem to have thought of it on a larger scale. Reduced, as it must be for the pages of our smallest books, the bookplate seems lacking

Wood engraving for the Phillips bookplate. Kent received Phillips' critique after returning from Ireland. There is no evidence of his making a replacement, and it is not known that the original design was put to use.

in delicacy of line and confusing in its big forms and scattered lights. On thinking it over I feel that we should try again—something simpler, just one dark against one light. How would this appeal to you—a mere suggestion of a casement window opening out on a happy valley and a distant line of mountains. In the window a shadowy head and shoulders silhouetted black against the landscape, as of a dreamer looking out. This is one of your conceptions and yet I do not seem to recall a print of exactly that. Another would be a figure darkly silhouetted stretching out exultant arms into the great light of a big simple sky. That idea you may have used more than once but always with fresh inspiration.

Marjorie and I are picturing you and your bride in wild Ireland. It should be a wonderful summer and I hope that the country is as haunting in reality as it is in the Irish plays and poems.

Let us hear from you—as soon as you get back. I shall be impatient to see what aesthetic spoils you have brought back from the western isles.

The summer spent near Glenlough on Ireland's northwestern coast would be Frances' "first adventure in unaccustomed living." They took over the one-room wreck of a thatch-roofed house whose previous resident had been a cow, whitewashed its stone walls, built furniture, hung curtains in the one window and called it home. County Donegal's headlands and steep ocean cliffs exhilarated Rockwell, and he painted them without interruption while Frances learned to bake bread and joined the local women's knitting circle. To her, it was a rustic summer outing, not a way of life, and she took the inconveniences in stride. It was a hopeful beginning for their marriage.

Arriving in New York weeks ahead of Rockwell, she rented a six-room flat and separate studio at 3 Washington Square North, a four-story building where artists had lived and worked for decades. It faced the open expanse of the square, and Kent's studio at the rear of the upper floor afforded northern light. There he could complete the canvases from Ireland and turn out black-and-white illustrations for the advertising work that came pouring in.

Built as a single residence in 1833, 3 Washington Square was divided into apartments in 1884 and became known as the Studio Building. Along with Kent and Hopper, William Glackens and Guy Pène du Bois lived there at various times. But Hopper held the record, residing in his modest studio on the fourth floor from 1913 until his death in 1967. Also, John Dos Passos wrote *Manhattan Transfer* there in 1925.

While Kent was abroad, "a nice young couple" from Texas had stopped by Elmer Adler's office to ask if he might persuade Kent to make a bookplate for them. Louise and Gilbert Lang collected his books and could afford to spend a hundred dollars and would be satisfied with a simple pen-and-ink drawing. Soon after moving into the studio on Washington Square, Kent completed the Langs' bookplate. It was most likely the first bookplate commission for which Adler served as Kent's agent and printer.

Adler customarily designed the bookplates and stationery for his wealthy clientele, but his designs were largely typographic, seldom including graphic elements beyond a decorative border. With Kent resettled in the city and receptive to commercial work, Adler began in earnest to solicit bookplate commissions for him. He started with his own friends: the book publishers Blanche and Alfred Knopf, Iphigene and Arthur Sulzberger of the *Times,* advertising genius Burton Emmett and attorney Maxwell Steinhardt. Their social standing would only enhance the marketability of a Rockwell Kent bookplate, and the venture promised to be profitable for the printer as well as the artist. Kent's standard fee would be a princely two hundred fifty dollars, to which Adler would add his charge for the printing.

Kathleen continued to receive Rockwell's mail in Vermont and faithfully forwarded it to New York. Soon after returning from Ireland, he received a letter from William A. Kittredge of R. R. Donnelly & Sons of Chicago. The Donnelly company was then best known for printing the New York City telephone directory and Sears-Roebuck catalogue, although its Lakeside Press under Kittredge's direction published one book each year as a holiday gift for employees and customers. "In an effort to contribute something to the improvement of standards in the making of books," he wrote, "this house proposes to have designed, to print, and to publish in limited editions certain books of American interest." As one of the country's leading artists, Kent was invited to design a book from Kittredge's list of twenty-five works, "books which should have a place in every reading library and books which people really want to read." Kittredge suggested that he make three choices. *Moby-Dick* was the fourth title listed—just below *Huckleberry Finn, Tom Sawyer* and *Two Years Before the Mast.* It was Kent's only choice.

Granting the artist complete freedom, Kittredge proved to be the perfect client: "Believe me, Mr. Kent, all of this is inspired by a great desire to make this book unique, personal, and [as] prophetic as the genius of its author and his illustrator." His goal was to have the book in print within ten months, in time for Christmas 1927, and Kent got to work, confident that he could meet the tight deadline.

BENNETT CERF AND DONALD KLOPFER, BOTH IN THEIR TWENTIES, well-heeled and ambitious, had had the improbable great fortune of purchasing the Modern Library in 1925. What they got for their $150,000 was 107 titles: the reprints of classics, old and new, that sold at a modest price. Setting about to transform the popular series, Cerf and Klopfer turned to Elmer Adler for advice on giving the little books a more appealing and

substantial appearance. He put them in touch with Lucien Bernhard, who created the new Modern Library trademark, and with Rockwell Kent, who designed its signature endpaper. "I never thought that the day would come when the Modern Library would be able to afford to have Rockwell Kent do anything for it," Cerf wrote in self-congratulation.

Within the year, Cerf and Klopfer became smitten with the idea of also publishing fine limited editions. As Cerf recalled:

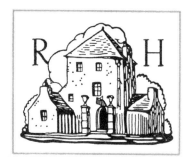

Final rendering for the Random House trademark, 1926.

The house Kent designed for Bennett Cerf and Donald Klopfer remains one of the most venerable American trademarks, as well as one of the country's best-known (although imaginary) buildings.

> *One day Rockwell dropped in at our office. He was sitting at my desk facing Donald, and we were talking about doing a few books on the side, when suddenly I got an inspiration and said, "I've got the name for our publishing house. We just said we were going to publish a few books at random. Let's call it Random House."*
>
> *Donald liked it, and Rockwell Kent said, "That's a great name. I'll draw your trademark." So, sitting at my desk, he took a piece of paper and in five minutes drew Random House....*

According to Cerf, it was Kent who suggested that they publish an illustrated edition of Voltaire's *Candide.* It would be the first Random House book, and Cerf commissioned him to illustrate it, with Adler in charge of the page composition and presswork. Putting aside the more daunting *Moby-Dick,* Kent carefully researched eighteenth-century period details to create the close to eighty tableaux and dozens of decorative initials that would decorate every page of the book.

While working on *Candide,* he also designed bookplates for Adler and Cerf. For Adler's, he ignored the classical figures of Mercury and Pegasus on the Pynson Printers letterhead and represented Adler as a solitary printer gripping the armature of a press. Kent used his own R. Hoe & Co. Washington handpress as the model and sketched the figure from several vantage points before settling on one. (He would later concede that the printer's costume was anachronistic to the 1860s press.) Cerf's bookplate, for which the artist charged two hundred dollars, is notable for the apparent absence of his name, which would make it useless. In his sketch, Kent had clearly lettered *Bennett A. Cerf* in a panel below the illustration, but in the final drawing, Cerf's name was camouflaged within its fine lines.

Kent had realized early on that printing bookplates from wood engravings was impractical. The process was tedious and time consuming, and the medium limited the detail of a design. Instead, he made ink renderings, approximately twice the size of the final bookplate, from which a copper

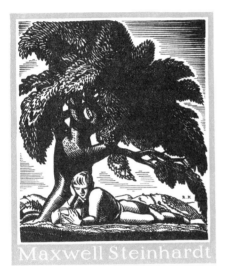

Maxwell Steinhardt

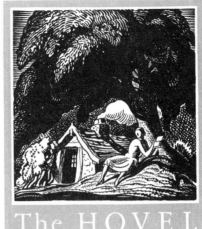

The HOVEL
BLANCHE and ALFRED KNOPF

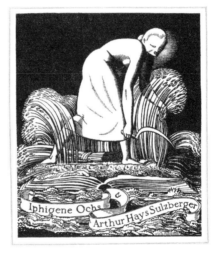

Iphigene Ochs & Arthur Hays Sulzberger

*Bookplate for
Maxwell Steinhardt,
1928.*
Carl Zigrosser listed
him among the major
collectors of Kent's
printed works in 1933.

*Bookplate for
Blanche & Alfred Knopf,
1928.*
The Hovel refers to their
home in Purchase, New
York. Blanche enjoyed
a close friendship with
Elmer Adler, who was a
regular at the monthly
Book Table luncheon
arranged by Alfred and
held at various hotels.

*Bookplate for
Iphigene Ochs & Arthur
Hayes Sulzberger, 1928.*
Mrs. Sulzberger was
the daughter of Adolph
Ochs, owner and
publisher of the *New
York Times.*

Sketch for a bookplate for Elmer Adler, 1927.
(Rare Book and Manuscript Library, Columbia University)

Bookplate for Elmer Adler, 1927.

Bookplate for Bennett A. Cerf, 1928.
Cerf's name is hidden in the fine lines of the rock face.

Bookplate for Emily Milliken Lambert, 1928.
Its fine lines, broken column and elongated figure suggest the illustrations Kent had made for *Candide* the previous year.

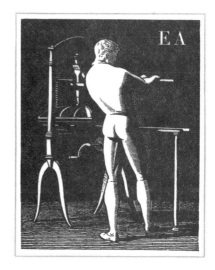

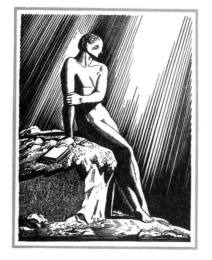

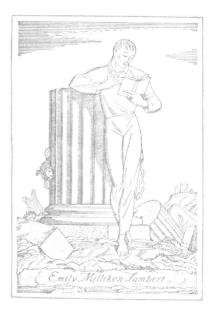

Bookplate for the Elizabethan Club, ca. 1929.

Founded in 1911, the Elizabethan Club is a private organization for Yale students and faculty who share an interest in literature and sipping tea. The club library in an 1811 clapboard house, is known for its original Shakespearean folios and Elizabethan manuscripts.

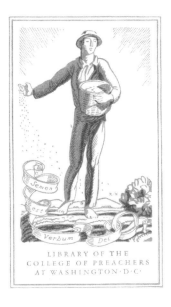

LIBRARY OF THE
COLLEGE OF PREACHERS
AT WASHINGTON·D·C·

Bookplate for the Library of the College of Preachers, 1928.

The College of Preachers was founded in 1924 at the National Cathedral in Washington, D.C., to provide continuing education for Episcopal clergymen. The Latin *Semen est verbum Dei,* "The seed is the word of God," is taken from Luke 8:11.

Bookplate for Burton Emmett, 1928.

An advertising agency executive and copywriter, Emmett collected literary manuscripts as well as woodcuts and prints. Carl Zigrosser listed him as one of the preeminent collectors of Kent's printed works. In 1924–25, Emmett served as president of the American Institute of Graphic Art.

*Bookplate for
the Chicago Latin School,
1928.*

Founded forty years
earlier, the college
preparatory school
offered a curriculum
based upon the study
of Greek and Latin.
Its bookplate was
commissioned through
the Weyhe Gallery in
New York.

*Bookplate design for
Ione Robinson, 1928.
(Graphic Arts Collection,
Firestone Library, Princeton
University)*

After returning from
Paris in 1930, she
received a Guggenheim
Fellowship in painting,
which took her to
Mexico City. There she
became an apprentice to
Diego Rivera, assisting
with his murals for the
Palacio Nacional.

plate for printing was produced by photoengraving. Hand tooling the metal plate ensured that the printed image would be faithful to his original drawing. As demonstrated so clearly in the Adler bookplate, Kent's experience with white-line wood engraving had transformed his pen-and-ink work. Large areas of solid black and evenly spaced parallel lines for shading gave the drawing the appearance of an engraving.

Cerf described Kent as "the leading commercial artist in America" in the late 1920s. He was certainly the busiest. In order to meet commercial deadlines and honor his book and bookplate commitments, he resorted to employing assistants. One of these was Ione Robinson, whom he recalled as "a beautiful and venturesome girl." Only seventeen, she was an art student who had moved from Los Angeles to New York. Her ultimate destination was Paris. After Kent hired her to help in his New York studio, she wrote to her mother in January 1928:

I am really learning so much here, even though it is a great strain and I work long hours. I suppose one would call it a test in discipline: I have had to learn to draw exactly like Mr. Kent and what's more, to copy his handwriting, as I sign most of his work. I don't approve of this; it makes the whole thing like a small factory, especially the work on the book Candide. *There is to be a special edition, hand-colored, and I must do all of this; one hundred copies, each with one hundred drawings. That makes [ten thousand] for me to do, and I work all day and late into the night under a strong blue light.*

Mr. Kent never gets tired; his energy wears everyone out and he is inclined to drive people.... This house is like a three-ring circus, but I don't pay much attention to any particular ring; I simply know that they are going on all the time. He makes a great deal of money, and what I am to get is a drop; but a drop big enough to take me to Europe, I hope. I don't believe that an artist's work should be like a factory. Mr. Kent has a system for everything, but perhaps he needs it to pay his bills, which are overwhelming for an artist.

Recognizing the young artist's talent, Rockwell apparently presumed himself to be her mentor.

I have finally finished Candide, *and I'm worn out. Mr. Kent is giving me a short vacation to work on my own things for a while. But I am angry with him: He made me burn all of my early paintings, and I believe he even enjoyed seeing them burn. When he suggested it I agreed out of pure spite, just to show him that I could and would make new ones. I feel that I have learned*

all that I can from him, and I want to leave this job. I certainly don't want to be a second Kent, because I don't think he is a painter. I don't like Rockwell's cold, hard lines and forms in his paintings; nevertheless, this same technique in his black and white drawings has power.

Kent appreciated Ione's assistance enough to design a bookplate for her. The central image, a pair of hands, alluded to the surrogate role she had played so well. Marked with his print specifications, the drawing was sent to Adler. Before the copper plate could be made, however, Ione resigned and sailed to France. The project was abandoned.

In early 1928, 1,470 copies of *Candide* were hand set and printed at Pynson Printers, then "signed by the artist." Priced at fifteen dollars, they sold out on the first day of publication, many at several times the list price. Each of the hundred Ione had colored by hand sold for seventy-five dollars. To meet a demand that was unprecedented for a 170-year-old literary work, Random House published a less-expensive edition one year later. Its selection by the Literary Guild ensured even wider sales and propelled Rockwell Kent to the forefront of book illustration. Looking back on *Candide,* he said:

> *It was my great good fortune, in this my so far most important commission as an illustrator, to work in close cooperation with a man of such rare typographic taste as Adler, and one so unsparingly devoted to the highest craftsmanship in printing. From the project's very inception we worked closely together, planning the book's format, choosing type, designing its pages, selecting the paper which would best lend itself to the delicate type we had chosen—a Bauer Foundry type by Lucien Bernhard—and to the correspondingly delicate lines of the illustrations. It was for both of us a work of love; the book when finished showed it.*

Adler, the quiet impresario, was rewarded for *Candide*'s aesthetic success when Cerf and Klopfer invited him to become a partner in Random House. Without having to forsake Pynson Printers, he would assume responsibility for the series of limited editions they envisioned. Adler already had an idea for his next Random House project: an elegant little book of Rockwell Kent's bookplates.

Five / The Personal and Chosen Symbol

1928 to 1929

AS RINGMASTER OF THE "CIRCUS" AT 3 WASHINGTON SQUARE, ROCKWELL awoke each day before dawn and climbed the stairs to his studio, leaving Frances to manage a household that sometimes included two children. He had accepted her young son, Dick, as one of his own. His sixteen-year-old daughter, Katie, "a lovely child…deeply sensitive to all beauty," was a serious student of the violin; living in New York during the winter months made it possible for the to study at the David Mannes Music School.

Manhattan in the late twenties was to Kent "a wonderful place to have a good time…a mad, exuberant, licentious time," and he appeared to have stopped chasing solitude:

We had the place; we had the means; and Frances was graced with such warm-hearted charm as endeared her to everyone. We opened our season with a great housewarming to which were invited just about all our friends from the hitherto quite separate worlds in which we two had moved. From bankers on the right to struggling artists on the left, we got on splendidly—though I must confess to a grim satisfaction at seeing a bearded bohemian friend of mine, one Rex Stout, sit down as a dark horse to a game of poker with a banker and two brokers; and clean them out.

Kent's studio bustled with commerce, while only a few feet away, Edward Hopper silently painted in the tiny studio where he lived and worked. The two artists had literally started out together, Hopper having been born in Nyack, just across the Hudson from Tarrytown, one month after Kent. Later, as students at the Chase School, they had sketched side by side under the spell of Robert Henri's readings from *Leaves of Grass*. (Kent remembered him as "the John Singer Sargent of the class.") Neither had strayed from realism in the intervening twenty-four years, although when painting at Monhegan, Kent concentrated on the island's landscape while Hopper favored its weather-beaten old houses. In terms of recognition, Edward was

David Mannes and his wife Clara taught violin and piano at their music school on 74th Street. Kent enjoyed a flirtatious friendship with their daughter Marya, for whom he designed stationery with her initials.

Rex Stout, like Duncan Phillips, had provided financial support for the Kents' summer in Ireland. In 1927, Stout began writing full-time. His great achievement would be a series of mystery novels with the 286-pound detective Nero Wolfe as the lead character.

the tortoise to Rockwell's hare. Like Kent, he had relied on illustration, mostly etchings, to pay his way. Up until 1924, Hopper had earned but two hundred fifty dollars from the two paintings he had sold; three years later, when Kent took the adjoining studio, Hopper's exhibitions were selling out. What the two neighbors had most in common, however, was the bathroom they shared on the fourth-floor hall. While Kent flaunted his radical politics and ignored prohibition, Hopper went somberly about his business, rarely socializing. He was a quiet man; his paintings spoke for him.

Rockwell had discovered something that set him apart from his fellow artists: his voice. Given the newspaper coverage that followed his Alaskan sojourn and the personal nature of his writings, he had become a public figure, and a public figure could always command a platform and audience. When the Commonwealth of Massachusetts sentenced Nicola Sacco and Bartolomeo Vanzetti to death that year, Rockwell voiced his protest and made news by cancelling an exhibition of his paintings in Worcester. He seized every opportunity to speak his mind. The publisher of the new magazine *Creative Art* hired him to "contribute an editorial to each issue, in which you will have the fullest opportunity of expressing your personal views." As a frequent public speaker, he railed against the Academy and promoted a home-grown American art. When a movement was underway to establish a national gallery for contemporary art, he fervently took up that cause as well.

The politics of art provided a distraction from the workload that had turned him into "a machine for making money." As he described it, he worked in the studio "all day and every day, and hours at night" while Frances read to him. The reality of their marriage was less idyllic.

What he needed most was a secretary, and Frances had the one skill he lacked: She could type. His assistant Ione Robinson described him as "a bit of a Prussian when it [came] to making people work," and he made no exceptions for his fragile young bride. He presumed that she would adjust to the well-established regimen of a middle-aged man and be at his beck and call during every waking hour—up at five, to bed at ten, unless they were entertaining or being entertained. Fortunately for her, he had by then given up vegetarianism.

The most alarming fact she faced, however, was his ongoing pursuit of other women. Never secretive about being an unfaithful husband, he expected Frances to socialize with her rivals. In the winter of 1928, she escaped to Paris. To woo her home, he launched a barrage of letters and poetry. One of his poems, decorated with a daisy, concluded:

Of the Academy, Kent later wrote: "When I was about twenty-two I exhibited two pictures at the National Academy of Design, had both pictures hung 'on the line,' and sold them both. I exhibited at the National Academy once or twice again, I believe, and then blew up in disgust at such a hide-bound outfit and have never darkened its portals or obscured its walls since."

So when you go to bed at night
Pluck one day's petal by the light,
And reading, know your lover true
No matter what that lover do,
No matter if—well, never mind—
Remember only Love is blind,
That lovers, being blind, may fall
And never hurt their love at all;
And if a lover falls for vice
It's only that he finds it nice.
So dearest, gallivant in France
All unconcerned about my pants
And know that as I love you still
I always and forever will!

The problem, to his way of thinking, was New York, "a spendthrift's place where all, the rich and poor, spend money and the reckless spend their lives." She agreed to the solution he offered: They would move to the country.

THREE HUNDRED MILES TO THE NORTH, NEAR THE VILLAGE OF AU SABLE Forks, New York, they purchased an abandoned farm. It met his wishes: "level land for farming, mountains to look at, and the quiet of a countryside that had not been invaded by summer colonists." Where the farm's broad mountain meadow met the surrounding forest, they built a house with a westward view of the Adirondacks. It was completed in the spring of 1928:

At first glance it is a surprisingly little house—long, to be sure, but seemingly only one story high, except for possibly some rooms above as indicated by small dormers. But we wonder if it can be a new house, for it is not characteristic of the simpler, so-called Colonial, houses of our New England forebears, but appears so integrated with its surroundings as to suggest having grown there. Sort of old-fashioned people, these Kents, you must conclude. And inside too: what furniture! A miscellaneous lot of stuff that must have belonged to parents or grandparents; and pretty shabby, come to look at it.

And there are books, books everywhere: lining the whole west wall between windows; on shelves and in cases in every available space; on the tables, on shelves built under them; on the piano—damn it; under the piano. Books in the study; three walls of them. Books in the office passageway. Books in the bedroom. Good books, most of them; grand books, some; trash, a smattering.

Books to make you laugh; books to make you cry; books to instruct and bore. Books, books: why all these books? God knows—except that we like them, that some are as dear friends, and all are as a crowd of many people with any one of whom we may at any time exchange at least a greeting.

In thirteenth-century Norse mythology, Asgaard was the chief city of the middle world, home to the gods and their kin.

The two hundred acres would be called Asgaard and eventually comprise an enormous barn for stabling horses and tending to dairy cows. In the seclusion of the pine woods that encompassed the pastureland, Kent would build a simple studio.

His separation from New York was complete. By then, he was well enough established that commissions for advertising reached him no matter how far he was from the city. His printmaking was well represented at the Weyhe Gallery, where Carl Zigrosser was building a devoted clientele for his wood engravings and lithographs among art museums and a growing number of private collectors.

That autumn, however, two projects took precedence over everything else: the book of bookplates for Elmer Adler and *Moby-Dick* for William Kittredge of the Lakeside Press. Kent had accepted the commission for *Moby-Dick* two years earlier, but had drawn only a handful of the one hundred fifty illustrations he figured it would take to do justice to Melville's tale. Although type for the text was already set according to Kent's specifications and true to the author's final manuscript, Kittredge was resigned to postponing the book's publication for the third time: "I suppose that work of this character always takes a great deal of time." He was a patient man on two counts—eighteen months earlier, he had written the artist regarding a design for his personal bookplate:

The expressions of your genius which take the form of symbols and devices for bookplates and letter headings are always admirable. I am about to build a plain little house, the appointments of which will be rather nice. I have an idea for a symbol to be used on linen and silver, as a bookplate and letter heading: the flight of an arrow from Earth to the furthermost star in the heavens.

In adapting this for use it might be desirable to enclose it in some shape— circle, oval, or oblong. It should perhaps be in reverse—white on black. As a bookplate it might have a low horizon of symbolic mountains and sea in foreground. It should be adapted to use with or without names or initials.

I do not know whether this will interest you or not or whether you will approve the idea. If it does interest you, and I pray it will, please consider this

a commission for the working drawing. Send me a memorandum of the cost and I will send you a check by return mail.

"I shall be delighted to carry out your idea of the arrow and stars," Kent had replied. "I like it very much." To Adler's relief, the Kittredge bookplate would be large enough to fill a page of the little book that had become his pet project. It was to be published by Random House in 1929, but with so few bookplates to Kent's credit, it had become necessary to include his marks—his letterheads for friends and family as well as trademarks for businesses. Among the logos were those for Random House and the Viking Press; the Open Road, a travel agency; Lenthéric, a perfumer; the Harvard Society for Contemporary Art; and the Cleanliness Institute, a trade association of soap manufacturers. But bookplates would be the book's major component, and to that end, Adler kept Kent busy with commissions. Most were printed by the Pynson Printers, and as each one went to press, he counted off another page of his book.

At Christmas, Kent raised Adler's count by producing a set of bookplates or stationery for each member of his immediate family. The most significant was the bookplate for Frances and himself, in which two rose vines entwine as a valentine. Twice the size of the bookplates from his first marriage—and noticeably more romantic—it would eventually be pasted over the bookplate he had shared with Kathleen. He also designed stationery for Frances' widowed mother, Edna Johnson Lee, and a bookplate for Frances' son, Dick. (Although never legally adopted, he would grow up as Richard Lee Kent.)

In his most recent will, handwritten during their separation, Rockwell had instructed Frances to "give (eventually) my children the things that were my father's and family mementos. And leave them in your will those things which are more personally mine—and the books. Probably Rockwell and Gordon should have the books—but you'll know that years hence." Thinking that it was his sons who would grow up to appreciate his library, he designed bookplates for them, but stationery for Katie, Clara and Barbara. He did sketch a bookplate for Barbara, without seeing it to completion. (Years later, he would describe Clara as "my book-loving daughter.")

Seventeen-year-old Rocky was the child he knew best, and his bookplate captured the freedom of youthful adventure. By then, Rocky had not only endured the Alaskan winter on Fox Island but also made a five-month bicycle trip from Massachusetts to Cuba with a chaperone and three other twelve-year-olds, then sailed alone from France to attend a New England boarding school. It was a point of pride to Rockwell that his elder son's

individuality set him apart from his classmates. In a January 1927 letter, Rocky had written:

> This evening I saw a boy staring at me. I asked him, "Do you think I am crazy? You know most of the boys do." He said, "Yes, I know." He didn't say that to be funny either because he is not that kind of a boy. Some reasons why they think that I am crazy are as follows: I don't tell or enjoy filthy jokes; I don't swear like a trupedore; I read very slowly; I have pictures by Michel Angelo in my room; I have no lobes on my ears; I play Red-Seal records; my leg does not jump when you hit it in the right spot; I skip chapel regularly; I don't like some trinkets, that I am attached to, broken; I keep a strait face when I fib or lie; I am a vegeterian; I scared the whole corridor in a practle joke that lasted six weeks; I have played numerous other practle jokes; I stuck a pin through my cheek for 50¢; I have beaten up several boys who are considered stronger than I; I don't like living in a mess; and above all, I lost my temper when my bed was dumped. There are many other reasons, but none of them as far as I can see, really prove that I am crazy.

Most of the bookplates that would end up in Adler's book were designed for people with whom Kent was at least acquainted, although in one case, Zigrosser had simply jotted his order for "Another, for The Chicago Latin School" on a sheet of Weyhe Gallery stationery and mailed it to him. The resulting design could have suited anyone, but most were more carefully prescribed. Kent's bookplate for George Gebner Schreiber was so specific to the owner's interests that it could be for no one else.

Occasionally a client selected a quotation to be incorporated with the design. While this created innumerable challenges for the artist, Kent recognized that the borrowed words were a revelation of the owner's character. George Ewing requested *Homo sum humani nihil a me alienum esse puto*—"I am a human being, so nothing human is strange to me"—from the Roman playwright Terrence. For Robert J. Hamershlag of Westchester County, it was a quotation from Pliny, the first-century Roman scholar: *Ut studiis se literarum a mortalitate vindicet*—"See through literature the deliverance from mortality."

As one would expect, a majority of Kent's bookplate commissions came from the wealthy and well-to-do of the Long Island social circuit. Although still a determined Socialist, he had resigned himself to the reality that his success as a painter depended upon their patronage. It had been gratifying to occasionally encounter a millionaire with a social conscience, and in his

*Bookplate for
Frances & Rockwell Kent,
1928.*

*Bookplate for
Gordon Kent, 1928.*
Kent wrote of the
bookplate he designed
for eight-year-old
Gordon, "I have
ventured…to determine
his becoming a good
horseman." His wish
was fulfilled, and
seventy-four years later,
Gordon Kent continues
to use his bookplate
design on his business
card.

*Bookplate for
Rockwell Kent III, 1928.*

*Bookplate for
Richard Lee Kent, 1928.*
It was made from one of
Kent's wood engravings,
*Boy with Branch and
Bird* (1921), which was
based on Kent's painting
of his son Rocky from
the same year.

*Bookplate for
George Gebner Schreiber,
1928.*

*Bookplate for
George R. M. Ewing Jr.,
1928.*

*Bookplate for
Robert J. Hamershlag,
ca. 1929.*

*Bookplate for
Helen Pearce, 1928*
She received five
hundred copies as
a Christmas gift
from Kent.

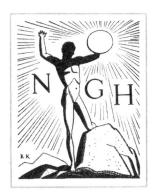

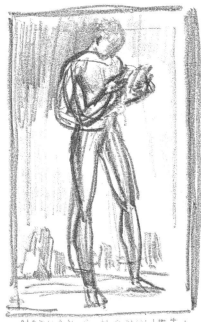

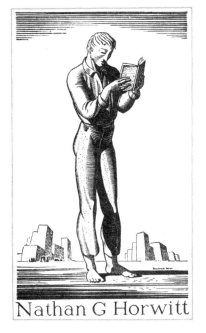

Nathan G Horwitt

Kent described the
multitalented artist as "a
devoted young friend."
The earlier of the two
Horwitt bookplates
seems prophetic. A
product designer drawn
to the modernity of
Kent's graphic art, he
would, in 1940, create
a wristwatch with a
simple gold dot to
represent the sun at
high noon on its
numberless black face.
In 1960, its prototype
was selected for the
Museum of Modern
Art's permanent
collection. Production
began a year later, after
his patent was acquired
by Movado, the Swiss
watchmaker.

*Bookplate for
George Milburn,
ca. 1928.*

A native of Oklahoma,
Milburn earned his liv-
ing as the writer-editor
of a series of joke and
how-to books. In the
1930s his short stories
were published in the
New Yorker and he
received a Guggenheim
Fellowship. He later
made a career of writing
hardboiled detective
novels. The source of his
bookplate's inscription
is unknown: *In this Boke
my name is Writ. Prither
give an Eye to It. Doth
thy Bookish Hearte desire
it And thy peace of Mind
require it, I will e'en
resign it, tho' Greaving
much to see it goe! And
it speed not back Anon
Friend, Abide my Malison.*

*Bookplate for
Ray Slater Murphy,
ca. 1926.*

Adler added a border
and typography to
Kent's wood engraving
to create Murphy's
bookplate. Kent was
apparently not involved
in its overall design.

*Bookplate for
William A. Kittredge,
1929.*

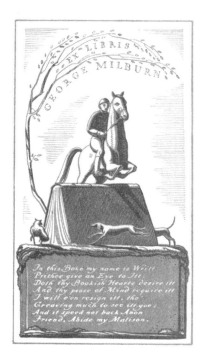

EX-LIBRIS · EDWARD PRICE EHRICH

*Bookplate for
Edward Price Ehrich,
ca. 1929.*

Its design reflects Kent's
judgment on hunting:
"When you know
each shot to mean at
once the death of a
living creature and the
exultation of a sports-
man, it appears, to
put it mildly, as one
of the more deplorable
aberrations of mankind."

*Bookplate for
J. B. Neumann, 1929.*

*Bookplate for
Merle Armitage, 1929.*

One of the leading
collectors of Kent's
printed works, Armitage
was the author of
Rockwell Kent,
published by Alfred A.
Knopf in 1932. He
would go on to become
one of the country's
leading book designers.

*Bookplate for
Somerset Maugham,
ca. 1929.*

The British novelist
W. Somerset Maugham
was then the highest
paid author in the
world. There are no
records of Kent's
receiving a commission
for his bookplate or
Maugham's having used
it. (At the time,
Maugham resided in
France.) It was possibly
designed for the
distinction a popular
author's name would
lend to Adler's book.

Sketch for a bookplate for Ralph Pulitzer, ca. 1928.

It is reminiscent of *Man on a Mast,* which Kent had painted in Newfoundland as an expression of his own deep despair.

(Rare Book and Manuscript Library, Columbia University)

Bookplate for Margaret & Ralph Pulitzer, 1928.

In 1930, Ralph resigned as president of the *New York World,* and a year later, the Pulitzer heirs sold their three newspapers. Pulitzer's second marriage lasted the rest of his days. He died in 1939.

friendship with Fredericka and Ralph Pulitzer, he had been drawn to their "unassumed naturalness and warmth that one does not ordinarily associate with the wealthy."

Ralph was the eldest son of Joseph Pulitzer, who, as publisher of the crusading *New York World,* had reinvented American journalism by promoting social and government reform on its pages. After his father's death in 1911, Ralph had taken the reins of the paper and maintained its liberal course. That the elder Pulitzer had never shown any confidence in his abilities only added weight to what was a burden from the start. Kent would say that "the gentle, noble qualities that so endeared [Ralph] to his friends proved incompatible with his inherited responsibilities—as *they* may well have been with his own happiness."

The Pulitzers' nineteen-year marriage ended in 1924. Two years later, Ralph chose Rockwell to illustrate *Dreams & Derisions,* a book of verse he had written under the pseudonym John Burke. A limited edition would be privately printed by Pynson Printers. No other artist could have been more empathetic; they were two middle-aged romantics, divorced and floundering. The bookplate Rockwell sketched for his friend was perhaps the most emotionally revealing of his bookplate designs. When Ralph married the novelist Margaret Leech in 1928, Kent put it aside and designed another as a gift to celebrate their marriage. Months later, Ralph wrote to him:

> As you know, I have for some years been very skeptical as to the duration of devotion. In my case at least, it has always been easy to win it but impossible to hold it. But now I do believe that there is a wonderful possibility of our love lasting out my life.

Adler's book was nearing completion in January 1929. To fill the last of its eighty pages, he volunteered Kent to design a bookplate for Merle Armitage, a West Coast art collector and cultural impresario. Kent adapted its design from the bookplate he had completed for J. B. Neumann, a New York dealer in European modernist art. But it was rendered by brush with a quickness that increased its dramatic effect. In May, Armitage wrote to Kent:

> I entered the bookplate which you designed for me in the International Bookplate Exhibition just held here and it won the prize for "best design in any medium." Now here is the difficulty; the prize in addition to the honor is a $10.00 Award. Do you get it or do I get it or do we split it or should a Board be appointed to arbitrate?

The exhibition mounted by Adler traveled to the Akron Art Institute and the Milwaukee Art Institute in 1930.

After Kent's bookplate art was exhibited in the Pynson Printers gallery, Adler finally brought *The Bookplates & Marks of Rockwell Kent* to completion in June. Its pages of delicate Japanese paper were printed by hand, using gray as a second color. Individually numbered and signed by Kent, the twelve hundred fifty copies sold out immediately, without benefit of the praise it received in the July 6 issue of the *Saturday Review of Literature:*

Kent wrote an essay, "On Symbols" as a preface to *The Bookplates & Marks of Rockwell Kent.* (See Appendix I.)

It is difficult, in considering the graphic art of Rockwell Kent, not to go into ecstasy. Two, possibly three, other men in America have his supreme gift of incisive delineation, but it is an unusual gift. It is almost metallic in its sharpness, yet no metal can show in itself the crispness of black ink on paper. The best type displays this crispness, but not often is there a designer who so nearly approaches the final sophistication of design as does Mr. Kent. Technical sophistication is admirable, but when united to virility in design it is something to marvel at, and in these bookplates we have the two elements of successful drawing for reproduction united in work which is as distinguished as anything America has to show.

The fine reception the book received no doubt pleased Adler, but Kent was not around to celebrate it. He was shipwrecked on a desolate shore three thousand miles away.

ARTHUR ALLEN HAD BEEN AMONG THE KENTS' GUESTS AT THE ASGAARD housewarming in August 1928. A printing industry executive, he had driven up from New York City and donned a white jacket to help tend bar. Making small talk with his host, he mentioned that his twenty-one-year-old son was going to sail a yacht from New York to Greenland. Without thinking twice, Kent blurted, "God! May I go with him?"

Known as Sam, Arthur S. Allen Jr. was a student of naval architecture at the Massachusetts Institute of Technology. He and his friend Lucien Cary Jr. had recently sailed from Nova Scotia to New York and were making plans for the six thousand-mile Greenland voyage the following summer. Although confident that they could sail it alone, he welcomed the forty-six-year-old artist to join them.

Preparations for such an undertaking began with a request for permission to land on Greenland, a territory of Denmark that was virtually closed to all visitors. In order to prevent contact between the native Greenlanders and the outside world, government regulations were particularly stringent. Once permission was granted, Allen purchased a thirty-three-foot yacht for his

son. It was designed by Colin Archer, the distinguished British yachtsman, after ancient double-ended Norwegian fishing boats and fitted with an iron keel. By January 1929, the senior Allen was able to report to Kent:

Bookplate for Arthur S. Allen Jr., 1928.

> *I have had a discussion with Sam about the name of this boat. As he and I have had an argument about the lack of direction of a good many young men these days and I have tried to instill in his mind the importance of this particular subject, we think we will call her* Direction. *I hope she will follow a definite direction and always get there.*

"He was a beauty!" Kent wrote of his young captain, "tall—over six feet, strong and lithe; slow moving, slow and courteous of speech, and calm....He loved the sea and he was made for it." Kent made a bookplate for him, most likely as a gift, and when Sam spoke of the naming of the boat, he referred to the bookplate's design:

> *Father has the honor of naming the little vessel.* Direction, *he says. This is of the order of* Endurance, *which I believe was Shackleton's ship, or* Perseverance, *which is a big Hudson River towboat. So* Direction *she will be. She should have "Direction – New York" painted on each quarter, and Dad thinks that you could be persuaded to do this. I should like to have a suggestion of the globe of my bookplate on her bows, but this may not be practicable.*

To Kent, there was "something forbidding about her name, ominous... Call your ship *Daisy* or *Bouncing Bess*—and the sun of life will sparkle on that course where fair winds drive her laughingly along." *Direction* was painted in golden letters on her stern.

His participation in the voyage guaranteed newspaper headlines when *Direction* set sail on June 17 from Baddeck, Nova Scotia. He had boarded with a sextant and chronometers, ten books and supplies for sketching and painting. As navigator, he realized early on that "in such wind and sea *Direction*, with every brave appearance of sailing a northerly course, could go exactly east and west; no more. And so much for a name." By July 3, they had reached Labrador. With their destination eight hundred fifty miles away, Sam got a letter off to his father:

> *We have encountered hard weather since Baddeck and had two Northeast*

gales, one of which we fought off Newfoundland, and about which the fish-
ermen are still talking. At one time she hove down till her starboard light was
under water....We have seen the lonely beauty of large ice at sea; we have met
the barren, desolate atmosphere of the hard coastline. It is a man's coast.

His next communiqué on July 18 was by telegram: "Lost ship on rocks—we
are safe and well—wiring plans later." *Direction* had reached the coast of
Greenland in a freezing July gale, and as Kent described it: "Her mission well
and faithfully accomplished, she dumped us on land, and sank." News of the
artist's misadventure made the front page of the *New York Times,* with daily
followups. Five days later, the paper reported that *Direction* had been recov-
ered for repair and two of the crew were headed home: "No explanation of
Kent's continued stay has been given...but it is probable the artist stayed on
to make some sketches."

Sam Allen sailed home on a Danish freighter that docked in New York on
September 11. Without Kent along to draw attention from the press, it was
an unceremonious ending to what his father called "a very triumphal trip."
In Tarrytown ten days later, Sam alighted from a streetcar onto a busy street
where two cars were approaching from opposite directions. One struck him
and the other ran over him. He died three hours later.

Six / So Many Thousand Miles

1929 to 1936

THE SINKING OF *DIRECTION* WAS HARDLY THE SHIPWRECK OF A BOY'S imagining. She went under quickly, not on the high seas but on the wave-lashed rocks of a fjord. The three sailors escaped with nary a scratch and with a good supply of food and provisions. It was Kent, the would-be hero, who volunteered to search for help, and after wandering the Narsak Peninsula for thirty-six sleepless hours, he reached an Eskimo settlement six miles away. After rescue was dispatched to his two mates, word of their fate was telegraphed to New York. Kent put the loss of *Direction* behind him:

> *I had come to Greenland to see Greenland. And, anticipating my enthusiasm for the country, I had brought paints. Fortunately my paints and brushes and some remnants of canvas had been salvaged from the wreck. With borrowed tools and lumber I could get in Godthaab I made stretchers; and augmented what canvas had been saved by duck and burlap purchased at the store, I was soon as well equipped to go to work as if no mishap had occurred; and, in leisure to work, my companions having returned to America, far freer than I should otherwise have been....I painted constantly, for it was as a natural outpouring of my enthusiasm for all that I beheld in that vast wonderland of sea and mountain.*

In September, he sailed for Copenhagen, where Frances was waiting with the unfinished drawings for *Moby-Dick*. Rockwell had had the good fortune of meeting the renowned Arctic explorers Knud Rasmussen and Peter Freuchen in Greenland, and they invited the couple to live in Denmark that autumn. Immersed in his work, Kent shrugged off the news of the October stock market crash an ocean away, and the final 157 illustrations of *Moby-Dick* were dispatched to Kittredge in November. A month later, Rockwell and Frances sailed for New York with six Great Dane puppies, a last-minute gift from Freuchen.

Awaiting Kent upon his return was a letter handwritten on letterhead

Bookplate for Elizabeth F. & Theo. C. von Storch, 1930.

from the Department of Pathology at Johns Hopkins University:

This is my third attempt at writing you; you see we are utter strangers... My wife and I had long cherished the hope that we could someday prevail upon you to do a bookplate for her. A few weeks ago my wife died. Now that vague wish has become a passion, almost an obsession. The reason: To me she was everything...the spirit of life, its beauty, incomprehensibility, sorrow—the warmth of the soil, the mystery of the sun in the west.

She wrote well, read better, drew poorly, played exquisitely, almost above life loved books, not only their soul but bodies, print, paper, binding and plate. She bound some, was working on more. You see everything is unfinished.... All my life I have tried to loose the inner voice and failed. So perhaps you see what her bookplate would mean. It could be done only by you and only if you understand. Perhaps a single figure with the name Elizabeth?

I hope you will realize the spirit in which I speak to a stranger (perhaps a half stranger, for your works make you friend to many)...

Kent answered Theo. C. von Storch's letter on January 6, 1930:

I have only just returned from abroad. I am sorry that your very beautiful letter has lain so long unanswered. I shall be very happy to make the bookplate; I'm quite touched by your wanting it so much.

I charge, ordinarily, two hundred and fifty dollars for a bookplate design. College professors cannot afford anything like that, so let you call the cost of this, however large or small a part of it you can easily pay. The cost of printing the bookplates is extra. Tell me when you write how many bookplates you would like to have.

During the Depression, Kent reduced his usual fee for a bookplate design to $150 or $200.

In fact, von Storch was a medical student. "I haven't much," he replied, "but I have more than the average student, being on my own. I have at present $95 in a savings account I started for [my wife]. I shall try to add to that as much as I can now and more later. Your offer means more to me than the price." Enclosed was a photograph of Elizabeth.

In June, Kent completed the drawing and arranged for the Pynson

Printers to make two hundred bookplates. He reduced his fee to fifty dollars, and wrote to von Storch, "I am permitting the original drawing for the bookplate to be reproduced in a magazine called the 'Colophon,' a book collector's quarterly."

In 1950, Kent would allow the Antioch Bookplate Co. to publish the von Storch drawing as a calendar.

The stock market crash was the deathblow for beautiful books in expensive limited editions and, consequently, Elmer Adler's association with Random House. He professed no interest in mainstream publishing and, with six Random House books to his credit, moved on to his next pursuit.

Four years earlier, he had assisted with the typography for an offbeat little magazine that Harold Ross was getting off the ground. Its first years had been perilous, but by 1930, the *New Yorker* was solvent and its list of subscribers growing. While banks closed and bread lines formed, publishing had defied probability and proven to be relatively Depression-proof. A magazine subscription was an inexpensive luxury that the consumer was reluctant to give up, and *Fortune, Esquire, Newsweek* and *Life* magazines would all be founded during those hard times.

Encouraged by the *New Yorker's* success, Adler launched *The Colophon,* a quarterly magazine for book lovers and collectors, in 1930. Taking its name from the term for a printer's trademark, *The Colophon* would present essays by the leading writers of the day (Sherwood Anderson, Sinclair Lewis and Edith Wharton, among others) with original and historic book art. As organizer and designer, Adler appointed Kent to its board of contributing editors. His first contribution was *The Colophon* logo; the drawing for von Storch's bookplate would appear in the fourth issue.

Logo for The Colophon, *1930.*

With Rocky enrolled at Harvard and the Depression deepening, Rockwell welcomed the commercial work that supported his "very serious burden of responsibilities" as well as his "greatest, deepest pleasure"—painting. The sale of a painting was a rare occasion, and the income from his prints had not "kept the pot boiling." To Zigrosser, he wrote:

Occasionally, I need money in a hurry. If there were any direct connection between the making of a lithograph and getting money for it, I would naturally make a lithograph, but there isn't, and consequently I look around and get an advertising job.

AS ADVERTISING COMMISSIONS BEGAN TO DWINDLE, BOOK ILLUSTRATION and the royalties from *Wilderness* and *Voyaging* became "the mainstay of the family's support." His drawings for *Candide, The Bridge of San Luis Rey, The Canterbury Tales* and *Beowulf* had established his reputation with

publishers, booksellers and readers. Illustrating literature—as opposed to the ponderous give-and-take of commercial art—was more a matter of communion than of collaboration. When *Moby-Dick* finally came out in the summer of 1930, his drawings would help correct the course of literary history.

The sixth of Herman Melville's novels, it had been originally published in London as *The Whale* in October 1851. That its English publisher had omitted the epilogue—leaving no survivor to tell the tale—was only a minor complaint of reviewers, and the complete edition, titled *Moby-Dick,* fared no better in the United States a month later. Nothing like it had ever been written, and its critics ensured that it would remain out of print for the next seventy years.

In 1920, to mark the centenary of the birth of an all-but-forgotten author, the Oxford University Press republished *Moby-Dick.* It marked a discovery for American literary critics, writers and scholars, who praised it for what it was: one of the great works of literature in the English language. Six years later it was brought to the silent movie screen as *The Sea Beast,* the story altered to accommodate John Barrymore as Ahab, its dashing hero.

The Lakeside Press had given Kent carte blanche, and seemingly endless time, to create its *Moby-Dick.* Inspired by his studies of whaling lore and visits to maritime museum collections, he delivered two hundred eighty drawings, almost twice the number he had proposed. After four years and three postponements, one thousand copies were printed in three volumes, packaged in an aluminum slipcase and offered for seventy dollars.

It was a book for bibliophiles—one thousand collectors who, despite the country's economic woes, purchased the entire edition before publication. It was not a book for readers. "When it comes to 'book lovers,'" Kent would later scoff, "it occurs to me that since their taste has been responsible for the premium which unopened, virgin copies obtain on the market, it doesn't make a bit of difference what you write in a book, for the 'book lovers' won't read it."

Kent's *Moby-Dick* would have suffered that fate, had Bennett Cerf not persuaded William Kittredge to allow the Modern Library to bring out its own edition in one volume. Cerf recalled, "We were so excited about it, we forgot to put Herman Melville's name on the cover, so our edition of *Moby-Dick,* to the vast amusement of everybody (the *New Yorker* spotted it), said only, 'Moby Dick, illustrated by Rockwell Kent.'" Resized and moderately priced, it was the edition that awoke American readers to Melville's masterwork. In 1931, it became a Book of the Month Club selection, which guaranteed that it would be read.

Kent had come home to Asgaard with his heart set on one thing: returning to Greenland. His congenial relations with the Danish government had cleared the way for a longer stay, and the book he wrote and illustrated about *Direction*'s voyage would help finance it. Titled *N by E,* it was published in December 1930 to great acclaim: "In every way—in prose style, in illustrations, in format—it is the one book of the year not to be missed," said the *Saturday Review.* Kent would only say of its success: "Maybe the most that books of mine can do, is to make young men adventurers."

Bookplate for Frank H. Whitmore, 1934.

Whitmore worked as a librarian in Brockton, Massachusetts. His bookplate, lettered by Juliet Smith, recalls Kent's illustrations for *Moby-Dick.*

In the short passage that described *Direction*'s fate, he wrote: "The sack containing the chronometers rolled back into the water. It was retrieved intact. Some things, washed from the rocks, were lost. The tide was littered with our gear and goods." In 1928, he had designed a pocket watch for the Hamilton Watch Company, and Carl Drepperd, his contact there, arranged the loan of the two chronometers for the expedition. The timepieces had been made for U.S. Navy torpedo boats. Both survived the shipwreck in working order, but Kent's own Hamilton wristwatch had not. In a letter to Drepperd, he wrote:

It was one of the many things that I could not save when we were wrecked. I recovered it, however, afterwards and put it immediately in kerosene, but I am afraid that the salt water damaged its works beyond repair. I am sending the watch to your repair department for their inspection; if they decide that nothing can be done with the present works, please have new works put in and have the bill sent to me. I think so much of the little watch that if I had lost it I would now be buying a new one just like it.

In appreciation of Drepperd's assistance, Kent offered to create a bookplate for his "six-shelf, two-trunk, one-box library." Drepperd supplied Kent with photographs of his hometown for the illustration, and after a sketch of the proposed design arrived in November, he wrote:

I feel as excited as a school girl—as two school girls after having received their first kiss. All of this from thinking about receiving a bookplate by you as a Christmas gift....As to the sketch, I have only this to say. The spelling of my name should be Drepperd, and I should like to see the figure with arms just slightly more upraised, and the figure one of youth with the form revealed

more—the draperies perhaps more diaphanous. Lancaster, Pennsylvania, the old town and the new, nestles in and among the Red Hills. Farmland and woodland. It is full of all kinds of traditions, and the thought that I have in mind is that here is the spirit—the essence of the thing—expressed in new, young life leaping upward.

Greatly revised in accordance with Drepperd's suggestions, it was printed in March 1931—one of numerous works Kent rushed to completion before leaving the quiet uneventfulness of Asgaard for Greenland that spring.

On Ubekendt, an island 225 miles north of the Arctic Circle, he built a one-room house and began a year's life as a Greenlander. He wanted to "spend a winter there; to see and to experience the Far North at its spectacular 'worst.'" Although Frances would join him a year later, in time to celebrate his fiftieth birthday, he knew from his months in Alaska that the greatest hardship would be loneliness. A young Eskimo widow, and mother of three, was enlisted as his live-in housekeeper and companion. He gave her the name Salamina. Traveling by dogsled, he began capturing Greenland's "landscape of isolation" on canvas.

Frances explained to her husband that "the Lees don't write." To him, that was unacceptable: "So not writing letters to dear ones far away was an old custom of the Lees, was it? Well, it was one custom that I didn't like."

When Frances failed to keep in touch by letter, Kent immersed himself more deeply in the life of a community barely two centuries removed from the Stone Age and drew closer to Salamina, his "Eskimo wife." In April 1932, Carl Zigrosser wrote, "Frances can tell you [when she arrives] that the Depression is getting worse. I don't know what is going to happen to the artists if it keeps up. We hardly sell anything at all. You are lucky to be out of the depressing influence for a while at least!" In May, Frances arrived, bringing news that they were penniless. The large investments they had been persuaded to make after the 1929 crash had been wiped out. But having lived nine months in one room, Rockwell took the loss in stride:

My own remaining assets were enormous. I had my health and my abundant energy; and although that energy, when harnessed to my cursed libido, led me into transgression, it was too valuable an all-round asset to be considered anything but a blessing. I had a wife whom I adored, and whose love for me her tolerance attested. I had my own five children who, with Dick, made six. And what grand kids they were! I had my work which was my passion. And I had our home, our Asgaard.

Carl Zigrosser, who was by then his sole liaison between the New York art market and the little kingdom of Asgaard, would occasionally report on

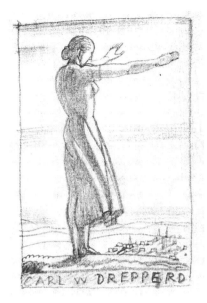

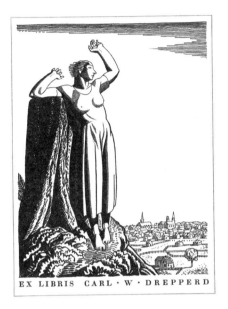

EX LIBRIS CARL·W·DREPPERD

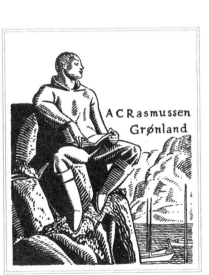

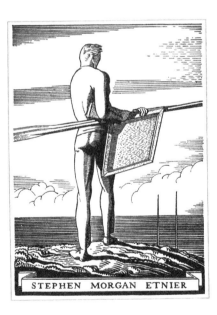

STEPHEN MORGAN ETNIER

Sketch for a bookplate for
Carl W. Drepperd, 1931.
(Rare Book and Manuscript
Library, Columbia University)

Bookplate for
Carl W. Drepperd, 1931.

Bookplate for
A. C. Rasmussen, 1933.
Frances Kent identified
Rasmussen as someone
who had been helpful
to them in Greenland.
His bookplate was a gift.

Bookplate for
Stephen Morgan Etnier,
ca. 1933.

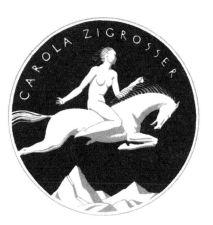

*Bookplate for
Carola Zigrosser, 1933.*

The precedent for its design was one of Kent's drawings for *Venus and Adonis* published by Leo Hart two years earlier.

*Bookplate for
Lucille Holt, 1933.*

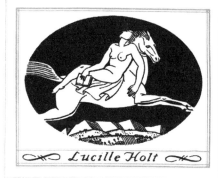

*Bookplate for
Leo Hart, 1934.*

*Bookplate for
Monroe Franklin Dreher,
1934.*

After arranging for Kent to endorse Kimberly pencils in 1933, Dreher commissioned a bookplate to be sketched with the pencils. It would show the trademark of his Newark, New Jersey, printing business: the Puritan hat and arrow. From Kent's sketches, he selected one design for his bookplate and one for the company letterhead. Writing to the General Pencil Co., Kent said: "I first became acquainted with the Kimberly Drawing Pencil in making sketches for a bookplate for Monroe F. Dreher Inc. I have been using them constantly ever since....That fact attests my liking for them. The Kimberly Drawing Pencil is a thoroughly fine pencil. Its leads are good and the wood is soft and straight grained. As a pencil consumer, let me thank you for manufacturing so good a tool."

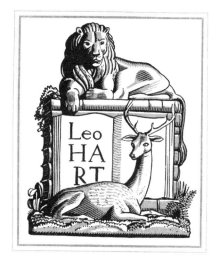

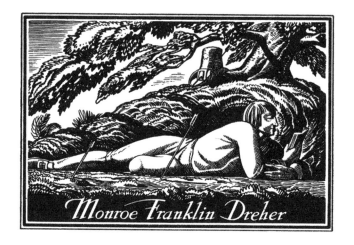

meeting young artists who were following Kent's lead, but Rockwell, having lost any ambition to teach, showed little interest in becoming a mentor. Reluctantly, he made an exception for thirty-year-old Stephen Etnier:

In pursuance of a letter asking that I take him as a pupil, and in defiance of my answer that I wouldn't, a young man who wouldn't take no for an answer arrived at my door, was invited in, showed me a number of pathetic little daubs that he had perpetrated, and somehow won my consent to take him as a pupil free of charge.

In Philadelphia, Etnier had heard Kent lecture on his Alaskan adventure: "It was sort of like reading *The Moon and the Sixpence* because here he was leading a romantic life....He'd never had any students. The pictures I took up there were not too hot. Mostly broken color and one picture that I had painted on a schooner coming back from Bermuda. I thought it was pretty good. But when I showed it to him, he said, 'Well, that part that you think is good is obviously an accident.'...I figured if he didn't fix me, nobody would. I loved his work. I was terrifically impressed by his work and also by his life."

So Steve and Mrs. Steve moved into town; and Steve began to paint. And, surprisingly, before the winter was over he was painting good, creditable, realistic pictures. His show of them, held not long after in New York, was well received. "You know," he said with obvious embarrassment when I met him at the gallery, "I didn't list your name among my teachers in the catalogue because the critics would recognize that I had gotten it all from you."

Zigrosser, having inspired, guided and promoted Kent's career as a printmaker, collaborated with the artist on a book of his art and writings. Titled *Rockwellkentiana,* it was published in 1933. As Carl gathered and catalogued its "few words and many pictures," Rockwell offered to make a bookplate for his fifteen-year-old daughter. In a letter, Carl suggested: "The mood— spring. Everything joyous and gay; spirit of youth. Carola riding in sky on Pegasus—no reins. Tail and mane flowing out in wavy lines (not straight) also her hair. As if she were riding on the top of the waves." The five hundred bookplates were completed that summer:

Adler delivered Carola's bookplate and we are all enthusiastic about it. She is immensely proud and pleased. As she says: "Now all three of us have Kent

The Moon and the Sixpence is Somerset Maugham's popular 1919 novel based on the French Impressionist Paul Gauguin's sojourn to Tahiti.

bookplates!" How beautiful and decorative it is with its pattern of red, black and white!

You are unstinting in your generosity. How much I have to be grateful to you for: a rich and long enduring friendship, and all the treasures of pen and brush that you have showered on me. And now, gifts to my daughter! You are a grand friend. I shan't forget it as long as we live!

As Carola's bookplate passed through his shop, Adler took note of it. He was already talking about printing a follow-up to *The Bookplates & Marks of Rockwell Kent,* confident that it would enjoy the same success.

The Printing House of Leo Hart in Rochester, New York, had published an edition of Shakespeare's *Venus and Adonis* while the artist was in Greenland. In addition to illustrating the book, Kent had promised Leo Hart a bookplate. Eighteen months later, Hart reminded the artist that it was to have been completed in Greenland. Apologizing, Kent wrote, "I found it quite impossible…to do any work except what was connected with my expedition there.…If you want me to make it now, please write me what you would like it to express. It has occurred to me that a lion and a deer would amusingly express your name and possibly, though I don't know, your character." Despite his misgivings, Hart directed Kent to proceed with the idea, and the bookplates were printed by Hart's company in time to serve as his 1933 Christmas card. (After Hart's death two years later, it was revised, without the artist's input, as a memorial bookplate.)

Acting on Kent's behalf, Zigrosser had brought in another commission that autumn. "We said the price would be about $350," he wrote. "Would you care to submit sketches? It is for a writer, Katharine Brush. I will send you a copy of her recent book of short stories which might help to give an idea of the kind of person she is." Her stories appeared with some frequency in the *Saturday Evening Post,* and her novel *Young Man of Manhattan* had been a bestseller in 1930. Kent replied that he was willing, but warned that there would be a delay: "Unfortunately I am about to start on my lecture tour. I expect, however, to have days on my hands between engagements, I shall then put my mind upon the problem."

Although he professed that "the thought of standing up in cold blood and addressing a great audience was nothing less than terrifying," Kent had agreed to barnstorm the country, lecturing on art and his Greenland experience. When he returned to Asgaard for the Christmas holidays, a letter from Zigrosser was waiting to remind him of the Brush bookplate. It was to be a gift from the author's husband, who had requested pencil sketches to show

Later, after a dispute over his royalties for *Venus and Adonis,* Kent was better able to assess Hart's character: "I found him to be a rather tough customer. I have since learned from others in the book business that he was generally so regarded."

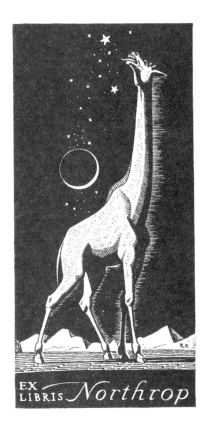

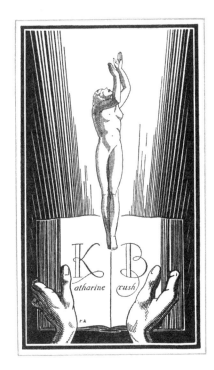

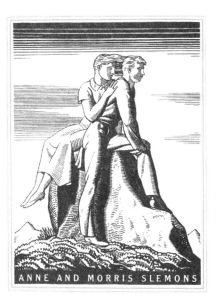

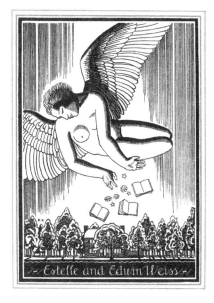

*Bookplate for the
G. N. Northrop family,
1933.*

Northrop ordered
his family's bookplate
through Carl Zigrosser
and requested "some-
thing about giraffes."
A resident of Chicago,
he owned a number of
Kent's prints.

*Bookplate for
Katharine Brush, 1934.*

She was a five-time
recipient of the
O. Henry Award for
her short stories.

*Bookplate for
Anne & Morris Slemons,
1934.*

A resident of Los Angeles,
Slemons was one of
the country's leading
obstetricians. Kent
was disappointed that
Adler replaced his hand
lettering with type: "It
does as much as could
be done with that small
part of the design to
cheapen the appearance
of the whole."

*Bookplate for
Estelle & Edwin Weiss,
1934.*

*Bookplate for
G. Hamilton Southam,
1935.*

Southam went on to
become publisher of the
Ottawa Citizen and the
first director of Canada's
National Arts Centre.

*Bookplate for
George E. Hite Jr., 1936.*
Hite was a New York
City attorney.

*Bookplate for the
Elnita Straus Library,
National Council of
Jewish Women, 1936.*

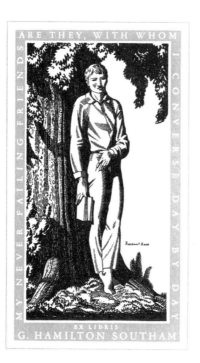

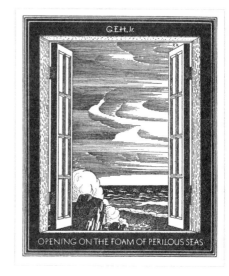

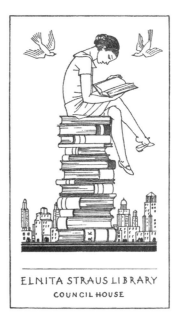

her at Christmas. Kent drew two pages of sketches before forwarding his choice to Zigrosser on December 21:

> *I am only sending one sketch because having made this one and liked it I cannot, at least at the moment, put my heart into alternate ideas. I do, however, want Katharine Brush to like the bookplate that I make for her very much. Having fallen far behind in my education in contemporary literature I have only just read a book of Katharine Brush's stories. I like them tremendously. Consequently, I not only value the honor of being pasted in her books but hope for the self satisfaction of knowing that she really likes her bookplate.*

In July 1934, the *Times* reported: "Because modern life irks him, Rockwell Kent, artist, left New York yesterday on the liner *Deutschland* on a trip to Greenland. His thirteen-year-old son, Gordon, accompanied him and will get his first experience of an Arctic winter." Kent had mortgaged Asgaard to finance their two-year stay; he would paint, write another book and chart the weather patterns for Pan American Airlines. Frances, having sworn to write more faithfully, would join them in the spring.

"It was an escape from discord into harmony," he said, "Nothing had changed: the settlement, its friendly people crowded on the shore to welcome me; and Salamina—tears of ineffable happiness flooding her eyes." Gordon adapted well to the rugged life, but unexpected cultural conflicts strained Kent's relationship with Salamina. Working nonstop, he completed the manuscript and drawings for *Salamina,* a book that recalled his previous visit. The solitary nature of writing and the absence of Frances brought "the most poignant loneliness" he had known.

Without explanation, the promised letters from his wife had ceased in September, and by summer 1935, it was apparent that she was not coming. Cutting short their stay, he and Gordon sailed for home in July. A wireless message he received while crossing to Denmark finally brought what he knew would be troubling news: Frances was hospitalized in Arizona. He also learned that, in his absence, Asgaard had been rented.

After returning Gordon to Kathleen and giving the *Times* an interview that focused on his son's educational experience—"Gordon went there as a little boy and came back a man"—Rockwell hurried to Tucson. There he found Frances on the mend from the serious injuries she had suffered in an automobile accident. She would recover. As for Asgaard, she explained that financial need had forced her to lease the farm, but not his studio, to

strangers. As he saw it, she had done nothing less than desecrate its sanctity: "You may trust *me* not to rent *your* things to the highest bidder."

Thwarted from going home by the interlopers' one-year lease, he went to work, agreeing to illustrate the complete works of Shakespeare and an edition of Whitman's *Leaves of Grass.* His most important commission, however, was a pair of murals for the Federal Post Office Building in Washington. In order to demonstrate the magnitude of the nation's mail service, one panel would be dedicated to Alaska, the other to Puerto Rico. To begin research for the project, he left Frances to recuperate in Arizona and flew to Alaska. There, sixteen years after his winter on Fox Island, he grieved over the changes time had brought to the territory and avoided visiting the place he had once called home. Home was Asgaard:

> *If ever I had wanted to* be *home and wanted home to yield the quiet that its setting promised us, it was when, that fall of 1935, after so many thousand miles—north, south, east, west—of knocking about, so endlessly many readjustments to new things and people and environments, we two together got there. Shut the doors and windows, draw the curtains, kindle a fire on the six-foot hearth, pull up the easy chairs, sit down, relax. World, let us be.*

In December, Adler presented Kent with commissions for one trademark and bookplates for Hamilton G. Southam, George E. Hite and the Elnita Straus Library. "Four a month," he wrote Kent, "will fill up a book in a year's time." With that, he scheduled its publication for December 1936.

The bookplate W. M. Southam of Ottawa, Canada, had in mind for his twenty-seven-year-old son, Hamilton, would include lines from "Stanzas Written in My Library," a poem by Robert Southy: "My never failing friends are they with whom I converse day by day." Adler had suggested the inscription, and the Southams specified the image of a young man, fully clothed.

Robert Southy had preceded William Wordsworth and Alfred Lord Tennyson as England's poet laureate from 1813 to 1843.

Pleased though they were with the sketch Kent submitted, Southam noted that the artist had taken liberty with the poetry, substituting "night and day" for "day by day." Kent responded, "I apparently couldn't help instinctively improving Southy's lines. And now I have to pay for being a literary genius"— and bore the cost of having the printing plate corrected.

Whether intended or not, Adler's first book of bookplates had become a catalogue for future commissions. George Hite requested something similar to Kent's bookplates for Josephine Holgate and Burton Emmett, with a few words from the Keats poem "Ode to a Nightingale": "magic casements, opening on foam of perilous seas." He specified that the scene through the

window be predominant, suggesting "a rough dark Arctic sea with white caps, rocks in the background…perhaps a single star in the sky." Kent followed Hite's guidelines, but felt the design would benefit from an interior foreground.

It was "in fear and trembling and with the deepest humility" that Hite submitted a written critique of the sketch. Among his notes:

> *I do not think I agree with Mr. Kent's suggestion of a tabletop with books in the foreground. The fact that the plate is pasted in a book carries the "library" idea with it.…I would like very much to eliminate the star.…Is the light from the rising or the setting sun or from the aurora borealis? I know very little about aurora borealis, but do they occur in windy weather? To get foam, we have to have wind. Would the wind blow the aurora away?…Could the idea of a "perilous" sea be intensified by making the rock in the right of the background more jagged?*

After inspecting the final proofs, Hite halted the printing to question the view of the sea barely visible through the minute slits between casement and sash. With Kent's assurance that "it can't merely repeat the values of the background as they appear in a wider field," Hite was appeased, and his bookplates were printed in two sizes that April.

The bookplate for the Elnita Straus Library was, as Adler described it, "a charity job" with a small honorarium:

> *I hope it will interest you because it would give us another good design for the contemplated book. A woman by the name of Elnita Straus left a bequest for a lending library in the Council House of the National Council of Jewish Women [headed by Arthur Sulzberger's sister-in-law]. And although the fund is small the requirement is that a bookplate be put in each book purchased with the fund.…The job of making a bookplate has been handed to me to do, and I am perfectly willing to turn over the $50 that we might get in order to have another Rockwell Kent design for our new book. So I sincerely hope that the idea will meet your fancy.*

The library would be part of "a settlement for children," with the bookplate pasted in children's books," and Kent responded with an illustration in the style of "Hogarth, Jr."

As Adler gathered bookplates for the new book, he could not help but notice the absence of prominent names on the list. The celebrity of the

Sulzbergers, the Knopfs and Somerset Maugham had added prestige to the first collection, and he was determined that the second volume be equally impressive. On a weekend trip to Washington in January 1936, he visited the Library of Congress and befriended Valta Parma, curator of the Rare Book Collection. Would that division have any use for a Rockwell Kent bookplate, he wondered—"if they were lucky enough to secure one"? Parma was enthusiastic over the idea, but warned Adler that a recent proposal to rename the library—to emphasize its national character—might delay the project.

To Kent, Adler confessed that his motivation behind donating the artist's services was less than charitable. A bookplate for the Library of Congress "would be a desirable addition" to their upcoming book. "I hope the idea of doing a design…will appeal to you," he wrote, "and if it does we'll be happy to contribute the printing. What sayest thou?"

Kent said yea, and his drawing was completed in October:

> *I have made this design in full consideration…that the Library is more than a Congressional library, that it is rather the library of all the people of the United States. If the name of the Library should ever be changed—and it certainly should be, to my mind, the Public Library of the United States of America—it would only be necessary to change the border….*

Adler was delighted when Lucius Wilmerding inquired about a bookplate: "Wilmerding is very much of a collector, has an exceptionally fine library, and is an ex-president of the Grolier Club, on the Board of Trustees of the New York Public Library. So his is a particularly good name to get into the new book." He requested something similar to Carola Zigosser's bookplate.

KENT'S EXTENDED ABSENCES HAD ARRESTED, BUT NOT SILENCED, HIS political voice. At Asgaard, between his northern sojourns, he had fought to restore passenger train service to Au Sable Forks and crusaded against corruption in the county government. He was not a joiner by nature, but, realizing the potential of a united effort, he became a charter member of the antifascist American Artists' Congress and the International Workers Order, a fraternal organization with the primary aim of providing low-cost health insurance to the working man, regardless of race. When the marble workers in Vermont went on strike, he would work tirelessly on their behalf.

ON THE DALLAS LEG OF HIS 1933 LECTURE TOUR, KENT HAD BEEN THE houseguest of Stanley Marcus, who headed the Book Club of Texas as well

Efforts to rename the Library of Congress were soon defeated. Kent's bookplate was the first to be specially designed for one of its collections.

as Neiman-Marcus, the family business. Marcus, an avid reader from childhood, had begun collecting rare books as a student at Harvard, operating a mail-order book business from his dormitory rooms that financed what had become an obsession. He was confident that his future resided in printing, publishing or bookselling. But "as graduation from college became imminent," he wrote, "I started having serious discussions with my father about what my life's work would be. While I was debating the various aspects of the book business, my father had no doubts at all that I was going to enter Neiman-Marcus."

In a December 1935 letter, he asked Kent to design a new bookplate for his burgeoning library. His only requirement was that it be small. In May, he wrote to the artist:

> I am awfully anxious to get my new book mark from you because I have a number of new acquisitions that are stacking up in alarming proportions, since I won't put them on my shelves until I have marked them. Won't you please knock off thirty minutes and turn out something for me?

And six weeks later:

> I hate to pester you about my bookplate, but my library is getting into a jam because I am trying to segregate all unmarked books. Besides we are expecting a new member of the family in August and wouldn't it be a terrible thing for a child to come into the world to a father who doesn't possess a bookplate? Won't you please take off a half hour and turn it out for me?

And a few weeks after that:

> I hate like Hell to pester you over a lousy little bookplate, but I know that if I don't, I won't get said bookmark for years to come. Truly, my library is getting in a terrible mess and friends are purloining my books right and left— all because you won't take off a half hour to make my mark.
>
> Billie is expecting to give birth in late August, so consequently we are bound to Dallas for the summer and early fall. We like the name "Kent" so much that we are thinking of naming the nub "Richard Kent Marcus."

By April 1936, Adler was desperate over the lack of material for the new book. He suggested including the initial letters Kent had drawn for *Candide*. Printed as an alphabet, they could handily fill seven pages, but Kent balked

at using work that had been previously published. A bookplate for Leod Daw Becker, a Kent collector, had been stalled for two years, and Kent had yet to begin Wilmerding's. Two months later, Frances finally responded to Adler's needling:

> *If you knew half of the trouble and distraction that we have been having up here in the country you would understand.... We have to clear up some of the mess we are in at present, however, before we can get at things that are not vitally necessary.*
>
> *Rockwell...is definitely having to put aside bookplate designs, etc., until he has finished Shakespeare, "Leaves of Grass," the two Post Office murals, and a few others that he has contracted to finish before now and which are driving him crazy. Maybe he will get caught up some day, but God alone knows when that will be. I don't.*

To satisfy Adler, Kent drew eight new "Candide initials" for the book. Carl Zigrosser saved the day when he reminded Kent of an alphabet the artist had presented him as a gift many years earlier. Having never been published, the set of decorative letters was passed on to Adler.

In truth, it was the marble worker's strike in Vermont that was distracting him from everything else, and on top of that, Rockwell and Frances had agreed to make Asgaard a home for five recovering mental patients that summer. Of that experience, he wrote, "The scenes! The histrionic acts! The dramas put on for perverse effect! And all by people so damned nice you'd love them if they'd quit." Work on the mural's Puerto Rico panel had come to a standstill when he realized that it lacked the authenticity of its Alaska counterpart. Leaving Frances in charge of the "nut farm," he escaped to San Juan in July to make sketches.

In August, Stanley Marcus received his long-awaited bookplate, which he promptly rejected and returned to the artist. The illustration of Pegasus, the mythological winged horse, was too familiar for him—and for good reason: In downtown Dallas, two 30-foot by 50-foot red-neon Pegasuses rotated above an oil derrick on the roof of the city's tallest structure, the twenty-nine-story Magnolia Oil Building, headquarters of Mobilgas. It was the company's trademark. Without realizing how prominent and ordinary that symbol was in Dallas, Kent wrote:

> *The bookplate drawing—which, because I valued it, I sent to you packed with great care—came back to me rather crumpled; because you, not valuing it, had, I suppose quite naturally, simply stuck it without protection in an envelope.*
>
> *I am so little interested in what symbols oil companies choose as their trademarks, and so inclined to take it for granted that the kind of people who think*

Sketch for a bookplate for Hazel & Richard Harwell, 1936.

Bookplate for Hazel & Richard Harwell, 1936.

Bookplate for the Library of Congress, Rare Book Collection, 1936.

Bookplate for Billie & Stanley Marcus, 1936.

Bookplate for LeRoy Elwood Kimball, 1937.
Originally designed for Stanley Marcus, it was sold to Kimball.

*Bookplate for
George Edwin Avery,
1936.*

The origin of its design
is *Hero,* Kent's 1931
lithograph. Intended
for John R. Palmer, the
bookplate was purchased
by Avery for $50.

*Bookplate for
Joe E. Kennedy, ca. 1937.*
Kennedy, then aged 21,
was the son of a Tulsa,
Oklahoma, oil magnate.

*Bookplate for
Frederick Baldwin
Adams Jr., 1936.*
Adams was one of the
editors of *The Colophon.*
A cousin of Franklin D.
Roosevelt, he began
collecting modern
English and American
literature as a student
at Yale in 1928 and
eventually served as
director of the Morgan
Library in New York.
Carl Zigrosser described
Elmer Adler, Burton
Emmett and Adams as
the "Three Musketeers."
Although the bookplate
was not designed for
Adams, he is said to
have associated it with
the Robert Frost poem
"Take Something Like
a Star."

of Pegasus as the property of an oil company won't ever open a book and see a
bookplate, that I just don't see what you mean. In this day of commercial
humbug and general thieving I won't even take the trouble to inquire into
whether or not the symbol that is significant to me has been used in commerce.
I feel that I would take so great a risk of finding that most any design that I
make was already suggested by some Texas trademark, that I don't want to
take the risk of making any more; and anyway what difference does it make
whether the design that I think of is already in use somewhere or that after I
originate one some concern steals it? It all comes to the same thing.

By the end of August, Adler finally lost patience with Kent's delays. Becker
and Wilmerding had requested a variation on the Carola Zigrosser design,
which should have been simple:

I know that you at times find this little shop a convenience and that you
would like to continue to have it in a position to serve you, and we at our end
would be mighty pleased if we can continue to function [accordingly]. But this
is possible only through one arrangement, and that is that we keep everything
moving along.…Haven't you caught up enough of your other work so that you
can clean up a few of the bookplates that we have on order and give a little
time to details of the second series? We are already booking orders, and if we
do not let the interest grow cold I am sure we can do mighty well with the
book. But it is another one of those things that has to be kept going. What
about it?

Still smarting over Marcus' rejection of the Pegasus bookplate, Kent sent the
rendering to Adler: "Maybe this one will do for one of the commissions you
have given me. If that is so, let me know so that I may rub out the initials
S. M. and insert the initials or name of your client." Within weeks, LeRoy
Elwood Kimball paid one hundred dollars for it.

Stanley Marcus, a gentleman accustomed to getting what he wanted,
persuaded Kent to redo his bookplate. The new design arrived soon after the
birth of Marcus' daughter, with a note from the artist: "I hope that Billie and
the little girl are doing splendidly. The very best wish I can send the baby is
that she turn out like her mother."

True to most of the causes Kent took up, the marble worker's strike ended
in defeat that August. But he fought his battles joyfully and returned to work
energized by the nobility of the good fight. His energy seemed to own him,
but it was not so with Frances. Exhausted and in increasingly poor health,

she could barely tolerate the prospect of another long Adirondack winter. To save the marriage, Rockwell reluctantly yielded to an arrangement by which Frances would thereafter spend eight months of each year in Tucson.

On October 20, the day she departed for Arizona, Frances typed a letter from her husband to Elmer Adler. It included an inventory of the contents of a parcel Kent was sending separately:

Palmer's bookplate was sold to George Edwin Avery; the "man's bookplate" most likely went to Joe E. Kennedy; the "man with a star" became a bookplate for Frederick B. Adams Jr.

> *A design made for that H's A., John R. Palmer. This is to have his name taken out and another's substituted. Maybe you can sell it to somebody or give it to some friend of yours. A finished design, except the name, for a woman's bookplate. A finished design for a man's bookplate. If you can sell this to someone, do so. And send the drawing back to me for the name or preferably the two initials to be put on it. Man with a star. A beauty. Sell it to someone. In addition I send you three little pencil sketches that you might sell to somebody for bookplates. You will receive the Wilmerding design when it is finished. My things are packed in the car and I am leaving in fifteen minutes. Goodbye.*

He had announced to Adler and his other friends that he would be taking a two-month camping trip in November and December.

Seven / Half-Time Happiness

1936 to 1939

WITH FRANCES OFF TO TUCSON, ROCKWELL BEGAN HIS SO-CALLED CAMPING trip by closing up the house and moving into his studio:

> *There were, after all, but two months left before, in January, I should leave for a three months' lecture tour; and the studio—without water, and unheated but for a wood stove—would be reminiscent of life in Alaska....Not once in those two months did I see friends. The daylight working hours were short; the hours before bedtime interminable. I'd write my daily letter and then draw or read. And rarely, just as in Greenland, did an answer to my letters come. Such disappointment, day upon day, somehow—like constant drops of water on a stone—wears at the heart.*

As he worked, he wrestled with the idea of pulling up stakes at Asgaard and moving to Tucson, even sketching a house he imagined building there. But when Frances failed to write, he dismissed the idea and destroyed the house plans. In that loneliness, he wrote the preface for Adler's book, a short essay in which he imagined himself living alone in an abandoned schoolhouse in a bleak Vermont countryside, passing his days with books.

"Again: By Way of Preface" (see Appendix II).

He had postponed making the bookplates for Lucius Wilmerding and Leod Daw Becker. As directed, Adler offered Stanley Marcus' Pegasus to each of them, but both insisted on a version of the Carola Zigrosser bookplate. With little enthusiasm for repeating himself, twice, Kent modified that design, retaining the airborne horse and substituting male figures. To his surprise, Becker requested a revision: His horseman had been drawn with two good arms, and Becker apparently had but one. A Madison Avenue publisher, he had fought in France in 1918. "The record says I was a good soldier," he wrote Adler. Kent's final drawing depicts the rider as an amputee.

There were other bookplates to be completed in time for Christmas. A Philadelphia art dealer had inquired about one as a gift for Nelson Eddy— *Rose Marie,* the actor's second picture with Jeanette MacDonald, was that

year's sensation—but the client had balked at Kent's fee of two hundred fifty dollars. Zigrosser had been more successful in landing a commission:

> *Dexter Cook (who exchanges milk bottles for wine bottles) has wanted a bookplate for a long time. He is a bit shy about asking you, so I said I would ask you how much it would cost him. It could be between you and him, as I would not charge any commission. He really wants two bookplates, one for himself and one for his girlfriend. He does not want them until Christmas. He is an awfully nice fellow and so is the girl. It would be a pleasure to do something for them.*

After Kent agreed to make the bookplates, each for one hundred dollars, Dexter Cook wrote to the artist, "Inasmuch as a pair of plates is to be done and since Ruth and I are intimate friends, it has occurred that some tie-up between the two might be worked out in their design." In response to the sketches he received just in time for Christmas, Cook wrote:

> *Ruth, who went along expecting the usual bread-and-butter Christmas, with perhaps a bottle of wine as an extra, was completely bowled over on finding herself included in the scheme. She did not even expect that mine, which she paid for, would arrive in time, so she was doubly surprised.*

Rockwell had designed and built the house at Asgaard for "good and happy and riotous times." New York friends were frequent guests, but over time Rockwell and Frances had established a select circle of friends in Essex County. He made bookplates for three of them, as Christmas gifts.

On an autumn day nine years earlier, the Kents had met Osceola Byron Brewster, "a man of strong and engaging personality—a north-countryman steeped in the lore of woodcraft, hunting, stalking and the history of [the] mountain region." Brewster had escorted them in his big Buick over the Adirondack foothills in search of an abandoned farm. When Rockwell and Frances returned from Denmark, he had helped resolve a household dilemma by adopting a couple of the Great Dane puppies. In 1936, after twenty years as district attorney for the county, he became the local justice of the New York Supreme Court. Kent had made arrangements for Adler to print Brewster's bookplate in October:

> *I have a bookplate for Judge O. Byron Brewster. When I send it to you, if you will be so kind as to do the printing for him for as little as possible, you will*

Bookplate for
Lucius Wilmerding,
1937.

Bookplate for
Leod Daw Becker, 1937.

Bookplates for
Dexter G. Cook, 1937.

Bookplates for
Ruth S. Brokaw, 1937.

Bookplate for
O. Byron Brewster, 1936.

Bookplate for
Pauline Lord, 1937.

Bookplate for
Louis Untermeyer, 1937.

After the publication of Adler's book, Kent wrote to Untermeyer: "The SOB who swiped and had his own ugly name abominably lettered upon your design is George Ely Russell. Who he is and where he lives nobody that I know knows." Over the years, Kent received numerous requests for bookplates based on *Flame,* but never revised its design for another client.

be helping me out in the obligations to him under which I am continually
falling. He wants me to put on the bookplate, which pictures one of his Great
Danes, the following—or its equivalent in Latin: He who steals this book best
beware the dog. The only Latin I happen to know is the declension of the word
amo, and the only way I learned it in school was...

> *Amo, amas, I loved a lass,*
> *Her form was tall and slender.*
> *Amamus, amantis, I laid her flat,*
> *And tickled her feminine gender.*

There being nothing said in the Latin quotation about books, it won't do for
a bookplate. Won't you please get and rush to me a good epigrammatic trans-
lation into Latin of Judge Brewster's thought?

Adler had the inscription translated, and a thousand bookplates were deliv-
ered to Judge Brewster soon after Christmas.

The Kents were not the only New Yorkers who had found sanctuary in
Essex County. Pauline Lord had created the title role in Eugene O'Neill's
Anna Christie in 1921, her realistic portrayal of the prostitute winning her
rave reviews in New York and London. Three years later, she returned to
Broadway in Sidney Howard's *They Knew What They Wanted*. Both plays
received the Pulitzer Prize, which enhanced her standing as one of the lead-
ing dramatic actresses of that era. Too shy to enjoy stardom, she retreated to
her home in Elizabethtown, thirty miles from Asgaard, between acting jobs.
She was a regular on the Kents' guest list and the recipient of a bookplate.

Similarly, the poet and literary editor John Untermeyer had left the
"stridency and violent tempo" of New York in the late twenties and followed
the Kents to the Adirondacks. He purchased a farm in Elizabethtown, called
it Stony Brook and had Kent design its library. Behind his scholarly
demeanor, Louis was as playful and fun loving as Rockwell and Frances.
When he visited, he arrived with pajamas, puns and the promise not to "ask
for art criticism, discuss communism, tell how the place might be improved
by moving the barns somewhere else, patronize the perennials or give the
outline of my literary plans for the next ten years... though, of course, if
anyone is at all interested..."

As a young man, Untermeyer had been, like Kent, active in the socialist
movement. Without benefit of a college education, he went on to become
well known and respected for his anthologies of American and British

When Rockwell's eldest
daughter, Katie, became
stagestruck, Pauline
Lord arranged for her
to serve as her personal
assistant and understudy
the ingenue role in the
1937 touring company
of *Ethan Frome.* Her
dramatic career would
be shortlived.

poetry. In 1927, Kent designed the jacket for the second printing of *Burning Bush,* a little volume of Untermeyer's poems. The drawing was a study for *Flame,* a wood engraving. Upon receiving it, Untermeyer wrote to him:

> *As I stammered to Frances, the drawing is breathtaking, adjective-beggaring and leaves me with nothing so much as the conviction that I really should write a new poem for it. It is even finer than the design on the wood block led me to suspect, and I'm genuinely proud to have it in my next (and I am brash enough to believe, my best) volume. It is so right in atmosphere and suggestion that instead of using it for jacket and colophon, I am happy to report—and I hope you won't mind—that Harcourt is going to use it as a frontispiece.*

For Untermeyer's bookplate, Kent redrew *Flame.*

CHRISTMAS AT ASGAARD WAS AN EXTRAVAGANT FAMILY AFFAIR, CELEBRATED "in consideration of Kathleen" on New Year's Eve. By 1936, most of the young Kents had reached adulthood, and there were grandchildren. Alone, Rockwell reopened the house and decorated it with a lofty, lighted spruce and handcrafted ornaments. Music reigned whenever they gathered, especially at Christmas, and the festivities proceeded without Frances. The circumstances of her absence were never mentioned. After the children drove away, the sudden quiet of the empty house spoke to Rockwell of abandonment. He saw himself as doomed "to half-time happiness for all that remained of this, my only life…"

The winter lecture tour that would take him westward through twenty-two states—and take his mind off Frances—began in early January 1937. On New Year's Eve, Adler sent word that the printing of an advertising prospectus for *Later Bookplates & Marks of Rockwell Kent* was underway, and that April, an exhibition of the bookplate drawings was mounted at the Times Annex. But the opening reception drew a small crowd, and two months before publication, only half of the twelve hundred fifty copies had been sold. Priced at ten dollars, the eighty-four-page book would be printed in multiple colors on heavy rag paper, numbered and signed by the artist.

After Frances returned to Asgaard, Rockwell got back to work on the Post Office murals. Each measuring six feet, six inches by thirteen feet, they were installed in the Federal Post Office Building that September. His depiction of a letter carried by airmail between America's arctic and tropic territories was well received until it was revealed that the text of the painted letter, apparently written in some obscure Eskimo dialect, was a plea for Puerto

Bookplate for
Marjorie & Richard
Dammann, 1936.
Its design was taken
from Kent's 1918–19
painting *To the Universe.*

Bookplate for
Juliet K. Smith, 1937.
She had worked at
Asgaard, assisting Kent
with the delicate
lettering and drawings
for *Moby-Dick*. He later
remembered how "the
called-for drawing of
an infinitude of short,
fine lines to form the
even, gray tone of a sky
drove [her] almost to
distraction." After she
moved to New York,
Kent often hired her
to add the lettering to
the bookplates he sent
to Adler, notably those
for Frank Whitmore,
the Library of Congress
and the Albright Art
Gallery.

Bookplate for
Ray Baker Harris, 1937.
Harris was a librarian at
the Library of Congress.
His bookplate was
closely adapted from
Kent's 1929 wood
engraving *Man at Mast.*

Sketch for the Donald Snedden memorial bookplate, 1938.

Mrs. Snedden had commissioned the bookplate as a memorial to her son, who had drowned in a yachting accident. This sketch depicts a mother's grief. It would be completed three years later as a commercial bookplate for the Greenland Press.

Photograph of Donald Snedden.

The basis for Kent's final design.

Sketch for the Donald Snedden memorial bookplate, 1938.
(Rare Book and Manuscript Library, Columbia University)

Memorial bookplate for Donald Snedden, Stanford University Library, 1938.

The Snedden fund remains active.

Rico's independence. Although Kent himself had planted the story in order to call attention to the oppression he had witnessed in his brief visit to San Juan, the headlines that followed were damaging. Disregarding the controversy, General Electric commissioned him to paint a mural for its pavilion at the 1939 World's Fair.

In January 1938, the *New York Post* offered its readers a series of reproductions of paintings that included Kent's *Winter* from the Metropolitan Museum of Art. A promotional booklet included a profile of the artist:

> *Rockwell Kent has probably the largest income of any American artist, his earnings sometimes reaching $100,000 a year....Guests at his home are required to get up at five in the morning. If they do not, he plays a phonograph outside the bedroom door until they do. Even when he stays up until two or three in the morning painting, he still insists that five is a good hour to rise.*

Kent's guests could vouch for their early morning reveille, usually to the blaring of "Ride of the Valkyries," but the assessment of his income was greatly exaggerated. A Philadelphia dealer in books and prints had recently sold the original illustrations for *Venus and Adonis* for a modest twenty-six dollars apiece, less his commission. Kent had earned only three thousand dollars for his Post Office murals, without an allowance to cover his travels or the assistants he employed.

A bookplate commission was profitable when Zigrosser or Adler set his fee. Without their mediation, Rockwell was admittedly "hampered in earning it by having a fairly soft heart." He enjoyed making a bookplate and would accept whatever payment the client could afford. The one he designed for Mrs. David Snedden of Palo Alto, California, was another "charity case." In 1938, she and her husband established a library fund at Stanford University as a memorial to their son Donald. He had died in a yachting accident off Long Island seven years earlier. To assist Kent, Mrs. Snedden sent a photograph of Donald back diving from a board into a lake, his chest arched upward. The resulting octagonal bookplate echoed Kent's 1921–23 painting *Voyagers, Alaska*. Two hundred copies were printed, and he called them "beautiful."

ROCKWELL PERSUADED FRANCES TO SPEND THE WINTER OF 1939 IN NEW York City, where he was painting *Electricity and Progress* in a rented loft. Measuring fifteen feet by fifty feet, the World's Fair mural would cover one

wall in the General Electric pavilion. He approached its design with epic ambition: Two floating nude figures, man and woman, dominated a landscape that depicted the progression of civilization from alchemy to industry. The touch of their fingers generating a spark suggested the centerpiece of Michelangelo's Sistine ceiling.

He was also beginning another book, which Frances would type from his handwritten manuscript. Both welcomed invitations to Elmer Adler's Thursday afternoon teas or the occasional visit with Carl Zigrosser, but as Kent recalled, "There was little time for relaxation and for the fun we both had hoped to have and to which long-suffering Frances was more than entitled." Twelve years earlier, their married life had begun in a sunny flat on Washington Square, but as the Depression ended and the World's Fair extolled the "The World of Tomorrow," Rockwell faced the uncertainty of their future:

> The slow *oxidation to which spontaneous combustion is attributed had been in process with Frances and me for some years without either of us, I believe, being fully aware of its potential danger to our marriage. Repeated friction had engendered heat; and which of us should first burst into flame depended partly upon chance but mostly on our relative combustibility.*

Despite the relative failure of his *Later Bookplates & Marks,* Adler continued to promote Kent's bookplate art. In 1939, he made arrangements for an exhibition at the New Orleans Museum of Art.

Eight / One Chinese Phoenix Rampant

1940 to 1942

IN HIS CLOISTERED CORNER ON THE EIGHTH FLOOR OF THE NEW YORK TIMES Annex, Elmer Adler typed a letter to Rockwell Kent. Its message would be news on page 19 of the next day's *Times,* although it was a report most readers would overlook. A block away, the belt of lights that circled the old Times Building blazoned the headlines of Hitler's troops sweeping through Europe and England's preparations for war. Good news was hard to come by in February 1940, and his was no exception.

Now well into his middle years, Adler had drafted a letter of surrender. And as with all things written under the *Times* roof, his words came to the point without undue emotion:

> *Here's a notice which we reluctantly are sending out today. Whether we are just another war victim, or something else, is difficult to determine, but we find it too difficult to keep going at this time.*
>
> *At the same time that we are discontinuing The Colophon we are winding up the career of Pynson Printers. I hope in the next few weeks to be able to announce my own plans for the next few years.*

A message titled "Fair Warning" was mailed to the two thousand subscribers, admitting more eloquently that "it is but a meager and melancholy satisfaction to the editors to reflect that the decade now rounding out has seen infinitely more serious casualties than *The Colophon,*" and suggesting that the halt might be temporary—"a pause, a hiatus, a caesura, a semi-colon." But those close to Adler realized the unlikelihood of his resuming publication. As one put it: "He had grown tired of taking financial risks for the sake of his ideals." After producing forty-five books, nine of them with Kent, and thirty-five issues of *The Colophon,* Pynson Printers had never made a profit, notwithstanding Adler's pricing. "He turned out beautiful work," recalled Bennett Cerf, "at only eight times what it should have cost." Many younger men had journeyed to New York to make their fortune, but it appeared that Adler had come to lose his.

Adler's letter arrived at Asgaard in the Valentine's Day mail. Kent would later say that "when Pynson Printers closed their doors there came to an end an era in printing in America," but on that winter's day, he was "turning out pages of minutely written, altered, interlarded, scratched out, nearly indecipherable manuscript." He was writing *This Is My Own,* a memoir of his last dozen years—a time of personal awakening that came while "the rotten, leaky, weak, ill-made, top-heavy, makeshift dam of false prosperity" broke and flooded the land. The fifth book written from his experiences, it would be the the most personal and political.

Although *This Is My Own* would cover his Edenic life at Asgaard and the span of his marriage to Frances, she had taken up residence in Las Vegas to await their divorce; and despite having hired a secretary, he was mailing batches of his handwritten chapters across the country for his wife to type. The remarkable amicability of the marriage's sudden end was exceeded only by Frances' approval of her husband's new secretary, who was already his fiancée. While *hurry* may not have been in Elmer Adler's vocabulary, it could well have been Rockwell Kent's middle name.

For both Kent and Adler, the early days of 1940 had seen an era to its unexpected end. Both had fallen on hard times. On April 12, the Saturday *Times* buried news of the artist's divorce in eight lines at the bottom of a page. Coincidentally, a final epitaph for Adler's *Colophon* appeared in its book review pages the following day: "Though The Colophon died young, it was a lusty, gay-spirited child, and it remained in good health to the very end." The same might have been said for the Kent marriage.

HER NAME WAS SHIRLEY JOHNSTONE, AND THAT HAD BEEN HER NAME FOR all of her twenty-four years. Born in England, she had immigrated to Canada with her widowed father, completed high school in Toronto and moved to New York to study singing at the Julliard School. She had a socialist roommate and a secretarial job. When a New York radio station interviewed a group of working girls and asked about their marriage ambitions, Shirley was the one who answered: "I would like to marry an artist…because I could be with him all the time." In early December 1939, she heard that an artist needed temporary secretarial help while his wife was away for the winter. She had never heard of Rockwell Kent, but wrote to apply for the job:

At present I am employed in the Fine Arts and Foreign Departments at Brentano's Book Store, as secretary, where I have been for a little over a year. I am anxious to make a change.…

I shall look forward to your reply, and if you should be in New York at any time in the near future I would very much appreciate an interview at your convenience.

The letter was neatly typed, but he admitted that it was the "easy, good, clear, well-formed hand" of her signature that impressed him most. Two weeks later, he was in New York, where Frances was hospitalized, and met Shirley over lunch at the Ritz:

The friendly, bright-eyed man who greeted me at once dispelled all uneasiness, those eyes making me think of a bird. With no preconceived idea of appearance, my first impression was one of disappointment. Older, perhaps, than might have occurred to me? Smaller? Less glamorous than an artist, a writer should look? The lunch that followed assured me at any rate, that I had found a friend and a new employer.

She started work at Asgaard on January 2, 1940. Kent had told a friend that the secretary he was looking for "should be lovely to look at, lovely to listen to, lovely to have about day in, day out." He also insisted that he was not looking for a wife; he had a wife. Within a few days after Shirley arrived, a dramatic proposal of marriage from the fifty-seven-year-old artist prompted her to repack her bags and skis, and take the next train back to New York, unwilling to interfere with what she assumed to be a happy marriage.

Having recovered from surgery, Frances wrote from New York of her plans to return to Asgaard before traveling to Tucson:

Please be glad to see me.... What a shame about Miss Johnstone! And you really need her so. I do hope that she is back with you and that her boyfriend and she will decide not to get married for some time. Surely she wouldn't have taken the job if she hadn't meant to stay with you for some months anyway.

A week later, Frances met Shirley, who had had second thoughts about Rockwell's proposal and returned. Frances gave her blessing to their engagement by agreeing to travel straightaway to Nevada for a quick divorce. When Sara Kent learned of the turnabout, she congratulated her daughter-in-law "on having taken the step at last." From the Las Vegas dude ranch where she had found temporary lodging, Frances wrote:

I went to the lawyer yesterday and we tried to find satisfactory grounds. It is

*very hard. I do not like to accuse you of nasty things and every time he'd say,
"But didn't your husband nag you—didn't he humiliate you—didn't he…"
I'd say, "Oh no, no. Not at all." Then he explained that I must be a perfect
angel and you must have treated me badly. Please help me out! I've said that
you nagged and were unreasonable. That you called me for a divorce. But I'll
have to think of more things. The report will only be "mental cruelty" but
for the judge you have to make a good case. You can imagine darling how I
hate to accuse you of things that aren't true. Of course it is just a form, but it's
not nice.*

Their fourteen-year marriage ended, and on April 30, Frances wrote:

*Darling, our lives are too entwined to ever be untangled. We both know that.
And I cannot conceive of not always loving you. But for your own happiness
and for Sally's, that fact must not be kept in the foreground and Sally must
not feel that Au Sable is not all hers…*

In the role of secretary
to Rockwell Kent,
Sally would continue
to identify herself as
Shirley Johnstone over
the next thirty years.
Kent had liked everything about Shirley Johnstone but her name. By then
she was getting used to being called Sally, the name he had bestowed upon
her. Most of his children were older than she, but they were unanimously
charmed by the woman who married their father in May 1940.

MONTHS PASSED BEFORE ADLER WAS ABLE TO NOTIFY KENT THAT "FROM JULY
first of this year I am to be associated with the university at Princeton. My
formal title is Research Associate in the Graphic Arts. And if I have nothing
else to show, I should be able to put on a pretty good display of the work of
Rockwell Kent, and this will be one of my projects during the next three
years." Princeton was ideal for Adler, the born teacher, and its ivory towers
were only thirty miles from Roaring Rocks, his century-old farmhouse in
Bucks County.

Public announcement of the appointment was finally made in late September
after the Friends of the Princeton University Library came forward with a
funding plan that established the library's graphic arts department in a house
at 40 Mercer Street. Ignoring Adler's lack of academic credentials, the
university had tailored the position to his strengths. He would curate exhi-
bitions, organize guest lectures and conduct study groups for students and
others interested in the graphic arts, their participation being extracurricular
and voluntary. And to Princeton, he would bring not only his enthusiasm
and knowledge but also something tangible: the ten thousand reference books

SALLY AND ROCKWELL KENT

ex libris EDMUND JOHNSTONE

Kathleen Finney Kent

Bookplate for
Sally & Rockwell Kent,
1947.

Kent delayed making
a bookplate for Sally
and himself until
seven years into their
marriage. The first of
their two bookplates,
it was pasted alongside
the one he had made for
Frances and himself.
In 1955, it appeared
on the dedication page
of his autobiography
It's Me O Lord, which
was dedicated to Sally

Bookplate for
Edmund Johnstone,
after 1940.

He was the father of
Sally Kent, and his
bookplate was based
on the Clan Johnstone
crest: hawthorn leaves
and a winged helmet
with an upturned spur
and length of rope. The
family motto, *nunqum*
non paratus, is translated
"never unprepared."

Bookplate for
Kathleen Kent Finney,
ca. 1940.

After the marriage of
his eldest daughter,
Kathleen (Katie),
Rockwell designed a
bookplate that expressed
her devotion to music.

*Bookplate for
Arthur G. Altschul,
1940.*

His father, Frank Altschul,
was a contributing
editor and one of the
financial backers of *The
Colophon.* Kent based
the bookplate design on
Man Shooting an Arrow,
an unfinished wood
engraving from 1920.

*Bookplate for
Edward W. Hickey,
1940.*

Hickey was the husband
of one of Sara Kent's
friends in Tarrytown.
His bookplate presents
a sardonic rendering
of Ichabod Crane, the
Washington Irving
character from *The
Legend of Sleepy Hollow,*
which is prominent
in Tarrytown's literary
history.

and three thousand examples of fine printing that he had collected over thirty years. An article in the *New York Times* noted that he would continue as director of its History of the Recorded Word exhibition. A corner of the library in the Times Annex was reserved for his occasional visits.

At Princeton, Adler began re-creating his universe, taking a paternal interest in the young men who gathered at the round table he brought from his Pynson Printers office. In early December 1940, he wrote to Rockwell: "I showed some of the boys Kent bookplates. One boy asked if I thought you would make him a bookplate for fifty dollars? I said I would ask."

Although the worst of the Great Depression was over, fifteen percent of the country's work force remained unemployed and, with war by then inevitable, those who received a paycheck continued to spend with caution. Fifty dollars would buy the best Hart Schafer & Marx suit or pay one month's rent for a studio apartment on Manhattan's East Side. Kent, hard pressed to make alimony payments to two former wives, was broke. Every dollar counted, and he could no longer afford to be charitable. When a Mississippi library wrote requesting a favor—that he design their bookplate and donate a copy of each of his books—he declined, saying: "Do realize that artists and writers must depend for their living upon the sale of their works to those who like them most and that since they must live, they must be practical to the extent of believing that the true test of appreciation is purchase."

Fifty dollars for a bookplate would be satisfactory. Without Adler actively promoting his bookplates, Kent had received only two commissions that year: one for Arthur G. Altschul and the other for Edward W. Hickey. A week later, he wrote to Adler: "Probably I'll be able to make a few bookplates around the first of the year. You might send me the information for the new plate that is wanted. I'll see what I can do." Adler wasted no time in responding on December 21 with photographs and a scribbled sketch.

Here is Tatum's idea for his bookplate. He is a graduate student in the art department, and after a six-week course with me, decided he wanted a Rockwell Kent bookplate.

He thinks he wants an oval—but wants to leave everything to you—also have you decide about ex libris or not. Whatever you do he says will be okay by him. He hopes however that you will give him any pencil study you make, for he wants to mount everything as the record of a design.

Name is George Bishop Tatum. The photo shows two studies of the bird. He hopes to have a chiaroscuro effect in the printing. Is everything clear?

Chiaroscuro is the treatment of light and dark that lends depth to a pictorial image. It originated in the sixteenth-century with woodcuts printed using several blocks, each inked with a different tone of one color.

On his sketch, Adler jotted "two color printing—be sure to sign R.K." He knew too well how often Kent neglected to sign his bookplate art. Each of the photos showed the sculpted relief of a bird from the ancient Pillars of Shên in China's Szechwan province. Tatum, a student of art history with ambitions of eventually acquiring a large personal library, had selected the simple image, known to him as the "Red Cock of the North," with the idea that it might double as the design for an embossing stamp.

Kent ordinarily provided his clients with two or three sketches from which to choose, but for so simple and straightforward a job as this, he made one and dispatched it to Adler on March 18, 1941:

Under separate cover go to you today the two photographs and the sketch for the George Tatum bookplate.

My studies in comparative anatomy and ornithology have led me to the conclusion that the bird represented in the sculpture is a rooster of the gamecock variety. The head that shows most clearly in the two examples is definitely a rooster's or, being shorn of comb and other appurtenances, of a gamecock. The tail can be nothing else. And while the neck might be of Annie Laurie or, more remotely, a swan's, maybe the sculptured bird is a phoenix.

So let me say that to whatever degree the bird that I have drawn looks unlike a gamecock it looks like a phoenix. And to those who may say "But it doesn't look like a phoenix," I can reply, as I did to the lady who said my Tuberculosis Association angel didn't look like an angel, "Have you ever seen one?" Anyhow, I think that a gamecock is a much less hackneyed symbol than a phoenix, or, for that matter, a swan; though I can recall no swan that ever did much except the one that raped Leda.

Anyhow, here's the sketch, and I propose making the bird in gray and white against a black background. The gray plate should be an all-over plate, thus obviating the difficulty of getting perfect register for such fine details as the lettering. The black, being printed on top of the gray, could be given, and should be given, very hard impression so that the bird would have that third dimension which you know to be so dear to the typographer's heart.

In his letter, Kent refers to the Scottish ballad "Annie Laurie" (whose heroine's "throat is like the swan"), to an angel he painted for the 1939 Christmas Seal design and to the Yeats poem "Leda and the Swan," which was based on the Greek myth.

Kent's library reflected the value he placed on research. With volumes on ornithology for reference, he sketched a variety of rooster. It was a far cry from the creature in Tatum's photographs, and six weeks passed before Adler finally pleaded in a short letter to Sally Kent:

I am still trying to sell a gamecock to a boy whose heart is all set on a phoenix. The greatest handicap to my success is that I really do not see why Rockwell should not give the boy his phoenix if that is what he really wants. For years Tatum's mind has been made up to have his phoenix, and to a lay mind like mine it is difficult to get Rockwell's reason for changing the design.

Smarting from Adler's vague disapproval, not to mention his pitiable appeal via Sally, Kent responded on May 6:

So it's a phoenix is it? Well, well! And why not have saved me a lot of study in the comparative anatomy of birds? Am I expected to have some kind of psychic understanding of what would seem to be your and Mr. Tatum's understanding of natural history? Just to be sure, Sally has reread—with, of course, unbounded pleasure—all your correspondence on the subject. Phoenix is not mentioned. Flames are not shown in the design.

I wrote you that I was having difficulty in identifying the bird. You just let me have the difficulty and then, when I get all through and draw the nearest thing that ever lived as what that sculptured thing was meant to be, you just calmly tell me that you're disappointed, and accuse me of trying to force a gamecock down the throat of a man who wants a phoenix.

The game, as you are playing it, is sort of one-sided. You hold all the cards and, at present it appears, even the photographs. If I had guessed phoenix and drawn one, you might have come back with a merry ha, ha and said, "How stupid of you. The bird is a boojum."

Of course I have no sensibilities about drawing phoenixes and if you'll send the gamecock back, and the photographs of the alleged phoenix I'll make something so like that allegation that, whatever other experts might choose to call the bird, you and Mr. Tatum will be forced to respect your christening.

And to the design in general as I have indicated and described it: Does that fill the bill?

His frustration mounting, Adler returned the photographs to Kent:

Doubtlessly I'm all wrong as usual, but when, in your letter of March 18, you wrote "maybe the sculptured bird is a phoenix," I thought it was your way of saying that you knew it was a phoenix. But perhaps I should have written to say "yes, it is a phoenix." Anyway, I never saw a live one, and I do not know what difference the name makes. What Tatum wants is a bird that looks like the photograph.

But Kent had not finished haranguing Adler and obviously took sport in what had indeed become a game:

I am not an archaeologist but a careful study of the two photographs leads me to the conclusion that neither bird is, or was meant to be, a phoenix, whatever that bird is. By the inscription on the monument of the smaller bird I judge that the thing is Chinese. I don't believe that the Chinese knew anything about phoenixes. We do know that they respected their pheasant. Study of the bird leads me again to the conclusion that it is meant to be a pheasant—is a very good pheasant and it is not even a partly good anything else—except that variety of the pheasant which is known to us as the gamecock.

The other bird has nothing peculiarly in common with the Chinese bird except a plume on his head and waving wings. The neck and head are clearly the neck and head of a swan and next to that of a goose.

And now you write that Mr. Tatum just wants it to look like the bird in the photographs and that it must be a phoenix.

Since there are two birds and not one, those birds being respectively a pheasant and a swan, it's just up to me to decide what Mr. Tatum thinks a phoenix looks like. Is a phoenix a bird of prey? Or a song bird? Is it possibly a pelican? Or—we haven't exhausted that possibility yet—is it a swan and, consequently, like one but not the other of the two birds sent?

As a tentative move in approaching what Mr. Tatum means I send you a rough sketch. The head is sort of bird of prey, but not any particular bird of prey. The neck is a sort of goose's neck, which is a modified swan's neck.

Maybe you and Mr. Tatum would work out a neck and head for the bird and I could sign the drawing "Designed by Rockwell Kent, head and neck by Adler and Tatum." Anyhow, please let me know.

By then, a flustered Adler was ready to concede the debate, leaving George Tatum to finalize the design by letter on June 10:

The legend of the phoenix revived from the ashes is foreign to Asian lore, but the "red bird" that the ancient Chinese associated with summer and prosperity was customarily translated as *phoenix* in Western writings on the subject. The photographs showed two phoenixes, one female and one male, carved in relief.

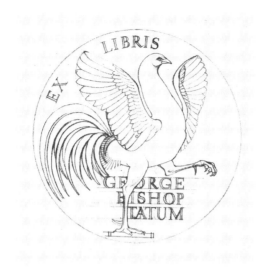

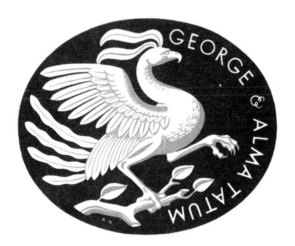

*Preliminary sketch
for a bookplate for
George Bishop Tatum,
March 1941.*
(Rare Book and Manuscript
Library, Columbia University)

*Bookplate for
George & Alma Tatum,
1941.*

*Revised final sketch
for a bookplate for
George & Alma Tatum,
June 1941.*
(Rare Book and Manuscript
Library, Columbia University)

Mr. Adler has passed on to me the sketch for the bookplate. I am delighted with it, and shout for it loudly. It looks like a phoenix to me, and the fact that you do not think so, only confirms a suspicion which I have had all along; that you, Mr. Kent, do not have a Chinese mind.

I have further, in addition to my thanks, only two remarks to make, the one a suggestion, the other a request. The Suggestion: I liked the lifted foot of the first sketch. It seemed to give life. Would it look good here? If not, forget the suggestion. The Request: Since writing first, I have decided to take unto me a wife. Will you be good enough to change "George Bishop Tatum" to "George and Alma Tatum"?

Again my thanks for all your time, trouble and patience.

While Kent had chafed under the necessity of compromise in his commercial illustrations, he was always accommodating when it came to a bookplate commission and served the client best when their contact was unmediated. On June 18, he wrote to George Tatum:

Brandishing his knowledge of heraldic terminology, Kent's letter described the figure's outstretched claw as *rampant* and the bookplate's colors as *argent* for white or silver, and *sable* for black.

I am sending you under separate cover one Chinese phoenix rampant, argent on sable, bearing the motto: George and Alma Tatum; and with it two photographs, representing respectively a swan and a Chinese pheasant—the swan and Chinese pheasant that, in defiance of all principles of eugenics, mated and produced a phoenix. I hope you like their misbegotten progeny.

The final rendering of the bookplate reached Princeton while Tatum was away. For weeks Kent fretted, imagining that his work had been lost in the mail or, yet worse, had met with disapproval. When Tatum at last received it, he responded:

Alma is here with me, and we are both delighted beyond words with your design. Misbegotten or not, the pheasant-swan is ours and we will love him. We would not change a pen stroke!

And Adler, who would supervise the color separation and printing of three thousand bookplates by the Princeton University Press, concurred with relief: "I think it is grand."

George Bishop Tatum and Alma Standish married on May 1, 1942, and in reply to their wedding invitation, Kent sent a short note: "I suppose the bookplate must have been the earliest printed announcement of the happy event of your marriage."

Nine / A Friend to Man

1941 to 1948

THE HESITANCY CARL ZIGROSSER FELT AS HE ARRIVED AT THE PHILADELPHIA Museum of Art was typical of a man who avoided change. Two decades earlier, he had opened the Weyhe Gallery and shaped it from scratch into an internationally known gathering place for artists and collectors. It had flourished through the twenties, but flagged during the depression years, when keeping it in business became more repugnant than challenging. He was a socialist, not a businessman. That and the increasing prospect of war had brought his "latent ambitions to the surface." On a January morning in 1941, he was starting over, as Curator of Prints and Drawings at one of the country's leading art museums. His qualifications for the position were his friendships with the leading artists of the time, his intimate connections throughout the art world. While he knew nothing about how a museum operated, that could be learned. It was the politics of a conservative institution that worried him. In a letter to Rockwell, he wrote:

> *Don't ask me to sign any petitions or manifestos just now. I am trying to establish myself firmly here, and have gone underground as far as political activity is concerned. Even the New Deal (and we all know how lame and mistaken a compromise that is) is anathema to several of the trustees. I feel that a stand now would jeopardize all that I want to build up for the next twenty years.*

He and Elmer Adler had steered Kent into the black-and-white work that not only carried him through the lean years but also brought the recognition his paintings had yet to achieve. When they left New York for Philadelphia and Princeton, Rockwell's dissociation from the city was complete. The steady stream of gainful commissions had already turned into a trickle. "I, this year, am poverty stricken," he admitted to Adler. In urgent need of an automobile, he sold him the bulk of his drawings for five hundred dollars.

Although Adler's two books of bookplates had been limited editions,

never to be reprinted, they continued to generate the occasional inquiry. Letters arrived at Asgaard, most often from ordinary people with an inordinate love of books, as well as an esteem for his art. In the correspondence that followed, Kent and the client would establish a rapport that had been impossible with Adler and Zigrosser as his agents. He fervently sought the client's input, and most of the bookplates he designed thereafter benefited from the personal nature of their letters.

Seeing that his bookplates were properly printed was another matter. May Greenberg, Adler's good right hand almost from day one, had gone to work for A. Colish, Inc., so Kent chose Abe Colish to take over his printing. Established in 1907, his Manhattan print shop was the first in the country dedicated to advertising typography. While Colish was not as fussy as Adler, he was an expert in fine printing, with ink-stained apron and hands to show for it. He was willing to be tested by Kent's demand for perfection.

GEORGE COREY OF LAKEWOOD, OHIO, HAD ACQUIRED KENT'S ENGRAVINGS *Flame* and *Northern Night* in December 1940. In writing to ask if the artist would inscribe them to his wife and himself, he added: "One of these days, when the Christmas bills have been paid, I am going to ask you to make a plate for me." Kent offered to take on the project, quoting a price of $150 and asking Corey for ideas for the design.

"I have vaguely in mind something like Kipling's 'honor, faith and a sure intent,'" Corey wrote back. As "a slight hint" at its design, he noted Kent's Henry Batterman bookplate, which showed a man at the foot of a ladder. "What I should like you to think of," he continued, "is the glory of honor, the decency of peace, and the sure intent of the peoples of the world to maintain them." With Europe a battlefield, Kent never ceased thinking of them. He submitted a single sketch, explaining that he was so pleased with it that he had not attempted an alternate, but allowed, "This does not mean that you must like it." Corey made one suggestion:

> *Although your sketch does not quite bring out what I had in mind, I like it so well that I am not inclined to try to throw you off on a different scent. The thought is there, all right, but I wonder if the plate wouldn't be stronger if the man were clutching for the star without quite having it in his hand. My idea is that man is still struggling for a place in the sun of a capitalistic economy, and is now only a little distance from attaining it. What do you think?*

"It was easy for me to carry out your idea," Kent replied, "for alternate

"Honor, faith and a sure intent" is from Kipling's 1897 poem "The Vampire."

studies of the sketch were of exactly that idea." Intending his bookplate to be "rather exclusive," Corey ordered but two hundred. "Probably I am prejudiced," he wrote, "but I think this is just about the best bookplate you have made. At least, of those I've seen."

Leonard L. Levinson of Burbank, California, wrote to Kent in April 1941 of his large number of books in need of bookplates, adding, "I'm a writer— which gives you an idea of how much money I can spend—or rather, can't spend." Not knowing what sort of writer Levinson was, Kent responded that he was interested in making the bookplate and stated his standard fee, but left room for negotiation:

> While I have to earn my living by jobs of this sort, I am hampered in earning it by having a fairly soft heart; and if you, knowing how much I do get, will let me know how much, no matter how little, you feel that you can pay, then, in the fourth letter of our correspondence, I'll tell you whether I can afford it or not.

Levinson was a scriptwriter for the popular radio comedy *Fibber McGee and Molly.* He had also created its spin-off, *The Great Gildersleeve,* a new radio series that would debut that August (and also mark the beginning of the classic situation-comedy format). Thinking that Kent had predicted they would have to exchange four more letters in order to set the price, his reply provided a scenario for their dickering:

> Suppose we set up a schedule in this matter of the bookplate.
>
> In my first letter I will note with surprise and a touch of horror that you charge $150 to $200 for a design. Not too much surprise, because that would be unflattering and I would be the last person in the world to say that your bookplates aren't worth every penny of this. But just the right amount of horror at the thought of me *paying that much.*
>
> Then after a good deal of muttering in an undertone under my Underwood, I will make a timid suggestion that possibly, if I deny my young daughter her orange juice at breakfast (and you know how cheap oranges are out here), hold my beautiful wife down to two pairs of stockings a year, and buy my motor oil in five-gallon tins from Sears, Roebuck and pour it in myself, then, maybe I could spend $50 for a design.
>
> You will reply to this, laughing gently and hollowly, saying that J. Edgar Hoover would give more than that for a nice clear thumbprint of yours. Then you'll make some casual mention about "coolie labor," gently tell me that a

nice, heavy rubber stamp is about my speed in bookplates, and kiss me off with a hint that, as a special unbending to one who is alleged to labor in a neighboring vineyard, you'll lower your price to $125—provided I never, never mention it to a soul.

I will mull your letter for several days (just to show you I'm not as anxious as you know darn well I am). Then I'll drop over to the butcher's, cadge a strip of paper, grab a penny pencil and try to give you the impression that I'm a socially-conscious writer without a pot to plea in. The burden of my song will be that I've accidentally stumbled across some old gold in my back teeth, sold this bicuspid bonanza for a sawbuck and can up my bid to $60.

Now it is your turn to write a gracious little note, telling me to get the hell out of your life and let you alone. You're a busy man and I'm just another reason why you prefer Eskimos. "Give me one of God's Frozen People," you'll write, "rather than one of those warm-blooded, Southern Californicating hagglers." Oh, yes—here will be a postscript to the effect that in honor of Decoration Day, you're having a month-end special on book decorating— $100 for design only. Let the chiseler rout out his own cut.

I'll send you a polite answer, expressing my admiration for the manner in which you are committing artistic and financial hari kari. I will regret deeply the unbridgeable chasm between $60 and $100. Then I'll turn my framed copy of Captain Ahab, by Rockwell Kent, to the wall (lest he harpoon me instead of Moby Dick) and announce through clenched teeth that I can't possibly afford more than $65, that $70 is the most I'd ever go and that my final offer would never be a cent over $75.

Your soft Icelantic heart will melt at this and your secretary will send me a penny post card, informing me that if I send the money (no stamps please), Mr. Kent will try to knock off a bookplate for me some day when he wants to wind up bored in the evening.

If you're up to following the routine outlined above, I can guarantee the following results:

A. You will have wasted time and effort, which, if applied to something worthwhile, would have brought in several times the amount I am chaffering over.

B. I will have acquired four letters signed by Rockwell Kent, which would only mean that I'd have to buy four first editions by Rockwell Kent in which to tip these letters.

C. You will have formed a mental picture of me that would make you shudder, retch and go pale every time you thought of sitting down and drawing a bookplate for a slob like that.

D. After a decent lapse of time, I will take my check for $75, which you will have cashed, have facsimiles made of it and use them as my bookplates.

Competitive by nature, Kent delighted in matching wits with Levinson:

Your letter has set you back a bit in this game of give-and-take that we are playing. You not only say you are a writer, but prove it by the tears you wring from us.

For just as I am about to wire you prepaid, "Am shipping two bookplates, free," I pull myself together and say, "Look here! A fellow who can move me like this can move anybody else like I don't know what. Bundles for Britain, Food for Finns, Popcorn for Greeks, or Lucre for Levinsons, he is worth a dollar a word to any cause. Let his daughter go without orange juice. She probably doesn't like it anyhow. Let his wife go without stockings. Bare legs are even more beautiful. Let his uniformed chauffeur risk spilling gasoline on himself. It doesn't stain. I'm not going to be soft-hearted. And above all, I'm not going to let him get away with being munificent to a poor artist. He thinks he can give me $75, does he? Well, he can't. He can give me $40. That is, if he likes the bookplate when he sees it.

And what I'm going to do is this: I'm going to send you two or three practically finished bookplate drawings. I can do this because I happen to be making designs that are to be published and put on sale (in the best stationery and department stores) on which I will get a royalty and become very rich. Needless to say, the design that you pick will be yours and nobody else's.

I think I will be sending the designs within a week. I would send them sooner but I have to go to New York tomorrow to parade on May Day.

Levinson chose from the designs Kent was then developing for the Greenland Press.

From the four sketches, Levinson's choice was the image of a ship's figure-head, which he called "Ancient on Prow." He promptly mailed Kent a check for the agreed-upon forty dollars and enclosed his "prayer for the continued strength of your good right arm." One thousand bookplates were delivered in early September, but to Levinson's dismay, an *R* had been substituted for his middle initial *L*:

I tried to think of a middle name starting with R with the intention of fitting the bookplate, but the only one I cared about was "Rockwell." It has a fine Anglo-Saxon ring to it which I admire greatly, yet I fear that it clashes with "Levinson."

It seems that I was named after two grandfathers, one a Leonard and one

a Louis. Should I neglect one, all of the fine Hebraic wrath of that particular tribe of forefathers would descend on my puffy little head before you could say "Hitler is a Bastard!"

I know how you feel right now, but don't take it too hard. I have had novels, plays, short stories, cartoons and even a dictionary flung back in my face. You're only having a bookplate rejected.

Levinson left *The Great Gildersleeve* at the end of its first season. He continued to write for radio and, in the 1950s, television. A humorist in the tradition of Mark Twain, he authored *The Left-Handed Dictionary, Bartlett's Unfamiliar Quotations* and *Webster's Unafraid Dictionary.* He combined humor with his hearty love of food in six cookbooks, including *The Eating Rich Cookbook* and *The High Calorie Cookbook.*

Kent admitted that the mistake was his and not only refunded Levinson's forty dollars but also paid for Colish to print the corrected bookplates. But their give-and-take continued: Levinson destroyed Kent's refund check, and Kent suggested that he save the original set of bookplates and "beget a son and name him Leonard Rockwell Levinson."

An inquiry from Gregory Desjardins of Cincinnati prompted Kent to invite the young man to visit his farm in the autumn of 1941. One of the few bookplate clients that Kent ever met face to face, Desjardins promised "to wear shoes and not chew tobacco at Asgaard to heighten the chance of your liking me." He was employed by an industrial fuel equipment business and took pains to justify the artist's reduced fee:

> *At the risk of having to do some explaining to a patient, but cooperative, family, who have put up with lean years and a minimum of extra doodads, I am sure I can permit myself the luxury of a hundred dollars for this that would mean so much to me. And if I were to add that I am able to earmark this small sum for this purpose more easily because there is misery and suffering going on in the world (which makes business a little brisker through our office), there is at least this thought: we are all entitled to find as much selfish comfort as we can, even in today's world, and as the bookplate will be a lasting comfort to me, and as the money will have to go back to state and society in any event, it may as well detour through Au Sable Forks on the way.*

He proposed that the bookplate commemorate his French Canadian heritage and provided the artist with his paternal lineage from 1612. After receiving Kent's sketch, which included the lettered names and birthdates of his ancestors, Desjardins changed his mind: "Like almost everyone else in America, I am the confluence of so many diverse ancestral currents that the thing to do is to try to stand on one's own feet and make one's own independent way… Old Claude or Jean Baptiste might have been horse thieves for all I know, despite their pleasing French names." Kent's revised sketch suited him better. It showed a man in darkness, climbing a wall of books to reach the light

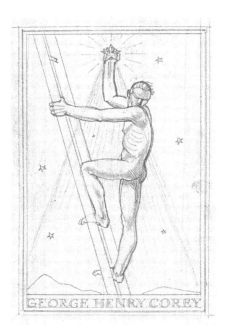

Sketch for a bookplate for George Henry Corey, 1941.
(Rare Book and Manuscript Library, Columbia University)

Bookplate for George Henry Corey, 1941.

Bookplate for Leonard L. Levinson, 1941.

The bookplate shown is from the original batch with Levinson's incorrect middle initial. Although Levinson made light of the error, he was unhappy with the typeface Kent had chosen and cajoled him into hand lettering the corrected version.

Bookplate for Gregory Desjardins, 1941.

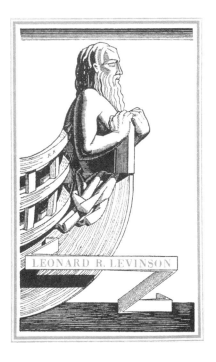

*Bookplate for
Arthur M. Rosenbloom,
1942.*

It recalls one of the
commercial bookplates
that Kent had designed
for the Greenland Press
six months earlier.

*Bookplate for
Henry S. Borneman,
1942.*

It suggests Kent's 1928
lithograph *Waldo Peirce.*

*Revised sketch for a
bookplate for
Marie Luise Hinrichs,
1942.*
*(Rare Book and Manuscript
Library, Columbia University)*

*Bookplate for
Marie Luise Hinrichs,
1942.*

beyond it. To Desjardins, it expressed "the eternal optimism of life," and Kent completed the drawing in October, before launching forth on another speaking tour.

HE HAD FORSWORN THE LECTURE CIRCUIT AFTER 1936, BUT THE FINANCIAL rewards of "barnstorming" were undeniable and, in 1941, irresistible. With "Art and Democracy" as his topic, he and Sally began a cross-country tour in October that would last through March 1942. He described Sally's experience as "a revelation of the vastness and splendor of the realm of which she had become a citizen," but she would recall

> *the grueling grind of trains and planes, state after state rolling by, speaking at a college in the morning, at a woman's club at lunch, on the local radio in the afternoon and at a lecture hall at night. Audiences that would coo over the lecturer and tell him that last week's lecture was good too and [that] they were looking forward to so-and-so next week, and invite him to an all-night party.*

On a holiday break from their travels, Kent accepted a bookplate commission from Harry A. Levinson. The New York bookseller described his client, Arthur M. Rosenbloom, as "about 37 years old, personally rather shy [with] tastes more on the quiet side." What Levinson knew best were Rosenbloom's reading habits and noted that he purchased philosophy and poetry, specifically William Blake, Keats, Shelley, Rossetti and Swinburne.

Before Kent got started with it, whatever images the list of poets might have conjured were dispelled by the December 7 bombing of Pearl Harbor. While war had raged throughout Europe, Kent had written in *This Is My Own:* "Here in America leave me and mine and all Americans at peace. Here and not elsewhere let us die...." His pacifist stance had put him at odds with friends like Louis Untermeyer, who, after one inflamed debate, wrote:

> *We have gone over this too often and too painfully. We stand at opposite extremes. We cannot convert each other. But there is no reason why we should irritate and anger each other. I propose, therefore, that we declare a "moratorium" on these differences. I propose that, when we meet, we refuse to badger each other with futile arguments and the likely consequences of personal rancor.*
>
> *If that is impossible, then I propose that we put our friendship in cold storage, so to speak. If we cannot meet without recriminations, let us not meet at all until the situation is clarified or even—if need be—until the war is*

over. This may be a drastic, and perhaps quixotic, way of preserving a relationship which is very dear to me, but I know of no other way. And it is a friendship I would like to preserve before it is destroyed by the times or our own emotions.

The advance of German troops on Russia had already shaken Kent's position on neutrality, and he grievously accepted the inevitability of his country going to war. The events of December 7 converted him.

One study for Rosenbloom's bookplate depicted a man holding the globe to his chest. Through bookplates Kent had often illustrated his fundamental belief "that the reading of books and the experience of art in general should lead to action; that we don't, properly, love books for art's sake, but for life's." In the final sketch, the earthbound reader looks upward, distracted from his book. It was mailed on December 13.

Life at Asgaard followed the daily routines and seasonal cycles of any farm. Whether Kent was there or not, hired hands had kept his cows pastured and their rich Jersey milk delivered to a wholesaler. After his relationship with the dealer abruptly ended, he found himself catapulted into "the pasteurizing, bottling and peddling of milk." From cow to customer, he and Sally would do it all. The war affected everyone, and Kent was no different. When he volunteered to do his part by designing civil defense posters, his offer was ignored by Uncle Sam:

> *Apparently, the only way an artist can serve his country now is by doing something else. My "something else" is milk production. To produce more milk I have had to enlarge my barn. To enlarge my barn I have had to accept every job that came along.*

In 1942, when Maxwell Steinhardt asked him to donate artwork for a benefit auction, he replied, "I will neither embarrass myself by offering my pictures for sale, nor offend good causes by donating worthless things. I'll have to try to be useful in other ways." It was a painful admission. That year, he met Hans Hinrichs, head of the Brewing Industries Foundation and a serious collector of his paintings. Hinrichs nurtured their growing friendship with adulation as well as cases of ale and German wines delivered to Asgaard and, in June, commissioned Kent to design a bookplate for his twenty-five-year-old daughter. Kent knew her by the nickname Putzie, from the German *putzig* for "tiny or cute." Because she was an aspiring aviatrix, he sketched a winged figure taking flight from an open book. It was an image that she found flattering, but unsuitable:

Kent's younger son, Gordon, had enlisted in the Army in July 1941. Although Rockwell had not condoned the idea, he recognized that his son's experience in Greenland and what he recalled of the Inuit language would prove useful to the war effort. Without having undergone basic training, Gordon was dispatched to Greenland as an "Arctic expert" and was there the day Pearl Harbor was bombed. Rockwell, speaking of the painting he titled *December Eight,* said, "The road that led out into a wider world has been open for generations, and youth has taken it; and more youth now in these days will take it. And many, because of what will happen to them, will never return." After serving four years in Greenland, Gordon returned, having risen in the ranks to technical sergeant and received the Soldiers Medal for Heroism.

There is more freedom in the figure than I deserve. I think that is my criticism more than anything else. It's a powerful drawing and its simplicity classic, but it's not Putzie. She is, unfortunately, still pretty earthbound in spite of her flying....Perhaps if you knew me better, I'd feel the sketch belonged to me, to the Putzie who loves Matt Arnold, Hardy and Browning, who adores people that are individuals, but not crowds, who loves the freedom of seals swimming and tries to grasp it when she's in her plane swooping through space, but yet all the time is such an ordinary, conventional person that there's always an inner conflict.

Missing, she said, were "the longing, the desires, the moodiness that is so much a part of me." Finally, she suggested that his drawing be revised to show her "sitting on the edge of the world," reaching for the unattainable. After a few weeks, Kent answered:

You have written me a very beautiful letter, and one that makes me want to make only such a bookplate design for you as will delight your heart.

 I have been doing so much rushing around lately, making speeches for war causes, that I am in rather a jam with my work. When I get a little decent leisure I will make some more sketches and send them to you. And I will read your letter again and again both for profit in what I have to do and pleasure in reading it.

In late July, he sent her two new sketches: "Please be just as frank about them as you were about the other. I won't attempt any sales talk about what they signify. It's what they signify to you that counts." She responded:

My bookplate is superb, Mr. Kent, and certainly reveals the genius that you are. It's me—it's what I wanted—and yet you hardly know me. Yours must be a very wise intuition!

 The one I like is the woman on the rocks. Where do you plan to put the ex libris part so as not to detract from the balance and strength of the sketch? Also, what should we say? "Ex libris" is to me almost trite and I am battling us: *the dignity of* Marie Luise *or my real name, though unfortunately I wasn't christened so,* Putzie. *I guess the former is to be preferred. I leave all this up to your judgment and taste, but as you work and finish up, will you take some of the haggard look from her face—though don't mistake me, I don't mean an expressionless Powers model look. These questions are petty, but I am* excited. *It's too good to be mine.*

Kent rejected the initial printing of one thousand bookplates, which distorted the figure's facial expression. Abe Colish agreed that the print job was unsatisfactory, owing to the paper he had chosen. He printed a new batch in time for Kent to present them as a Christmas gift.

A Philadelphia dealer in rare books and prints approached Kent with a bookplate commission for Henry S. Borneman, whom he described as "a booklover, mystic thinker and Mason":

> *The thought is that he would like to express in line the idea of the Seeing-Eye—God—the Everlasting Arms—Jehovah—All Power—reaching down to help man in his reaching up for cultural pursuits.*
>
> *It is a Blakeian theme, although most ideas he has found expressing the idea have been the opposite—man reaching up for the Eternal.*

Kent had reservations about interpreting "thoughts that are so definite and clear" in the client's mind, but he was nonetheless willing to attempt the commission. In the meantime, Borneman had refined his idea as an interpretation of William Blake's *The Ancient of Days,* a depiction of "God in the Heavens, compass in hand, bending over the nebulous world." Printed from a copper etching and painted with watercolor, it depicts the creator as an architect. An admirer of Blake, Kent replied that he would use that image "as a suggestion of the kind of symbolism your client has in mind," but would not incorporate it into his design.

The single sketch that the artist submitted showed the creator sheltering a child who has planted a tree. It was in keeping with Borneman's first suggestion, and he was delighted with it.

Dorothy Gillam, a young volunteer for the nonprofit American Committee for Russian War Relief, had helped with the arrangements for a speech Kent delivered in Reading, Pennsylvania, in June 1942. A month later, she wrote to him:

> *I have been very eager to give my father, one of the greatest book lovers of all time, a bookplate. And since he considers you the greatest bookplate designer living, I have long wanted to reach you. Only the fear that it would be way beyond my means has prevented my writing. But at least there is no harm in finding out!*
>
> *Exactly what design to suggest I'm not sure. Father's tastes are extremely conservative....Certainly the design or the inscription should suggest that books are his world.*
>
> *This may sound very silly to you, and I'm sure it's a completely unorthodox*

approach, but I don't know just what I should say. Perhaps I have given you some idea, anyway. And naturally, what I must know is the approximate costs for a completed plate, of about 1,000–1,500 copies. I hate to measure such beautiful art in terms of 'money,' but I'm sure you understand that for most of us workaday people it just can't be avoided.

Kent quickly replied that he would take the job "on any terms you like," insisting that she not pay him "one cent more than you can afford." She offered one hundred dollars on one condition: "I certainly realize that the amount I am able to pay does not begin to approach the value of a book-plate you would design, and I honestly hope that you feel free enough to— shall I say—withdraw? You wouldn't hurt my feelings in the the least, I assure you." Kent's commitment was steadfast: "I'll do nothing whatever to hurt your feelings and as little as possible to hurt your pocketbook."

Upon receiving the completed ink rendering, she confessed with great embarrassment that its youthful "woodland spirit" was not suitable for her father: "I just don't think my father ever was young… I have always known him to be a 'Victorian' gentleman, *extremely* conservative in all his tastes and opinions, quiet and gentle and charming, lovable, dignified and *very* old-fashioned. And deeply emotional." Kent promised to redo it, and in January 1943, she wrote to remind him of the project:

I wonder whether it might be possible for you to make the bookplate, or send the pencil sketch anyway, by my father's birthday, in March.

The main reason for my asking is that my father has been quite ill since Christmas, and his health is not likely to improve considerably. It seems necessary for him to give up his beloved library, or the major part of it this spring—and I should hate very much to see his precious books leave his possession after so many years, without at least bearing his mark. The bookplate would, I think, lessen the tragedy of it.

Apologizing for his delay, Kent wrote:

In spare times I have tried to think of a design that would fill the bill. I have spent a lot of time scribbling and have gotten nothing. It is very difficult for me to make myself think in Victorian terms.

Why don't you look at my bookplate books…and just tell me what kind of design would seem to you to be right. I want so much to do one that you will really like very much.

Dorothy Gillam then turned the matter over to her father. After perusing the designs in *The Bookplates & Marks of Rockwell Kent,* he wrote Kent that "one in particular appealed to me beyond words." It was not a bookplate at all, but the Random House trademark. Even so, it had fed Burns Gillam's imagination, and he described the bookplate that would suit him perfectly:

The late nineteenth-
century poet Sam
Walker Foss was well
known for his home-
spun verse. "House by
the Side of the Road"
was written in 1899.

Instantly there came to my mind Sam Walker Foss' humanistic poem "The House by the Side of the Road," in which are these lines: "Let me live in a house by the side of the road and be a friend to man." Your homely but artistic design [the Random House trademark] seems to epitomize the very spirit of the Foss verse. As I said, the type of architecture is not material. However my preference would be for an all-American colonial white-clapboard house showing character and substance such as to be found along New England highways. I picture it shaded by an American elm or maple. Seated beneath a window or under the tree is the master of the house in simple, rural garb of a man of means. He is reading a book and lying promisingly beside him are a number of books indicating a lust for books and reading. He is glancing around as though attracted by an approaching wayfarer....Please look upon the foregoing, Mr. Kent, as an old man's suggestions. I submit to your riper judgment in matters of this kind.

That was enough for Kent:

I like the line that you have quoted and I will make that my guide—my point of departure or of destination—in the sketches that I will send you. Don't be disappointed if, with the man reading, you don't get a whole elm tree or a whole house. These, in the compass of a bookplate, would dwarf the figure of the man to insignificance.

As soon as I am able to dispose of work with which I am occupied at the moment I'll make some sketches and send them to you. Then you must tell me quite frankly how you feel about them, for a bookplate, of all things must fit your spirit.

Kent's sketches reveal his affinity for the picture Gillam had unconsciously painted. After the client made his choice, Kent forwarded his ink drawing to A. Colish. "Send the bill to me," he said, "I am paying for it and am charging them a lump sum for the finished thing. They are not people of great means." By the time her father received his bookplates, Dorothy Gillam had enlisted in the Women's Army Auxiliary Corps, and for the

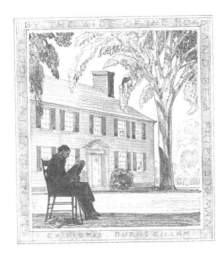

Original ink rendering for Burns Gillam bookplate, 1942.

It was rejected by Gillam's daughter, Dorothy, who felt that it was too youthful for her elderly father.

Sketch for a bookplate for Burns Gillam, 1943.
(Rare Book and Manuscript Library, Columbia University)

Bookplate for Burns Gillam, 1943.

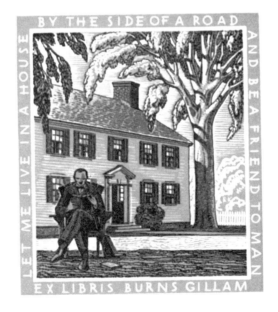

Bookplate for
Eleanor B. Church,
1945.

A faculty member at
the University of
New Hampshire, she
requested that the
design show a New
England church as a
play upon her surname.
Kent's design shows the
Old North Church in
Boston. Upon its
completion, he wished
her the "leisure to paste
the bookplates into the
books," adding, "with
my own library, I am
about a thousand books
behind."

Bookplate for
Martha B. Willson Day,
1945.

She was a painter
of miniatures in
Providence, Rhode
Island. Her bookplate
was based on a photo-
graph of the cabin
she had inherited in
Wyoming.

Bookplate for
Loring Pickering, 1946.

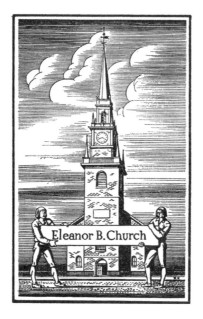

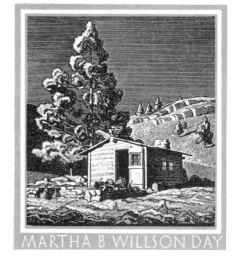

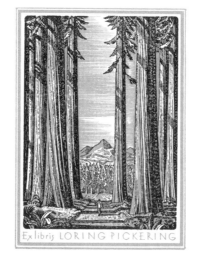

duration of the war, Kent received small checks from her until his fee was paid in full.

A LETTER FROM LORING PICKERING IN JULY 1946 REMINDED KENT OF THEIR "cocktail acquaintance" in Manhattan in the 1920s when Pickering ran the North American Newspaper Alliance. "I invoke this acquaintanceship now," he wrote, "to ask if you will design me a bookplate, and, if you will, what it should cost." The son of Loring Pickering, Sr., who had owned the *San Francisco Call,* he was living in Woodside, California:

> *If you care to undertake the thing, you will want some leads I should think. I live in the hills of the San Francisco peninsula; have done some shooting in Africa and Asia; was a colonel on Arnold's staff. This place,* Todos Bancos, *got its name because it was hopefully acquired via three mortgages. I also have some old Pickering bookplates, all heraldic.*
>
> *Should the job bore the hell out of you, just forget it, but as an old boot-legger, give me a ring if you find yourself near here.*

Kent responded, "Shooting in Africa or Asia? Do you want yourself a Nazi or a lion?" Pickering offered a suggestion:

> *Perhaps an open road might get across the things I like; and if you have seen it, a bit of the Redwood Empire road as it flows between the mountains and the California redwoods would give the idea both of freedom and the gothic. But choose your road, or chuck that idea if you don't like it.*

During the 1941–42 lecture tour, Rockwell and Sally had spent several weeks in Northern California; the sketch he sent Pickering recalled their visit. It showed a minute figure dwarfed by towering redwoods, to which Pickering playfully responded: "Can you make the little guy in the middle of the road walk away, not exuberantly, but with a slight suggestion of his chin up?" Kent recommended the Grabhorn Press in San Francisco, "one of the best printers in America," to complete the job.

Sara Kent had continued to live in her grand house in Tarrytown, and at age ninety-one, she was as charming and energetic as ever. "It was only in this last phase of her life that Rockwell respected his mother," Carl Zigrosser said. "She was very forthright in her opinions, and was the only one in the family who was able to stand up to Rockwell in argument." When Tarrytown's Warner Library inquired about a bookplate design in April, he replied

that he would make it as a gift from Sara, but warned that he was over-whelmed with other commissions. In July, the library wrote to inquire about his progress and noted their increasing need for the bookplate: "We are receiving right now requests from parents and friends of boys who gave their lives in the last war, for books suitable for memorials."

Kent's design, completed in October, depicted a young man, presumably the artist himself, on a hillside overlooking Tarrytown and the Hudson River's Tappan Zee. He talked the library board out of adding the words *in memory of* and provided a space in which sentiments could be handwritten. It was not until June 1947 that Abe Colish printed the two thousand book-plates. As the artist had instructed, they were delivered to Sara Kent, which allowed her to present them to the library—and take note that it was signed with her initials as well as her son's. Within a few months she died.

WRITING TO KENT IN MARCH 1947, ELMER ADLER SAID: "BY THE WAY, THE BOY for whom you made a bookplate, Bish Tatum, now is back from the war." He had come home to an America seasoned by war, empowered and redefined by its role in reshaping the world. Like Tatum and the other returning GIs, the sixty-five-year-old dairy farmer was ready to get back to work. Brimming with the energy of a young man, he presented an idea to Random House for *"the* final-for-all-time, triple-x, super *Robinson Crusoe* for young and old," but Bennett Cerf explained that there was no market for old-style illustrated books in postwar America. The harmless proposals he made elsewhere—an illustrated Bible and a series of paintings of the American landscape—would be squashed by his lingering identity with left-ist causes. Change was in the wind, however, and Kent was optimistic that the military defeat of fascism would make socialist principles acceptable to voters. He placed his hopes in Henry Wallace.

Wallace had served the Roosevelt administration as secretary of agriculture and vice president, then joined the newly organized Progressive Party after the war. In the upcoming presidential election, he would be its candidate. His idealism rooted in Christian morality, Wallace advocated social reforms as well as an international peacekeeping authority and world court to prevent any one country's domination in the postwar era. He also urged friendship with the Soviet Union. Kent not only endorsed Wallace but, having flirted with politics most of his adult life, became a candidate for Congress himself.

ADLER'S YOUNG COUSIN, ANNE COLEN, COMMISSIONED KENT TO CREATE A bookplate in November 1947. It was to be a birthday gift for her husband,

and he particularly liked the one the artist had made for Adler:

> *Would it be possible to do some sort of variation of that? He'd like his name on it—Bruce David Colen—but no other writing. In describing it, he said he wanted a plate with strength, dignity and simplicity. This makes him sound like sort of a stuffy bastard, which he isn't at all. But he felt you had put all those qualities into your design for Elmer.*
>
> *As I'm expecting a baby at any moment, I thought that would be enough of a present for Bruce, but he remarked, and I supposed rightly, that the baby would look pretty silly pasted in the front of a first-edition Joyce.*

In addition to their first editions, the Colens owned Barley Sheaf Farm, once the estate of playwright George S. Kaufman. Even so, Kent's "pre-inflation charge" startled Mrs. Colen. "I hereby lop $50 off the price," Kent responded, "and promise myself that I will do my best to add more than $50 in quality to the design." His sketch arrived in time for Colen's birthday on New Year's Day 1948. Anne Colen sent her husband's suggestions to Kent later that month:

> *The first is that you take out the background material, the table and piled up reams, and leave it perfectly plain; the second: that the straight press leg be moved so it doesn't come up right between the poor printer's legs. Do you think it looks slightly awkward?*
>
> *As yet the baby has not arrived—it's taking forever and when the time comes I fully expect to see a small boy and his dog. Again, thanks—and a happy new year to you.*

Kent replied: "If it is not too late, I suggest that the baby make his first appearance on skis, as appropriate to the season and your own high spirits." When Beatrice Colen was born a few weeks later, he wrote to her:

> *It was a great pleasure to receive the announcement of your coming out party, and I hasten to be among the first to welcome you into this old world of ours.... We have hopes of installing Mr. Wallace as Manager next fall and getting in such apple pie order that when you come to know the world you will find it an altogether delightful place. I wish you a long and happy life.*

For the first sketch, Kent had used his own handpress as the model, just as he had for Adler's bookplate. His revision showed a wooden press, which was

Kaufman referred to his 1740 farmhouse in the Buck's County hamlet of Holicong as "Cherchez la Farm."

Adler arranged the commission, which Kent accepted with reluctance: "I make plenty of designs for nothing and a good many for less than $250. But it doesn't seem that I should charge less than my top price to someone who has presumably much more money than I have…"

Afterward, he wrote to Adler: "I have done the bookplate for Mrs. Colen; and I have had the most delightful letters from her. They seem to be wonderful people. I thought they were just people who wanted a bookplate. You gave me no idea that they particularly wanted a design by me."

more appropriate to the operator's period attire. In March, he was ready to begin the final ink drawing. It would be printed by Colish, but Kent confessed, "Since Elmer quit printing we have no one upon whom we can *absolutely* depend to do things beautifully. Elmer would always take the trouble. We can't be sure others will."

By then, Asgaard Dairy had become a thriving operation; what Kent's Jersey cows could not produce in quantity they made up for in quality. In April, he learned a hard lesson from mixing enterprise with politics. His vocal support of Henry Wallace—as well as his having "Vote for Wallace" printed on the backs of the milk-bottle caps—resulted in a boycott of Asgaard Dairy products, what his customers had taken to calling "Russian milk." Two of Kent's employees had stood by him through the boycott, and in order to save the business, he sold it to them for one dollar.

Distracted by the election, it was August before Kent was able to complete the Colen bookplate. To a letter of apology, he added:

> *Although I can think of nothing worse than going to Washington, I am working as hard as I can to get there. Actually, there's no chance of it. I am only in the race in order to be of greater help to the Wallace movement up here. My greatest need is funds. I know you people are not rich, but if you know of right-hearted plutocrats, for heaven's sake incline them to lend a hand to a hard working Progressive candidate. We are managing to raise funds for the district committee by raffling prints of mine. They have been fetching up to $140 apiece.*

Regardless of his expectations, Kent was an active candidate, and the cost of running a grass-roots campaign had come as a jolt. Numerous letters were mailed to friends outside his congressional district, appealing for contributions to help pay for the thirty thousand pamphlets mailed to voters. His appearances were orchestrated to attract attention—from a farmers' picnic, complete with entertainment, to a speaking event that included a concert by his friend Paul Robeson.

To help finance the campaign, Kent accepted a lucrative commission from Arthur Wiesenberger, who headed a Wall Street investment firm. Each year Wiesenberger published a book on trusts, which was distributed to various subsidiaries, and needed a bookplate for the 1948 edition: "The usual ex libris format should be followed with a blank space at the bottom where a

*Bookplate for
Bruce David Colen,
1948.*

*Bookplate for
Arthur Wiesenberger,
"Security," 1948.*

A financier and art
collector, Wiesenberger
was acquainted with
Kent through their
mutual friends. The
bookplate he commis-
sioned was pasted in
the 1948 edition of his
company's yearbook,
Investment Companies,
which has been pub-
lished continuously
since 1941.

*Memorial bookplate
for the Warner Library,
1947.*

dealer firm could have its name and address added by a local printer." Kent's Wall Street experience had been disastrous, but, with the absence of income from the dairy, he could hardly afford to pass up a commission:

> *You know from having tried to think of an idea to symbolize investment companies that they don't come trooping along. I am rushing off herewith two sketches—pretty rough. One, a man at the forge is beating together into one strong, iron bar a whole lot of separate, bent and twisted strips of iron. The other one is a mountain climber made secure in attempting the heights by a rope leading to the next man above and securing the man below him by another rope. It seems to me that both thoughts are inherent in the plan of investment companies and that either would make an effective design.*

Although Wiesenberger saw promise in the idea of the blacksmith, he believed its message would prove too symbolic. Furthermore, he feared the climbers might imply that the stock market was always on the ascent:

> *Some of the important points we would like to stress are the benefits of diversification, competent investment management, dependability of the investments, security of income, and the economic justification of investment trusts in our economy. Of course, this virtually gets us into so many subjects that you may have to do a mural to put over the complete idea.*

He enclosed a photograph of Diego Rivera's mural for the San Francisco Stock Exchange as an example of how another artist had depicted the investment business. But when Kent was not forthcoming with a second design, Wiesenberger sketched what he conceded was "a very corny presentation" of what he called "the four pillars of financial security." Without putting up an argument, Kent prepared an ink drawing that won his client's approval.

Kent had specified two colors, but the proof he received indicated that Wiesenberger had ordered Colish to increase the coverage of the brown second color and requested a much darker ink. Attempts to correct the obvious problems only led to what Kent called "inexcusable" mistakes by the printer. By the time the seven thousand bookplates were printed, without his approval, Kent was too focused on the approaching election day to care.

The elections of 1948 are best remembered for the overnight turnaround that returned Harry Truman to office. Henry Wallace failed to carry a single state, and Rockwell Kent won two percent of the votes cast for congressman in the thirty-third district.

Ten / Good Intentions and Hard Work

The Commercial Bookplates

WITH AMERICANS READING THEIR WAY THROUGH THE GREAT DEPRESSION, personal bookplates became popular to the point of becoming a fad. *American Home* and *Country Life* magazines touted them as a sophisticated indulgence; schoolchildren were instructed in making their own during the annual Good Book Week; and for do-it-yourselfers, *Popular Mechanics* provided step-by-step instructions in its "Blueprint Your Bookplates by Photography." Other magazines devoted pages to mottoes and rhymes as an alternative to the traditional "ex libris." But it was the ready-made variety offered by most booksellers and stationers that made sophistication easy and inexpensive to come by. In the forties and fifties, Kent would design three collections of bookplates for mass production.

In 1940, Manuel (Manny) and Gertrude Greenwald approached him with the idea of creating fine stationery from his pen-and-ink drawings. Kent, who was probably acquainted with the couple through their involvement in organizing labor unions in Pittsburgh, suggested that personalized bookplates, custom printed with the owner's name, would be more successful. Although it was clear to Manny that there would be a greater market for stationery, he took up the bookplate idea in earnest. Selecting two drawings from *Rockwellkentiana*—the Helen Lowry bookplate and his 1933 wood engraving titled *Reader*—he had a local printer make samples. Kent was pleased with the quality and gave Manny the go-ahead.

The Greenwalds christened their fledgling business the Greenland Press in May 1941. It not only saluted Kent's Arctic exploits but also made subtle reference to their surname. (One year later, they would name their newborn son Michael Rockwell Greenwald.) After visiting the Pittsburgh book and stationery stores where bookplates were typically sold, Manny determined that the subject matter of the Greenland Press bookplates would be far less significant than the "Kentian quality" that would distinguish them from everything else in the marketplace. Kent's signature, prominently printed on each one, would promote their prestige.

The popularity of bookplates would continue through the 1940s, despite the emergence of the paperback in 1939.

By July, a collection of thirteen designs was assembled. In addition to the two trial bookplates, it included five designs that Kent had originally created for friends with whom he had lost touch: Katherine Abbott, Merle Armitage, the anonymous H. C., Gerald Kelly and A. C. Rasmussen. Of the remainder, three were completed from sketches for earlier commissions and three were original. From the latter, the Greenwalds chose his depiction of a boy releasing a dove for the company letterhead.

Signing one of his letters to Manny "yours for a million dollars," Kent could barely contain his optimism: "The whole enterprise seems to me to promise to be a big success. I suppose we ought both to prepare to abandon the labor movement and take our proper and well-earned place among the ranks of the leading American capitalists."

Adept at marketing, Manny had the artist compose an introduction to his wholesale catalogue. Writing quickly, Kent strained to make it "amusing enough to invite reading":

> *To those of us who borrow other people's books and then forget about returning them, to those—not of us—who* take *other people's books and never mean to return them, bookplates—other people's—are a nuisance. They're a nuisance to the* borrower *because there in that friend's bookplate, staring out at him every time he opens the book, is a visual rebuke to his procrastination and reproach to his conscience. And they're a nuisance to the* taker *because it's troublesome to steam a bookplate out. To many people, therefore, other people's bookplates are a nuisance; and to all people who love and honor and possess books, bookplates—their own—are, for the very reason that they trouble others, a blessing.*
>
> *And for other reasons and to other people are they, or can they be, a blessing: To those who are in no sense book collectors, who have never realized that good books like good friends ought to be kept, the mere possession of a personal bookplate will be an invitation to acquire good books to paste them into, and a stimulant to pride in ownership. It is for them that bookplates are designed.*
>
> *Maybe youngsters respond most readily to that subtle salesmanship of the idea of owning books which the possession of a bookplate practices. If that is so, then bookplates are for them. For one must first like books in general to come to learn at last which books are good. And from good books there is so infinitely much to be gotten that one can't start to read and treasure them too soon.*
>
> *Let's call it settled then: all people should have bookplates. But where and*

Bookplates for the
Greenland Press, 1941.
(Clockwise from top left)

Style A
An original design
for the Greenland Press,
it demonstrates the
weighty, sculptural
quality of Kent's figure
drawing of this period.

Style C
The Greenwalds
chose this original
design to use as their
Greenland Press
letterhead.

Style D
It was completed from
a sketch for the Donald
Snedden memorial
bookplate (1938).

Style E
The bookplate Kent
made for Helen Lowry
in 1928 was slightly
revised for this design.
The wife of his attorney,
Philip Lowry, she owned
the English Book Shop
in Manhattan. She
staged an exhibition of
Kent's bookplate draw-
ings there in late 1930.

Bookplates for the
Greenland Press, 1941.
(Clockwise from top left)

Style F

Designed for Gilbert
H. Doane, it had not
been published. In the
original sketch, the
charioteers are nude.

Style H

Six months later, Kent
would design a similar
bookplate for Arthur
M. Rosenbloom.

Style K

It reproduces Kent's
1933 wood engraving
Reader.

Style L

Originally designed for
Ruth Porter Sackett
but never published, it
depicts Artemis, virgin
goddess of the hunt.

The remaining five
designs were printed from
bookplates that had been
previously published.

how to get them is another matter. The best way by all odds is to pick a good designer; confide to him as data the story of your life, your likes, your aspirations. And for the hundreds of dollars which it may cost, commission him to design a bookplate that shall be yours alone. That is the best way to get a bookplate. And the next best way—a very good way too—is to get one ready made.

Even before the catalogue was in print, Manny received a hundred inquiries from retailers and orders from the three major New York booksellers: Dutton's, Scribner's and Brentano's. But his triumph was the news that Tiffany & Co. would sell them, marking the first time the Fifth Avenue firm had offered ready-made bookplates. With the approach of the holidays, it was an auspicious beginning.

One of the stationers Manny met had shown him an advertisement for bookplates that were "a particularly crude imitation" of Kent's. In passing it on to the artist, he wrote, "Dan Burne Jones, it seems, specializes in drawings in the Kent manner and these are sold by a little firm in Ohio which is not discriminating either in its designs or reproductions." In addition to being an artist, Jones was a collector of Kent's printed work, and when the Greenland Press bookplates were finally in print, he wrote to Manny and requested samples. He also offered to sell him the distribution rights to a bookplate he had designed specifically for collectors of Kent's books, one that reproduced the artist's self-portrait. Advised of all this, Rockwell replied:

I have been aware of this fellow Dan Burne Jones for years. He is apparently a genuine, unashamed worshipper of everything I do. That art should be like that, he takes for granted—and even sends me examples of his plagiaristic designs so that I can see that he too is getting to be an artist. He will only…be a great success when he has made a picture that nobody can tell was not made by me.

I think that as my publisher you might write to the Antioch concern and give them a piece of your mind. It probably won't do any good, however, for I think they're probably a bunch of racketeers.

Rather than contact the Antioch Bookplate Co., Greenwald wrote to Jones, warning him of the consequences of his blatant infringement on Kent's copyright. Sally Kent appreciated his taking a strong stand, noting that her husband had "always been soft-hearted about him for some reason." That seemed to resolve the Dan Burne Jones problem.

In October 1941, the first Greenland Press bookplates were delivered to

stores, timed to take advantage of holiday gift buying. But three weeks before Christmas, Pearl Harbor was bombed. Kent's first royalty check, issued in January 1942, totaled $36.86. Manny attributed their failure to the inconsistency in retail pricing, which ranged from three dollars to five dollars per hundred, and noted that blank bookplates had fared best. (Customers were apparently unwilling to wait for a name to be printed.) He also suggested that the high-quality paper and printing the artist had insisted on were irrelevant. Those designs most characteristic of his book illustrations had sold best. Undeterred by such a poor showing, Kent confessed that "checks for $50 loom as big on the horizon of the Kents these days as $500 checks once did." To ease Manny's disappointment, he wrote, "My only feeling is one of great appreciation of how hard you have worked to make this bookplate business a success and a sort of indignation that good intentions and hard work should have failed to bring you their due reward." Manny suggested that he create a few more designs, but Kent offered a better idea: a line of stationery embellished with the letter *V* for victory.

In the face of war and its impact on the economy, Manny doubled his efforts to promote the bookplates to department stores. As he predicted, sales and profits increased when they were sold blank, by the box. But in September 1943, Manny, "having been found sound in body and mind although slightly abnormal on the political side," was inducted into the Army, leaving his wife to manage the Greenland Press. Gertrude Greenwald, despite having a one-year-old to care for, was as capable and dedicated to the business as Manny. Sending Kent a royalty check for five hundred dollars in November, she noted her "pride in knowing we have made a success in this venture…The Greenland Press continues!"

As the war progressed, Manny's unit joined the mounting offensive in England, France, Belgium and, finally, Germany, while Gertrude defended the Greenland Press. Ernest Morgan of the Antioch Bookplate Co. was making overtures to Kent: "In order to get eight designs which would meet with public approval, it would probably be necessary to prepare ten in all and eliminate the two least popular items as experience indicated." Still believing Morgan's business to be "a bunch of racketeers" and citing his business relationship with the Greenwalds, the artist not only declined but also complained about their publishing Dan Burne Jones' takeoffs on his work. In response, Morgan expressed his viewpoint on the imitative nature of art:

I think that most art, often the finest, grows out of other art, and that the really creative artist, who starts, or releases, new currents, as you and Disney

have done, is rare. If history counts you as a great artist, it is more likely to be through the scores of Dan Joneses whom you have challenged and inspired than through your own actual work, excellent though it is.

Morgan then wrote to Gertrude with two proposals: that the Greenland Press sell Antioch their rights to the thirteen bookplates already in print, or that the Greenwalds accept payment to relinquish their exclusive rights to Kent's future work. Her response was an unequivocal no. Morgan's determination apparently knew no limit, and he continued to court the artist. In February 1945, he wrote:

Knowing of your concern with social and economical problems, I think you will be interested in the way we run our business. We have always regarded it as a social venture, and in the early years it was the center of much liberal and radical political activity.

Later we ventured into race relations, building a staff of Jews, Negroes, Orientals and "ordinary white folks." The results are very satisfactory. We took over the local newspaper and carried our ideas into print. The community even accepted a Negro as Society Editor.

Manny came home from the war brimming with ideas for expanding his business. He encouraged Rockwell to design more bookplates, but when nothing was forthcoming by 1947, he expanded his catalogue with the work of other artists, in order "to accommodate those book lovers who want dogs or ships or flowers in their bookplates." By the time Kent volunteered to design a new series, Manny wrote, "I must confess that the returns for this labor are not in balance. We continue to sell bookplates but each day brings new evidence of how limited is the field. It just cannot be an operation of much magnitude."

After two decades of hardship, America was facing an era of prosperity and comfort, dominated by an aspiring, youthful middle class. In response, the Greenland Press became Greenland Studios, a mail-order enterprise offering such "personal accessories for gracious living and giving" as paper napkins printed with beverage toasts in foreign languages. In November 1948, Manny wrote to Kent and proposed that he design a set of glassware decorated to suggest the four seasons. Enclosed was a copy of the Greenland Studios catalogue. "We were somewhat disappointed in the character of your offerings," Kent admitted, "feeling that the majority of them were not sufficiently distinctive to win your enterprise the attention and eventual prestige

that you would certainly welcome." Even so, Kent remained loyal to Manny's dreams. He agreed to design the glassware and also suggested a line of china to go with it. When his ideas proved more upscale and impracticable than the simple party glasses Manny had in mind, the idea was quietly forgotten.

Early in 1950, Manny notified the artist that they had discontinued his bookplates and were in discussion with Ernest Morgan about transferring the remaining stock to the Antioch Bookplate Co. A year later, Manny and Gertrude would open a shop in Pittsburgh, which she described as "one of those ultra, ultra swank gift shops where Madam comes visitin' with her poodle to pick up a bit of a gift…"

THE BOOK OF THE MONTH CLUB AND THE LITERARY GUILD OF AMERICA, both founded in 1926, offered their subscribers inexpensive editions of current books. From the beginning, the two organizations had been locked in head-to-head competition for the bestselling authors and titles, as well as for those readers who were most likely to start a new book every thirty days. The Book of the Month Club was fortunate in hiring Kent to design its subscription prospectus in 1936, but two years later, he was too busy to design a bookplate for its members. In 1942, he designed the logo for the Literary Guild and permitted them to issue prints of his wood engraving *Girl on Cliff* (1930) as a membership recruitment incentive.

When it became clear to Kent that the Greenland Press had lost interest in bookplates, he agreed to design a collection that the Guild would sell to its members. From his sketches, the club's executives chose four designs to be produced in two colors with "the artist's facsimile signature" and the owner's name printed free of charge. A brochure mailed to its membership announced that "your book club, through a special arrangement with Mr. Kent, is delighted to make available to you four exclusive designs at an almost unbelievably low price—only $4.00 for one hundred." The accompanying biographical note rang with hyperbole:

> *His approach to art is consistent with a philosophy which holds that art must be a widening social force and that the artist, to be understood, must address himself to the people as simply and directly as he would talk to a friend. In one branch of art, Mr. Kent stands alone. His superb craftsmanship in creating pen and ink drawings, his woodcuts, lithographs and copper etchings stand unequalled. Critics have acclaimed his work superior to many of the old masters.*

Kent was already an experienced designer of dinnerware, having designed three patterns for the Vernon Kilns (1938–40).

ROSE FOSTER

JOAN WATSON

Bookplates for the Literary Guild of America, 1947.

Style A
The image is similar to his wood engravings *Girl on Cliff* (1930) and *Mountain Climber* (1933).

Style B
Kent took the image from his oil portrait *Sally* (1944–49).

Style C
Flower and open book.

Style D
Standing woman.

MARION BERNIECE HUDSON

VIRGINIA K. MORSE

In 1949, after Kent had given away his Asgaard Dairy and lost an expensive election, he wrote to the Literary Guild with another idea for marketing his work to its members:

> *Over the years I have been honored, or pestered, with requests from people here and there and everywhere for prints of my wood blocks large enough to be suitable for framing. I have occasionally recommended that enlarged photostats be made of them. One such enlargement—enlarged about six times—hangs where I can occasionally see it in our local doctor's office. It looks swell.*

He proposed an exclusive portfolio of twenty-five of these enlarged prints. The Guild's response was prompt and curt: "We feel that the comparative lack of success with the bookplate offer a couple of years ago, and the lack of success with an art offer, indicates that a portfolio of prints such as you suggest would not be at all likely to be successful with Guild members."

ERNEST MORGAN WAS A COLLEGE STUDENT WHEN HE STARTED PRINTING bookplates from cast-off paper in the campus print shop in 1926. Within a decade, the Antioch Bookplate Co., named for his alma mater, had become a prominent manufacturer of bookplates. As an apprentice printer, Morgan had helped with the production of several of Kent's books. "It was a bit ironical," he said, "that for seventeen years we looked forward to the day when [Antioch Bookplate] would have sufficient distribution and financial strength to justify us in approaching Mr. Kent." When that day arrived, he was too late; little Greenland Press had prevailed. But, in April 1950, after acquiring the Greenwalds' stock, Morgan wrote to Kent:

> *Our bookplate sales, like Greenwald's, have declined sharply in the last few years, and we feel certain that the prompt addition of an attractive Rockwell Kent assortment will substantially strengthen our line. But this cannot be accomplished with an assortment that has been in front of the dealers for five or ten years. Hence a new crop, preferably of eight designs, is called for.*

The Greenland Press bookplates had been printed in a variety of shapes and sizes, all much larger than Kent's custom designs. As a result, production costs were high and profitability limited. Morgan wisely specified a single format. He offered Kent five hundred dollars for the eight designs, an amount equal to the artist's fees for two individual bookplate commissions, plus a royalty. It would provide only a modest income, but Kent agreed

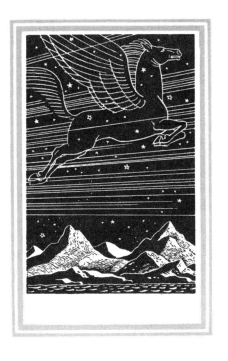

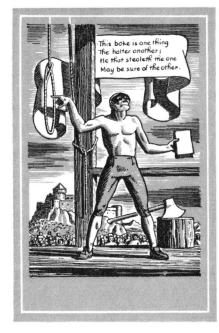

*Bookplates for the
Antioch Bookplate Co.,
1950.*

Style 7Y-51
Pegasus

Style 7Y-52
*This boke is one thing
The halter another;
He that stealeth the one
May be sure of the other.*
The source of the text
is unknown.

Style 7Y-53
Seated Man

Style 7Y-54
Derived from the
bookplate designed
for Katharine Brush,
it shows the nude
figure from behind,
which would have
been more acceptable
for a commercial
bookplate in 1950.

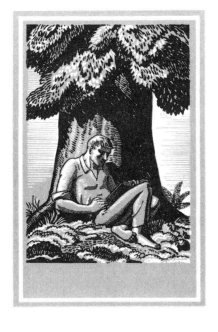

Bookplates for the Antioch Bookplate Co., 1950.

Style 7Y-55

Its design was based on Kent's most recent bookplate, which was for the public library in Bangor, Maine.

Style 7Y-56

Having lost touch with Pauline Lord, Kent adapted her bookplate to fit the Antioch format. She died later that year.

Style 7Y-57

…this our life, exempt from public haunt, Finds tongues in trees, books in the running brooks, Sermons in stone and good in every thing.

From Shakespeare's *As You Like It.*

Style 7Y-58

The bookplate Kent had made for Anne Rosenberg in 1927 was slightly revised to meet the Antioch quota. Reproduced from one of the sixty Alaska drawings of 1919, it was a view of Resurrection Bay.

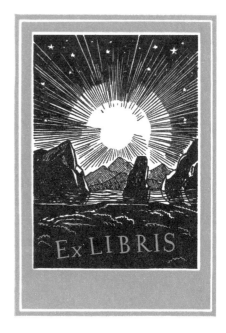

to most of Morgan's terms: "The only concession I ask is not to submit sketches. I think I have a clear enough understanding of the type of design that you believe will sell to go ahead and make the finished drawings without consultation. This will make it much easier for me to get the designs done before July 1st."

Given the six weeks Kent had to design eight bookplates, Morgan agreed to accept whatever the artist designed. Without the time-consuming burden of approval, he completed them in three weeks, modifying three designs from previous commissions. Pauline Lord had disappeared from the limelight, and he adapted the actress figure from her bookplate to the Antioch format; another was a version of his recent design for the Bangor Public Library; and his Anne Rosenberg bookplate was reworked with added detail.

They were printed on gummed paper, of which Kent disapproved, and a set of one hundred with the owner's name imprinted sold for four dollars. In August 1951, Morgan was able to report to Kent that his bookplates were "working out very nicely," although there was little demand for several of the collection. "Under these circumstances," he continued, "the correct business procedure is to ask you to make some new designs." Kent, who was then under increasing scrutiny for his divergent political views, responded:

> *The public is composed of many different categories of people, with one or two categories predominating and the others constituting what are termed minorities.…If I were you, I would not disregard the minority taste among your customers but continue to offer them designs which are distinctly different from those that are proven to have the greatest mass appeal. By withdrawing those "different" designs you wouldn't necessarily force their prospective buyers into buying the more popular. They simply wouldn't buy what* you *have to offer. Just as, if I can't find the kind of book I want on the publisher's list, I turn to another. I am not going to be forced into buying a* Gone with the Wind *just because the publisher doesn't happen to have published a book on sociology that I am looking for.*

He was, however, receptive to Morgan's idea of a feminine counterpart to the man reading under a tree. When the bookplate publisher replied with a treatise on merchandising and what he called "cultural morality," Kent ignored his letter. In December 1952, Morgan wrote that he still needed the bookplate suitable for women and saw the need for another that a married couple could share. One year later, after Kent had failed to provide the two new bookplates, Morgan wrote a letter calculated to get the artist's attention:

Obviously we can't ask you to spend much time on new designs—especially in view of the modest financial return. What I propose is that we work out a few ideas, conceived in terms of your style and techniques, and then submit these to you in sketch form. (Perhaps Dan Jones would help me with this.) If some layouts appeal to you, then you can quickly render them in your own style.

After Christmas, Kent finally wrote that he was immersed in writing and illustrating his autobiography, but promised to get to the two new designs as soon as possible. He also made clear his objections to working from another artist's sketches: "I have all my life leaped over backwards to try and have what I have done stem from myself alone."

After a five-year wait, Morgan received the two new designs in January 1956, and they seemed to live up to his long-suffering expectations. That same month Kent learned that Antioch had sold what remained of his Greenland Press bookplates to Marboro, a discount bookseller, and proceeded to reprimand Morgan: "It is the first time in all my life that anything of mine has gone onto the bargain counter. I would have done everything possible to have prevented this." Morgan's explanation, that Marboro was actually *giving* them to customers who purchased a book, did nothing to soothe Kent's disappointment.

The last two bookplates were added to the Antioch catalogue in early 1957, but in January 1958, Morgan wrote to Kent about his woman reading under a tree:

Most of the designs which you have done for us have sold quite well and we have been very happy about them. This design unfortunately has been an outstanding exception. None of us here at the office liked it when it came in, but we took the attitude that someone else might like it and I suspect also that we allowed ourselves to be unduly influenced by the esteem in which we held the artist.

Up to the present time, we have sold, I think, two boxes of this design. An item could be more dead than this—but not much! I still think that the design itself is basically sound. I think the trouble is with the girl: the pose, the dress, and the face.

Kent's annual royalty was based on the number of bookplates cut and readied for selling, not on the actual number sold.

He asked the artist to "make a fresh go at [it]," and within a few weeks, Kent revised the design to his satisfaction.

Although Kent often suggested that he might design other bookplates for Antioch, he never did. His annual royalty of $10.47 per 16,000 bookplates

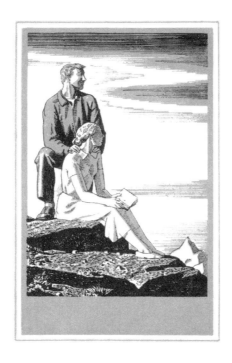

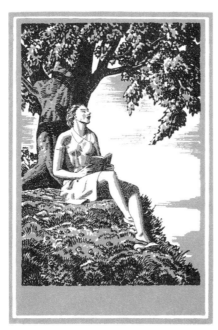

Bookplates for the
Antioch Bookplate Co.,
1957–58.

Style 7Y-59 Couple

Style 7Y-50 Woman
This is the only version
found in the archives
of Antioch Publishing.
It is presumably Kent's
second effort.

provided a steady annual income of several hundred dollars for fourteen years until sales plummeted in 1965. That year his annual check totaled $22.27. Embarrassed by the decline, Morgan asked the eighty-three-year-old artist if he had any ideas to rejuvenate interest. But Kent could see the future of American graphic arts. It held no place for him:

> *I had hardly expected that old-fashioned bookplate designs such as mine would continue in public favor. It might be in tune with "pop" art to make bookplates of people's signatures—either printing them bottom to bottom as when we fold a wet signature to get a quaint-looking design, or just scrambling it to make it completely meaningless.*
>
> *I appreciate your wanting, in our common interest, to hit upon a new idea, but I can't at the moment think of one.*

Eleven / Camerado!

1950 to 1960

IN THE AIR OVER EUROPE, A FLIGHT ATTENDANT ASKED KENT IF HE HAD noticed any turbulence. He replied that he had felt nothing out of the ordinary, and she explained that they had just passed through the Iron Curtain. It was 1950. At age sixty-eight, he was little prepared for the jolting ride he would take through the decade ahead.

Months earlier, he had welcomed the commission to design a bookplate for the public library of Bangor, Maine. It would identify volumes purchased through its Louise Baldwin Thompson Fund. Ever allegiant to the state of Maine, Kent lowered his $300 fee to $100. The city librarian, Felix Ranlett, specified "something quite simple, yet of the institutional type," citing as examples Kent's bookplates for Burton Emmett and the Library of Congress:

> *Inanimate objects are, perhaps, preferable to human figures.... We are doubtful if symbolic human figures, either clothed or unclothed, are desirable for this bookplate. The symbolism of these is sometimes hard to grasp and the figures become pictures rather than symbols so far as the reader is concerned.*

Kent made two pencil studies: one, a fir tree; the other, a tree stump. Ranlett rejected the tree because the star drawn in the sky above it gave it the appearance of a Christmas tree. The tree stump was acceptable:

> *Most people do not immediately recognize the stump as such, but rather think it is a rocky crag. When I tell them that the object is a stump (or so I suppose it to be) they say, "Well, what is the symbolism?" That is a question! What is it?... Two things may be said against the stump, though neither of these need absolutely abolish it if you yourself feel that it is ideal. One is that in Maine, with our many forests, we are particularly sensitive to forest fires, and the burnt stump is above all else a symbol of the devastation of the forest fire. The other point is, that if the stump represents mortality, it also, perhaps, represents a life cut off in youth, which is not the case of*

Louise Baldwin Thompson, who lived long and usefully.

Please consider a rocky crag of similar proportions to the stump and soft-ened by flowers and ferns about its base. This might be symbolic of the strong character of Louise Baldwin Thompson, and of the rugged strength of the State of Maine. It does appear that no matter what I say, everyone looks for symbolism beyond mere design in a bookplate.

Undeterred, Kent revised the bookplate to add the symbolism it apparently required above all else:

I am sending you herewith another sketch made somewhat in accordance with your suggestions. It is a modification of the tree stump design. You notice that I have retained the tree stump instead of replacing it by a rocky pinnacle. I hated to give it up for, using it as I have with the young pine growing from it, it becomes a symbol of the constant renewal of life.

The stump is not to be thought of as the stump of a burnt tree but, rather, as the remains of a giant that had endured its allotted time and from the heart of which the seedling of a new generation is springing. This is a phenomenon—the young tree growing out of the decayed heart of an old one—I have observed frequently in the woods. Here on my farm I am surrounded by pines, and for the seedling that I will draw I have a model not six feet from the threshold of my studio.

The image of a young tree growing from a stump is prominent in Kent's illustrations, beginning with *The Generations* (1918). It is thought to be his first attempt at wood engraving.

Upon receiving the design, Ranlett wrote, "The new tree growing out of the old is very good symbolism and it has a particular application here since the original Bangor Public Library, which was founded in 1883, was destroyed by fire in 1911."

The sapling may well have represented Kent's hope for renewal after the devastation of world war. As president of the International Workers Order, he traveled to Paris that April for the World Peace Conference. The United States had chosen not to participate, which made the presence of Kent and the American delegation unofficial. "It came as a sad reflection," he said, "that our country, which had risen to be the greatest industrial and financial power in the world, was not a world power when the theme was peace."

In March 1950, European delegates from the World Congress of Partisans of Peace attempted to visit the United States. The goal of their mission was to meet government leaders and discuss the banning of nuclear weapons; among the twelve denied entry for being "known Communists or fellow-travelers" was Pablo Picasso. A few days after they were turned away, Kent

made his first visit to Moscow as a member of the corresponding American delegation.

The group of fifteen were warmly received, and in an interview with *Tass,* Kent stated that the American government's stance on the Cold War was not representative of his own viewpoint. Several translations later, the *New York Times* reported that "Rockwell Kent said in Moscow last night that the U.S. Government 'is not my Government.'" From there he traveled to Stockholm, where he was elected to the International Committee of the World Peace Congress. A year later, when he would attempt to validate his passport in order to attend a World Peace Congress meeting in Prague, his request would be refused: "The department is not willing at this time to grant you passport facilities for travel to any country for any purpose." Along with Paul Robeson and a handful of other conspicuous American peace activists, he would lose the freedom to cross the borders of his homeland.

KENT RECEIVED ANOTHER BOOKPLATE COMMISSION IN NOVEMBER 1950 BY way of Fred Smith & Co. in New York. Like the Bangor project, it was a memorial bookplate for a library collection. Edward Mallinckrodt and his brothers had founded the Mallinckrodt Chemical Works in St. Louis in 1867; after his death in 1927, Edward Jr. became head of the company. To honor his father, Mallinckrodt had established a library fund at Harvard College, his own alma mater. Another artist had already made a stab at designing the bookplate, and Kent received the rejected studies as examples of what *not* to do. They depicted a solitary tree growing on a mountaintop. LeRoy Provins, who represented Mallinckrodt, explained:

> We would like to retain the general elements that you will notice in the enclosed sketches; that is, the four Latin words, and the path up the mountainside, indicating the hard road to wisdom and learning. There has been some suggestion of having the figure of a man going up this path, but how practical that is for something so small as a bookplate I leave to you the artist.

In addition to the Latin words and honoree's name, which was lengthy enough, the bookplate would also include *Lamont Library Harvard College.* In a letter that was eventually passed on to the artist, Mallinckrodt wrote:

> The idea of the Latin phrase which we sought to represent graphically is the idea of progress of a good life (which could be the progress of all good human life) from the beginning of life when a man starts only with his original

endowment of ability (or perhaps genius) which is ingenium; *to the next stage, which is arrived at by those who learn, when a man has acquired learning or knowledge—*scientia; *to a still higher point of development in life when genius, character and knowledge are recognized by his fellow men and he is in a position to exert a power and an influence for good—*auctoritas; *to the final height—the shining uplands—where a fully developed man of genius, learning and influence finally attains the consummation of his work in service for and interest in all people—*humanitas.

In reply to Provins' initial inquiry, Kent sent two sketches and noted his difficulties in incorporating the many elements in so small a format:

> *The Tree of Knowledge—for such I assume it to be—is one symbol for Learning; and the lofty mountaintop, difficult of attainment, is another. But they are not to be combined. The tree wouldn't grow on the mountaintop, and, if it could, you couldn't see it if the mountain is high. And if it isn't on the mountaintop why should the aspirant for learning bother to climb the mountain when he could sit comfortably in the tree's shade at the bottom?*
>
> *Showing the path ascending the mountain is inconsistent with any pretense of realism. You couldn't see it on a lofty mountainside unless it were a four-lane highway. Without the path it seems to me to remain quite clear that to attain wisdom that aura-capped mountain has got to be ascended; and the presumed difficulties of ascent are consistent with the proverbial difficulty of attaining wisdom.*
>
> *I think the figure of a young man is essential to the idea, for the scene is not one to be observed from a car window but by Youth itself as a goal to be attained.*

Impressed as he was by Kent's initial drawings, Mallinckrodt complained to Provins that "the present sketches both show just one major mountain in the background without any idea of progression from peak to peak." Kent replied:

> *If I had received Mr. Mallinckrodt's recent memorandum at the outset of this commission and with no more instruction than to give pictorial expression to it, I would have taken a five- or six-foot horizontal canvas and begun to paint that vast panoramic landscape of valleys, hills and mountains, of morasses that would be treacherous and torrents that would be difficult to cross, and steep ascents that would discourage all but the most hardy and determined; I would have shown cities increasing in splendor as, successively, they rose*

beyond the reach of clouds and storms; in short, I would have painted, or tried to paint, the whole world as a setting for the Pilgrim's Progress that Mr. Mallinckrodt's idea suggests.

But to do this in the narrow confines of a bookplate seems to be impossible. I can see no way to do it but through a much simpler way of symbolizing it; and so I have picked a tree instead of the world.

This interpretation of Mr. Mallinckrodt's thought is such a radical departure from the original sketches and from what, in fact, Mr. Mallinckrodt himself has had in mind that I am sending only a rough sketch of it. I know that it would make a handsome design, with the tree and the human figure in strong relief against a black background.

Won't you submit this to Mr. Mallinckrodt's consideration. Incidentally, I wish it were the big picture I were doing for I am quite enamored of the idea.

Mallinckrodt rejected his suggestion, and in August 1951, Kent submitted a revision with an alternate arrangement of mountain peaks. In December, he was notified of Mallinckrodt's approval of the drawing, with one exception: "He still is fond of the idea of having a sun and its rays in the design and wonders if it can be incorporated." Provins noted that they would pay more than the agreed-upon four hundred dollar fee "if there is an additional charge for the inclusion of the sun…" Believing that his work was nearing completion, Kent replied that "for the sun's rays there is no extra charge."

Six months later, a beleaguered Provins wrote to Kent with news that his client had come calling with the final rendering in hand:

It seems that the American Alpine Club has been studying the drawing; maybe there's been an international congress on the subject. Anyhow, some of the members got together and suggested a slight modification of your mountains, as you will notice in the enclosed photostat. It's all in the interest of making the mountains look a bit more like those they actually climb, but as for the aesthetics, I have no comment. In other words, I suppose they doubt that they are good enough climbers ever to conquer your great, bare "Humanitas" rock.

Do you suppose you could temper the severity of your mountain somewhat, without seriously impairing the composition? I send along the photostat only as an indication of the change that Mr. Mallinckrodt and his fellow mountaineers have in mind.

I'm considerably embarrassed at asking you to make any more alterations, but to quote the boss, "A lot of Harvard boys are climbers, and we want to make sure that the mountains meet both aesthetic and realistic requirements."

Having already devoted nineteen months to Mallinckrodt's mountain, Kent was outraged at the thought of reworking it:

> At last, after my final sketches have been approved, after the final drawing and the color separation had been made and when nothing remained but the little detail of allowing for the amount of lettering that would be required, along comes your letter telling me that the Alpine Club—or whatever it is—has decided that my mountaintops were not like the alps and putting it up to me to do the whole thing all over again.
>
> Please don't think me unreasonable or lacking in stamina if I just, at this moment, throw in the sponge. No. I can't do it.
>
> I will gladly send you all that I have done on the bookplate, with the sole reservation that, if the drawings are altered, the bookplate shall not be considered as having been designed by me.
>
> If the young mountain climber who, presumably, has climbed one peak after another on his way to scaling the highest had indulged in the conferences and discussions that have attended my attempts to just delineate a mountain peak, he would never in the course of a whole long life [have] managed to get anywhere.

He resigned from the project, but in November 1952, Provins telephoned and persuaded him to make the requested adjustments to the line work in the sky. The mountaintops would remain as Kent had drawn them; he was, as he reminded Provins, something of an authority on mountaintops:

> I spent a month in the Canadian Rockies last fall looking at them hard and painting them, and I can assure you those are perfectly reasonable mountains—at least of the Canadian Rocky type. And that means that mountains can be almost any shape in the world. And are.

Eight hundred Mallinckrodt bookplates were finally printed in 1953. "There was more fussing and fidgeting and redrawing about this job than any comparable one that I have ever had anything to do with," Kent said of the project. "I am not particularly proud of this bookplate, for I feel that whatever inspiration it might have had was eventually fussed out of it."

He had become increasingly less occupied with art than with the public notice that resulted from his activities on behalf of world peace. A California library and New York high school made news by removing *The Canterbury Tales* from their shelves merely because he was the illustrator. Although he

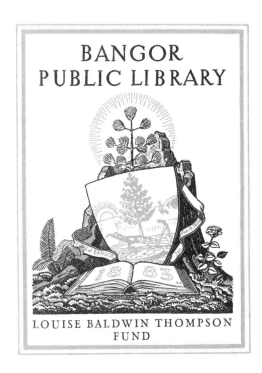

Bookplate for the Bangor Public Library, 1949.

Kent sent the approved drawing to Abe Colish and requested that the printer add *Louise Baldwin Fund* in a typeface consistent with his hand lettering. Five hundred bookplates were printed, and Kent wrote to Colish, "You will share with me the pleasure of knowing that the people in Bangor have fallen all over themselves about the bookplate and have given it big publicity."

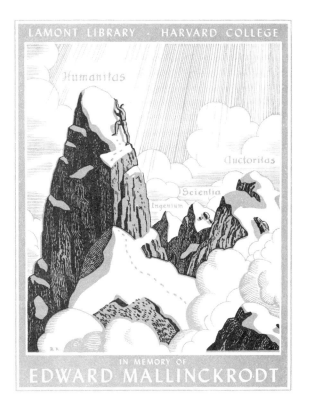

Memorial bookplate for Edward Mallinckrodt, Lamont Library, Harvard College, 1953.

Although it took more than two years of fussing to arrive at the final design, Kent was deeply disappointed with the outcome. The border lettering was added by the printer.

*Bookplate for
J. Whiting & Helen
Otillie Friel, 1953.*

At 6 ⅛ by 8 ¼ inches, this version of the Friel bookplate has the distinction of being the largest of Kent's printed bookplates. It was used to label the folio books in Friel's collection. Kent personally preferred bookplates with a width of a bit more than two inches.

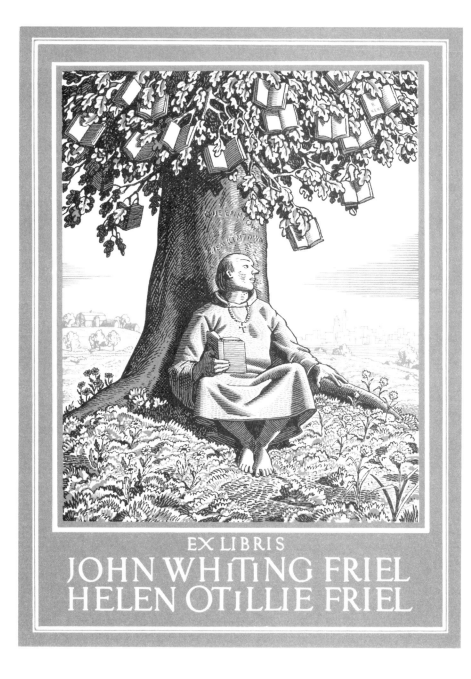

EX LIBRIS
JOHN WHITING FRIEL
HELEN OTILLIE FRIEL

considered himself "too palely pink" to be embraced by the Left, he was too red to be overlooked by the Right. When Louis Untermeyer was fired from the popular Sunday night television show *What's My Line?*, it was clear that the combination of public recognition and liberal convictions could have terminal consequences.

The innocently named Smith Act of 1949 had been legislated as a means of outlawing the advocacy of ideas that might eventually lead to the overthrow of the American government, and although the Communist Party was its obvious target, other organizations would tumble. Created as a provider of affordable health insurance, the International Workers Order had grown to include 183,000 members, a number that gave it undeniable political influence. Many of its members were foreign born. As president of the Order, Kent was accused of having been a member of the Communist Party and subpoenaed to appear before the New York State Supreme Court in June 1951. Admitting to having considered membership, he testified that he "did not believe in Russian communism for America":

> *I am an American. I believe in Democracy. I believe all men are created equal. The International Workers Order includes all races, creeds and colors. I believe the more people keep in contact with the people of the world; the more human we are.*

Despite the testimony of Kent and others, the court determined that the organization was "Communist dominated" and therefore subversive, and ordered its dissolution. The profitable policies were then transferred to a private insurance company.

AMONG THE BOOKS IN J. WHITING FRIEL'S LIBRARY WERE A LEATHER-BOUND set of *The Writings of Mark Twain* (remarkable for its author's autographs as both Twain and Samuel Clemens), William Morris' Kelmscott Press edition of the complete works of Geoffrey Chaucer and the two little books of Kent's bookplates. Friel, a World War I hero and steel-industry executive, decided in July 1952 that it was time to replace the bookplate he had used for decades. To his way of thinking, a bookplate should provide a more specific reflection of himself than the family coat of arms had. He advised Kent that he and his wife lived in a Georgian house, "mostly hall," at the top of the highest hill in Jenkintown, Pennsylvania. He noted that his ancestors had lived in Queenstown, Maryland, from colonial times, while his wife was a native of Cincinnati. There they had met and begun collecting books.

Untermeyer was one of the four original panelists on *What's My Line?* when it debuted in February 1950. After he was identified as having attended a 1951 peace conference at the Waldorf-Astoria, a letter-writing campaign led to his being ousted from the show and blackballed from television. Bennett Cerf replaced him on the *What's My Line?* panel.

His rough idea for the new bookplate was enclosed. It showed a monk, copied from an old woodcut, and the inscription "Envy them those monks of olde. Ther books they reade. Ther beades they toled." He was unsure of the source of the text or its correct "Chaucerian spelling." With that, he encouraged the artist to "please proceed along whatever lines Rockwell Kent feels should be followed."

In reply, Kent promised to start work in November, after two months of painting in the Canadian Rockies:

> I will try and find a friendly, learned authority who will know the very quotation that you have used or can at any rate give us authoritative Chaucerian spelling. It seems to me that the lines can not have been by Chaucer or a contemporary, for it seems unlikely that they would write about "monks of old."
>
> The verse seems to me to call for the featuring of a monk reading. But how to bring your and Mrs. Friel's American background into the picture and escape the obvious anachronism is a real problem. In the sketch that I send you I have suggested that the tree, which has flowered in books, has grown from the soil, on the left of Maryland, with Maryland's flower, the black-eyed Susan growing there and a farm in the background; and, on the right, Ohio with its red carnations and a city in the distance. Then on the tree we can carve anything you like.

The farm pictured was reminiscent of Asgaard, and the monk bore a resemblance to Kent. Friel suggested only one change: that the city skyline be slightly altered so as to be identifiable as Cincinnati. After a professor of English at the University of Saskatchewan dismissed the quotation as having no historic or literary significance, Friel chose to dispense with it, leaving the "medieval fellow in a habit" it had suggested under a tree somewhere between modern-day Maryland and Ohio. Kent completed the drawing by "carving" *Queenstown* and *Jenkintown* on the tree trunk. Before his bookplate went to press, Friel wrote to Kent of "a slight correction—the spelling of Mrs. Friel's name had two *t*'s and one *l*, which we corrected to *Otillie*. The artist in our advertising department later remarked he felt he could print just like Mr. Rockwell Kent." In March 1953, printing was underway at the Brownell Photo-Lithograph Co. of Philadelphia. Friel's bookplate would be produced in four sizes on a very fine laid paper with a slightly heavy weight.

With the notoriety that came from the airing of his political views in the national press, it was gratifying to Kent whenever someone like Friel, or even

Mallinckrodt, sought his services. His paintings were not selling, and one by one his business clients canceled their long-standing contracts. As his friend Arthur Price explained to him:

> *The Arthur-Daniels assignment that bounced is easily understood. You are being blackballed. In the trade they speak of you as "hot." Politer circles have told you they cannot afford to associate with controversy. And by all odds, you are the most controversial character running loose today. The only change I can see for the future is that you will become even more so. And, as I said before, you love it.*
>
> *The sad part, and it must bother you at least a bit, is the injustice of putting labels on the creator of fine art. By all the rules of the game, the artist must paint and the author must write the things they feel and anyone who interferes with that is denying our essential freedoms. How can we quarrel with what you write and paint if we do not allow the free expression of these viewpoints?*

The modest income from bookplate commissions helped. When his royalty from the Antioch Bookplate Co. began to slip after three years, Ernest Morgan wrote in 1952, "We do encounter some opposition on political grounds as a result of the prevalent war hysteria, but not a great deal. The majority of our customers seem inclined, happily, to accept a man's art without quarreling with his social and political ideas." In reply, Kent wrote, "Our satisfaction should be mutual: Mine in that the pictures that I sell can only serve the cause of peace; and theirs in that the money paid will go in taxes to support their war."

More disturbing were the personal relationships that had begun to evaporate. A letter from Hans Hinrichs written "in sincerity and sadness" ended their friendship:

> *Do you still believe that what little liberty we have can be preserved unless we stop all compromising and sympathizing with the would-be destroyer of that very same American heritage which you have glorified in words and pictures?*
>
> *Politically, you and I are worlds apart, but I will still spend my last penny to buy your canvas of the* Monhegan Lobstermen, *reproduced in* Life, *and donate it to the National Museum in Washington or, if you prefer, to the United Nations building, in order that future generations of America may never forget the genius of Rockwell Kent, the artist, but forgive the blindness or stubbornness of Rockwell Kent, the political trespasser.*

After Hinrichs commissioned Kent to design his daughter's bookplate, which ended up a gift, he hired Kent to write and illustrate *To Thee!*, a book commemorating the centenary of the Rahr Malting Co. of Minneapolis. By then, Hinrichs was well on his way toward assembling the largest private collection of Kent's paintings in the country.

THE ASSUMPTION THAT KENT WAS A COMMUNIST HAD PERSISTED, DESPITE his testimony to the contrary before the New York State Supreme Court. When Senator Joseph McCarthy reopened his campaign to rid the State Department's overseas libraries of subversive titles, Rockwell Kent was one of the authors brought to his attention. Six of the artist's nonpolitical books, eighty-one copies in all, were in the collections of libraries attached to U.S. embassies and consulates. It was not the books' content that was in question, it was the author's name, placing him in the rarefied company of Dashiell Hammett, Lillian Hellman and Dorothy Parker.

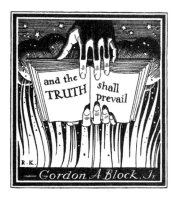

Bookplate for Gordon A. Block Jr., 1938.

The design of Block's bookplate reflected the artist's and his client's discussion of the book-burning campaign in Germany in 1938. It was commissioned through Leonard Sessler, a Philadelphia dealer in rare books and prints.

The tenant Kent referred to was the Chicago family that had rented Asgaard from Frances while he was in Greenland. Realizing that eviction was impossible, he had refused to accept their rent, which was to him tainted money.

McCarthy and Kent met in a Washington hearing room in July 1953. On that day, the senator was the lone committee member in attendance. Proceedings began with Kent's declaration that he had come voluntarily. When McCarthy reminded him that he had been subpoenaed, the artist handed him the subpoena which, never having been signed, was unenforceable. He had also prepared a written statement that he asked to read. McCarthy, at his bullying best, refused his request: "We won't have any lectures by you, Mr. Kent." Fearless, Kent shot back: "You won't get any lecture from me; I get paid for my lectures." The senator then challenged Kent, if he "had the guts," to simply answer yes or no to the question of his Communist Party affiliation; in exchange, he would be allowed to read his statement into the record. Kent would only confirm that twenty years earlier he had donated eight hundred dollars to the party, explaining that he had received the money as rent from an "insulting" tenant. Passing it on to the party was the most "hateful thing" he could think to do with it. The hearing ended with Kent reserving his right to not answer no.

In describing Kent's encounter with McCarthy, Carl Zigrosser wrote: "Rockwell was one of the few during the shameful McCarthy era who had an impregnable position, and was therefore able not only to defend himself but also to counterattack." Had he been permitted to read his statement, he would have accused McCarthy of conspiring to overthrow the government and compared his book-burning campaign to Hitler's.

The most difficult admission was one Kent would make to himself: that politics had sidetracked his painting. To one friend, he wrote, "I have gotten quite accustomed to painting pictures without the least expectation of their being seen except by Sally." He had ignored the enthusiasm the New York art critics reserved exclusively for Abstract Expressionism, but when pressed into art criticism himself, Kent would call nonobjective art "the cultural

counterpart of the atom bomb." He continued to paint what he knew and loved, Adirondack and Monhegan landscapes. Several months before his face-off with McCarthy, the Farnsworth Gallery in Rockland, Maine, had expressed an interest in not only exhibiting his work but also expanding the museum to permanently house his hundreds of paintings, drawings, prints and manuscripts. In August, however, the museum trustees ruled out any association with the notorious Rockwell Kent.

Believing that "there is no human power comparable to the printed word" and encouraged by friends, he began to write his way out of that summer's disappointments. In an autobiography, he would set the record straight, have his say and resolve the disparity between his identities as an artist and a peacemaker. Several publishers expressed an interest.

Kent chose Dodd, Mead to publish the book he titled *It's Me O Lord*. Abe Colish would design it; Kent would draw each of the ninety-four chapter headings. The pages would be liberally illustrated with almost two hundred drawings from his previous books as well as his drawings for magazines and advertising. Unable to recall or locate many of the commercial illustrations from thirty years earlier, Kent enlisted the help of Dan Burne Jones, his presumed protégé and one of the preeminent collectors of his black-and-white work. To meet the publisher's deadline, Rockwell and Sally devoted all of 1954 to research and writing, to the exclusion of everything else: "I find that writing, and particularly the projection of myself into the past that the writing of such a book requires, just makes it virtually impossible for me to do anything of another nature." But in December, with his manuscript due by month's end, he put aside his writing long enough to complete a bookplate that had languished on his worktable. It was a gift promised to Irene von Horvath two years earlier, and in a letter, she had casually reminded him that "the sketch of the hand with dividers still haunts me."

At the invitation of a friend, she had traveled to Lake Placid for a vacation in the summer of 1942. A message was waiting for her at the hotel: Her friend's plans had changed, and Irene found herself stranded. She was a recent graduate of Carnegie Tech with a master's degree in architecture, numerous honors and no money. By chance, she met the Kents, and ended up spending five weeks at Asgaard, helping Sally with the vegetable garden and looking after one of Rockwell's grandchildren. She already knew and admired Kent's work, and he was impressed by her determination to enter a profession that looked askance upon women joining its ranks. On her behalf, Rockwell wrote to Ewing and Chappell in New York: "I should think that in these days of manpower shortage an architect who has any work at

In his autobiography, Kent blamed the Farnsworth Gallery decision on Stephen Etnier, the young painter he had taught twenty years earlier. Etnier went on to model his career after Kent's and become a distinguished Maine painter, without giving Kent due credit. They met again in 1969 at an exhibition of Kent's paintings, after which Kent wrote to say "how truly happy I am at seeing you again and realizing that we are still old friends." He apparently realized his mistake in accusing Etnier of sabotaging the Farnsworth acquisition.

all, and who wants draftsmen who are not going to be drafted away from him, would just grab a girl with her training and ability." His letter was to no avail, and she would visit every architectural firm in the Manhattan telephone directory before landing a job with the last one on the list.

Reminiscent of an illustration from *Moby-Dick* that had been inspired by a William Blake drawing, the bookplate Kent had sketched for her showed a pair of calipers, a draftsman's simple measuring tool, held open beneath a penetrating sun. A registered architect by then, Irene was on the verge of leaving New York. "A certain human scale is lacking here," she wrote to him, "and the workmanship is appalling. I would like to see how architecture is practiced in other places." By the time Kent completed her bookplate, she had settled in Santa Fe, New Mexico. The finished drawing arrived at Christmas, and she wrote Kent that it was "the most beautiful bookplate I have ever seen."

It's Me O Lord would be published in May 1955, and Kent faced the challenge of reducing his gargantuan manuscript to a quarter-million words. He deleted a hundred typed pages, and the task of wrestling with his changes fell to the printer's copy reader, Jeanette Clarke. Being the first person to read a book was a source of pride to her, and *It's Me O Lord* became her "most satisfying work experience." After she visited Asgaard, Kent described her as "one of the ever memorable few who have ever come into this house and shown the least interest in the pictures on the walls and in the books on shelves and tables. She is literally enraptured by everything that is here." The bookplate he made as a gift for her was based on an illustration in *It's Me O Lord* that she had fancied. Unknown to her, the man embracing a deer was the mark he had designed for Hildegarde Hirsch's stationery in 1917. *Hirsch* being the German word for "deer," it celebrated his adulterous affair with the Ziegfeld Follies dancer. Fifty years later, he had no qualms about redrawing it as a bookplate for Jeanette. "That it was drawn for me by you seems utterly miraculous still," she wrote. "Of course the first book that will be plated is *It's Me O Lord.*"

Reviews for his autobiography were mixed. In the *New York Times*, Orville Prescott wrote, "On finishing *It's Me O Lord,* one feels considerable respect for Rockwell Kent's artistic integrity, for his political courage and for the energy and zest with which he has pranced through life," but concluded that the six hundred pages were "intermittently interesting, frequently tiresome reading."

Without a pause, Kent turned his attention to a much smaller document. For five years, the Passport Office had denied him the liberty of traveling outside the country. He applied once again for a passport, although he

admitted that he and Sally were no longer financially able to travel abroad. Having a passport had become a matter of principle:

> I have made the application in expectation of its refusal and with the intention, with the backing of the Emergency Civil Liberties Committee, of carrying the issue through the courts in the hope of a final decision that will re-establish the right of all American citizens to that official certification of their citizenship which I hold a passport to be. I am not asking for permission to travel, believing the right to travel to be one of those time-honored, inherent rights referred to in the Ninth Article of the Bill of Rights.

At an interview conducted by the Passport Office in early November, the evidence offered against issuing his passport were passages from *It's Me O Lord* that detailed his associations with known Communists. He stood by what he had written and declined to sign an affidavit of Communist Party membership. After his request was denied, he told reporters, "I am not a Communist and I have never been a Communist, but I'm damned if I will sign one of those things." Mention of the interview in the *Times* prompted Ernest Morgan to write to the Passport Office:

Ernest Morgan of the Antioch Bookplate Co. was the only associate of Kent's to take a stand on his behalf.

> It is not necessary to share Mr. Kent's political orientation to respect and appreciate his warm human feeling and unselfish social ideals. If and when our American civilization goes to pieces, it will probably be in part the result of smugness and of the failure of our human sensitivity to keep pace with material progress. To help shake his fellow citizens loose from this smugness, and to sharpen human sensitivity, is one of the great services that a man can perform for his country, and is certainly a proper function of artists and writers. This is exactly what Rockwell Kent has been doing for years. The fact that such people as Mr. Kent make us uncomfortable is often an indication of their value, rather than otherwise.
>
> Mr. Kent is not a man to be feared in any conspiratorial sense. Whatever his social or political ideas may be, he remains a strong individualist whose first allegiance is to his own inner conscience. We may question his ideas, but we can hardly question his integrity. His is not the personality that any cynical, conspiratorial organization would dare bring into its inner circle. This fact is far more meaningful than any oath he might take.

Kent then filed suit against Secretary of State John Foster Dulles, "the undertaker and embalmer of human hopes." Preparation for legal action was, in

fact, well underway. The Civil Liberties Committee had enlisted the services of civil rights attorney Leonard Boudin, and Kent's case would be heard with Dr. Walter Briehl's. A Los Angeles psychiatrist, Briehl had been denied a passport for, among other things, articles he had written for the magazine *Social Work Today*. Kent most likely conferred with Briehl when he traveled to Los Angeles a week before the hearing.

There he was introduced to David Grutman, with whom he shared the friendship of Albert E. Kahn, leader of the American delegation to the Stockholm peace conference. Over oysters, steak and crepes suzette, Grutman proposed that Kent design his bookplate:

> *I would like the bookplate to indicate that through books we seek and achieve truth, knowledge, freedom and happiness. If possible, have a* shaded *area symbolic of ignorance and despair and a* light *area expressing learning and hope. Take it from there!*

Grutman's business, the Barco Garment Co., manufactured uniforms worn by working men and women. By any definition, he was a capitalist; but by nature, he was a man of strong liberal convictions and quiet courage. Two years earlier he had helped finance *Salt of the Earth*, a motion picture that employed the talents of a number of Hollywood's blacklisted filmmakers. Advertised as "an honest movie about American working people," it recounted a 1950 strike by Mexican-American miners, whose union had endured the same red-baiting that had divided Hollywood. He also had a sense of humor that Kent appreciated in those dour days:

> *I trust that you won't make too vigorous a protest about your passport because they may put you behind the bars and it would hold up my bookplate. Are you seeking a passport for out of this world? Seriously, if they have to worry about Rockwell Kent, I think they're in one hell of a state of barbaric fear, for all I could learn about the gentleman was that he wanted to do for and love mankind as the most devoted of lovers.*
>
> *I eagerly await the sketches, and I wonder with amazement at your keen interest and respect for my simple hopes and aspirations.*

Pleased with Kent's representation of enlightenment, he suggested that the artist simply letter the bookplate with his surname, "for the plate could then be passed on to the inheritors."

When Joseph O. Jackson, a former bookseller in Detroit, wrote to Kent

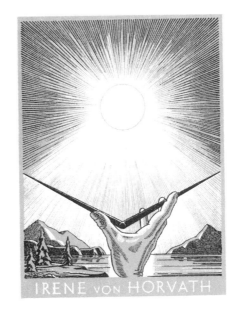

Bookplate for
Irene von Horvath, 1955.

Bookplate for
Jeanette Clarke, 1958.

Bookplate for
David Grutman, 1956.

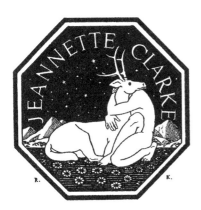

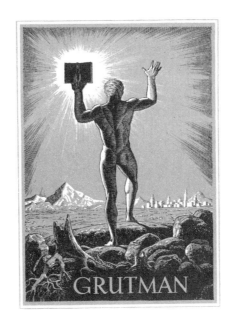

*Bookplate for
Joseph O. Jackson, 1956.*

*Bookplate for
Jacquie & Dan Burne
Jones, 1956.*

*Sketch for a bookplate for
the Society of Jesus, 1957.*
(Rare Book and Manuscript
Library, Columbia University)

*Bookplate for
the Society of Jesus, 1957.*
Commissioned by
J. Whiting Friel, it was
rendered in a style
similar to the personal
bookplate Kent had
designed for the Friels
three years earlier. His
depiction of the
conversion of Ignatius
Loyola was based on
extensive research and
is true to the earliest
portraits of the saint.

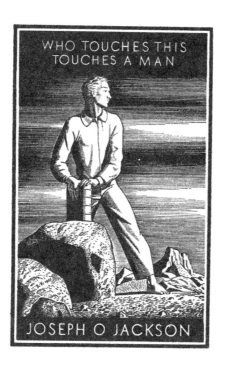

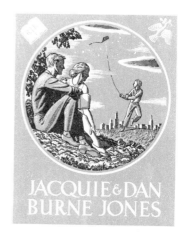

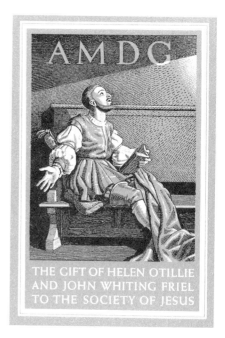

about designing his bookplate, he enclosed a newspaper clipping regarding Kent's passport battle and offered encouragement:

I have always admired your work and I find myself with increasing admiration for, what seems to me, your staunch American spirit. We can use more of such stalwartness these days and fewer sunshine patriots; ours is also a time which tries men's souls.

But to come to my second point: I have long wanted a personal bookplate and I can think of no one whom I should like to have do it as much as you. My means (like your own) are limited. I can't afford to go to Athens or Rome…but perhaps I can afford a Rockwell Kent bookplate…

My idea of design would be a single male figure (not necessarily nude) suited to lines of Whitman's which have been in my mind for years:

> *Camerado! This is no book;*
> *Who touches this touches a man…*

As a matter of fact, I think "Who touches this touches a man—Whitman" is superb and sufficient. No "ex libris" or "from the books of"; just "Joseph Orville Jackson" on it somewhere, with your signature and the year. The year is rather nice—being the centennial of Leaves of Grass, is it not? Does adding the "Whitman" insult the reader? Maybe only "Who touches this touches a man"?

Kent responded with appreciation for Jackson's "good words" and, as any graphic artist would, his willingness to reduce the text:

I would love to make your bookplate, and I like your idea for it tremendously. I agree with you that "who touches this touches a man" is sufficient. I don't think you need the Whitman, but I do think that the line should have quotes, for not everyone would recognize it as from Whitman and, attributing it to you, might take it as being a bit vainglorious.

I have liked so much what you have written that I hope you will not dislike too much what I must write. I have for years had a fixed fee for bookplates. It is three hundred dollars. But also, like doctors, I reduce my fees at times to meet my patient's pocket-book. You write that you can't afford to go to Greece and Rome, so just tell me honestly how much of my price you can afford.

To conclude, I have never been given a better idea for a bookplate or a

better slogan, and I like your thought that it should be dated this year of the Whitman centennial.

Jackson could afford one hundred dollars, and Kent mailed the finished drawing in late January 1956: "I got so interested in the idea that I went right ahead and finished it without sending you preliminary sketches." He had also decided to dispense with the quotation marks and attribution, both of which would have crowded the text. "It pleases me *greatly*," Jackson responded, "having at the same time such strength and restraint. I shall be very happy with it, and more *proud* than I am *deserving* of it." He went along with Kent's omissions because "many will recognize it as being from Whitman and those who don't *should*," and reminded the artist to add the date to his initials hidden on the face of a rock.

Kent dispatched the final drawing to Abe Colish and, to ensure that Jackson was not overcharged for the printing, noted, "This can only be in black and without a second plate, for Mr. Jackson is a man of modest means." Three thousand bookplates were printed in early March, and after Jackson noticed that a quarter of them were "rather mediocre examples of good printing," Kent had the printer make another two thousand.

After receiving copies of the completed bookplate, Kent wrote to Jackson:

I hope that the quotation on the bookplate reminds potential book stealers that the theft of a book is more nearly homicide than larceny. It is strange that normally decent people are without conscience when it comes to returning books; and, I might add, that we who lend them persist in neglecting to keep a record of the loan.

The bookplate Kent designed for Jones and his wife Jacquie was possibly a gift in appreciation of their assistance in compiling the illustrations for *It's Me O Lord.* A Chicagoan, Jones had studied at the Art Institute in the 1930s, taught high school industrial arts and served on the editorial board of *Professional Art Quarterly.* The first record of his contact with Kent was a 1941 letter, in which the thirty-three-year-old wrote, "I'd like to meet you and shake your hand." His bookplates drawn in the Kent manner attested to his admiration of the artist.

Depicting what Dan Jones called his "triumvirate," the bookplate Kent designed for the Joneses perfectly reflected the dreams of American families in the 1950s. Completed in late 1956, it displayed the artist's initials more prominently than usual. An unknown number were printed in two sizes

with two different combinations of color. Jones, however, not only ignored Kent's color recommendation by choosing pink for a set of the small version but also made the mistake of entrusting production to a local printer. In a letter from January 1957, Kent critiqued the outcome:

> *Your own disappointment at the bookplates doesn't equal mine. I am thoroughly and completely disgusted with them. If they had been under my supervision, I could have had an infinitely better job done by the local newspaper office....I indicated a buff for the background. I would have changed this to gray—and a rather dark gray. The buff is much too light. The boudoir pink strikes me as horrible....If I were you, I would condemn the job and hand it to another printer. And whatever you do please let me see proofs. I will enclose a sample of the second color that I suggest.*

For the most part, Jones followed Kent's instructions to the letter when they were reprinted, using dark gray and buff as the second colors. He neglected to destroy the original edition.

THREE YEARS AFTER KENT HAD MADE HIS BOOKPLATE, J. WHITING FRIEL wrote to commission another one. Beset by poor health, he had decided to will his book collection "to the Society of Jesus—Jesuits—as we have three of them in our family." The bookplate for his bequest would depict St. Ignatius Loyola, the second-century founder of the order. In January 1957, Kent prepared a small sketch, once again misspelling Mrs. Friel's first name, and proposed that it be printed in black and gray, similar to Friel's personal bookplate. Raised a Protestant, Kent went to his local priest for assistance in gathering information on the order, including portraits of Ignatius. "The commission to do a Jesuit bookplate has started me on some very interesting reading," he said, "I am at the moment immersed in Parkman's *The Jesuits in Canada*—a moving story of devoted efforts." As a result of his research, he incorporated A M D G, representing the Latin *ad majorem Dei gloriam*, into the design. Friel forwarded Kent's first sketch to the Maryland Province of Jesuits in Baltimore, the eventual recipient, for comments, and they suggested that it be revised to depict the more dramatic conversion of Ignatius.

Ad majorem Dei gloriam, translated "all for the greater glory of God," was the motto of Ignatius Loyola.

Completion of the bookplate was delayed by the vacation trip Rockwell and Sally made to the West Indies in February. "Because of both passport restrictions and money, that cruise must be confined to waters and islands adjacent to our continent," he wrote to Elmer Adler, with whom they enjoyed a reunion in Puerto Rico. Having retired to the tropics from

Princeton, Adler had, in typical fashion, founded La Casa del Libro, a library dedicated to fine printing, in San Juan.

Upon their return, Kent was overjoyed by the waiting news: The Soviet cultural attaché in Washington had proposed an exhibition of his paintings that would travel from the Hermitage in Leningrad to the Pushkin Museum in Moscow. After dedicating months to the details of framing, packing and insuring the paintings for shipment to Russia, Kent resumed the Friel project in August. He adhered to a portrait of Ignatius that Friel had supplied and lettered the four initials. In the interest of time, Abe Colish was hired to set the three lines of type: "The inscription should have the character of the classic Roman inscriptions." That autumn, Brownell Photo-Lithograph printed the bookplate in four sizes to fit the full range of books, manuscripts and quarto volumes in Friel's collection.

The Moscow exhibit had been scheduled to coincide with the publication of a Russian translation of *It's Me O Lord,* both events coordinated to mark Kent's 75th birthday. But it was a celebration he would miss:

My wife and I have been invited to go there, but unfortunately the passport issue has not yet been resolved. It is interesting that this year the Modern Museum in New York is celebrating the 75th birthday of Picasso with a big exhibition of his work. Picasso—whom of course they would like to have attend the opening—will not be permitted to enter the country.

The United States Supreme Court argued *Kent* v. *Dulles* in April 1958. Two months later, Justice William O. Douglas delivered the court's opinion in the few, simple words that Kent had waited to hear:

Travel abroad, like travel within the country, may be necessary for a livelihood. It may be as close to the heart of the individual as the choice of what he eats, or wears, or reads. Freedom of movement is basic in our scheme of values.

In reversing the decisions of the lower courts, the Supreme Court made it clear that the Secretary of State had no authority to withhold passports from citizens on the basis of their beliefs or associations. Kent's passport was delivered in July, ending his six years of internment.

Twelve / One Single Human Being

1960 to 1971

KENT HAD MAINTAINED THE LOOKS AND VIGOR OF A MAN TWENTY YEARS HIS junior, but in 1960 even that younger man was beginning to show and feel his age. Nonetheless, painting was his response to living, and he kept at both. In a letter to a friend, he said, "For twenty years I have been painting, as it were, in a vacuum." The assemblage of paintings, what he had taken to calling the "Great Kent Collection," went unseen and unappreciated. Added to the uncertainty of what would become of it was another concern: "My pictures fill to overflowing the wooden storage shed attached to my wooden studio, resting in a bed of inflammable pine needles in the midst of a pine woods, waiting only for the first unextinguished match to be dropped to be reduced to ashes." That winter, he hit upon a solution, which he confided in a letter to Dan and Jacquie Jones:

> My situation at the moment is a bit complicated, for a reason that I must now tell you—though in telling you I must ask that you keep this a profound secret just between you two, and not a word to anyone else. We are arranging to give the entire "Kent Collection"—all paintings, drawings, prints, manuscripts, RK books—to the one people in the world who have demonstrated their high regard for what I do: the Soviet people. They have been informed of my offer, and plans for its acceptance are in progress. It will be a gesture, or act, of international friendship and the details and ceremonies attached to it are to be carefully arranged and managed.

"Well, dammit," Jones responded, "here's one American artist and his art that wasn't influenced by the Armory Show, here's one who has kept to his own beliefs in art and went in and produced his work in his own way unaffected by the isms and perversions of the French! We need such a gift to our National Gallery in Washington; have you offered it to America?"

He had not. Having plotted the Soviet coup with cloak-and-dagger secrecy, he made the announcement of the gift in November—from Moscow

after the paintings had arrived. It was a fait accompli, and he described the eighty canvases and eight hundred works on paper as a "pitiably small" token of appreciation for the Soviet defense of Stalingrad during World War II. But there was more to it than that: "In the course of one short year in the Soviet Union," he said privately, with reference to the 1957 exhibition, "many times more people have seen and loved my work than in the whole of my long life in America. That is of itself enough. My pictures are for them." Weighed against the indignities of McCarthyism, the Soviets' esteem had made up his mind.

His gift was trumpeted in the Soviet press as a magnanimous gesture, but the headlines that heightened his celebrity in Moscow were counterpoised by dismissive news stories at home. Ironically, the paintings of Henri, Bellows and Sloan, three of his early contemporaries, were enjoying critical reappraisal in New York exhibitions that year, while a majority of the life work of Rockwell Kent would never again be exhibited in America. Carl Zigrosser wrote to him:

> *I read in the papers recently that you have given your collection…to the Pushkin Museum in Moscow. I remember well the rejection by the Farnsworth Museum under shameful circumstances. I want you to know that I am planning to give my collection of drawings, prints and books to the Philadelphia Museum of Art. There will be at least one American museum which has a collection of your work.*

Carl had remained faithful to Rockwell, having pledged forty years earlier: "There is nothing that you can ever do that can affect my friendship." Rockwell, on the other hand, had been disappointed when Carl admitted to his growing appreciation of abstract painting. They were no longer rowing in the same boat. Dan Jones was the yes-man Rockwell needed, and had thus replaced Carl as his confidant.

Kent's uneasiness with Jones had vanished with the publication of *It's Me O Lord*. Through correspondence, the exchange of gifts and occasional visits at Asgaard, the two had become like father and son. A generation younger than Kent, Dan and his wife Jacquie were unabashed in their enthusiasm for his art. With friends deserting him and his star in rapid descent, Kent had found their unquestioning devotion hard to resist.

At various times, he described himself as a man who "wanted to lead the life of a normal human being" and as an artist who sought the approval of "the ordinary, regular, normal people of our world." Jones, anchored in a

Chicago suburb, was in every way the epitome of normal. He was intelligent without being an intellectual; he had never yielded to the pretensions of the art world; he was a political innocent who felt no shame over the vote he cast for Eisenhower; and, with a wife and son to support, he had put aside his creative ambition to work in a factory that packaged prepared foods.

In the early sixties, the Joneses and Kent began exchanging long, detailed letters several times each week. Back and forth, like back-fence neighbors, they mulled over the news of the day, the weather and their various aches and pains. Vicariously, Rockwell lived the typical American family life that he had never realized with Kathleen and his five children, as Dan wrote about Cub Scouts, Sunday school, YMCA day camp, family vacations and Jacquie's washday chores. Gifts were exchanged at Christmas and on birthdays, and from time to time a case of Instant Breakfast or Sugarless Lemonade Twist arrived at Agaard. Had they been cases of champagne, Kent's gratitude could have been no more effusive. It was the thought that mattered.

Before the Kent Collection was shipped to Moscow, the Joneses persuaded him to sell them a painting, and as the friendship flourished, their holdings of his work grew, sometimes purchased for a pittance, sometimes received as gifts. In 1963, when *Art in America* asked for Kent's assistance in compiling a catalogue of his works for a magazine article, he referred the editor to Dan Burne Jones, "my official bibliographer."

Dan Burne Jones was the author of *The Prints of Rockwell Kent: A Catalogue Raisonné*, published in 1975.

KENT'S IDENTITY AS A BOOKPLATE ARTIST LIVED ON LONG AFTER MADISON Avenue stopped calling. In earlier times, whenever an individual had been considerate enough to request permission to reproduce one of his images for a bookplate, he would reply, "It happens that I earn my living in part through making bookplate designs, and consequently I must protect myself in that by charging the relatively nominal sum of $25 for the right to use a design that has already been made." But in the 1960s, he simply said yes. Being remembered was compensation enough. A commission to design a bookplate from scratch was even more gratifying, if only for the sociability it brought him.

Harry M. Geller, a composer, arranger and conductor, had reached a turning point in 1961. In his middle years, he was giving up the petty demands of a Hollywood career in order to fulfill the serious musical ambitions he had nurtured from childhood. A jazz trumpeter with the Benny Goodman and Artie Shaw bands in the thirties, Geller felt relief at emerging from what he called the "jello bath" of the recording, motion picture and television industries. His expectations for the future were more guarded: "At least the only

Kent's commercial career ended with an *Esquire* magazine ad for Rémy Martin cognac in 1948 and the design of a line of drapery fabrics two years later; Esther Shepherd's *Paul Bunyan* in 1941 was the last book by another author that he illustrated from cover to cover.

thing looking over my shoulder now is the warm ray of the morning sun."
Encouraged by mutual friends, he had telephoned Kent in June to commission a bookplate. In a follow-up letter, he wrote:

This is a difficult letter to write for many reasons. Principally, I think, because when I was a very young boy, I read N by E *and it had a profound and lasting effect on me and thereby formed an image that has become one of the eternal dreams in my personal fantasy bag. As I told you on the phone, I still have hanging over my desk, and the only thing that does hang there, a signed wood engraving titled* Flame. *It has had great personal meaning for me and although it would be impossible to convey to you all that it has meant, let me tell you that I have always felt a kinship with the feeling of* absolute *striving and* reaching *that the engraving manifests for me. But so much more—and strangely enough, it hasn't changed over thirty years.... Forgive the obviously adolescent outburst but that's what comes of delayed expression in hero worship.*

He suggested that Kent combine elements from *Flame* and the bookplate for the Warner Library:

It would show a figure climbing up and looking toward either the sun's rays or flames, and carrying in one hand a baton and under the other a book—in the background a city skyline and in the distance, mountains...

In early October, Kent mailed five sketches to Geller in Los Angeles:

You will note—I fear regretfully—that I have only used the baton once. It seemed to me, since my ideas were fairly realistic, that it was perhaps a little incongruous to have a figure waving a baton on a mountaintop—as though, like God, he was directing the Universe. But that's for you to say.

Please be as critical as you please about the designs I have sent you, for a bookplate is too personal a matter not to be as nearly as possible what its owner would have it be.

Take your time about returning the sketches to me, for we are having such splendid weather that I will be mostly out of doors, and I will presently be starting for two weeks painting in Virginia.

The Virginia millionaire J. J. Ryan had become Kent's benefactor in the fifties. (His grandfather, Thomas Fortune Ryan, was an early patron of the French sculptor Rodin.) For a decade, Ryan kept Kent busy painting landscapes for his private collection.

As it turned out, Geller favored the fifth design, the one that Kent had questioned. It was the most musical and dramatic, and Geller admitted

that it was the one that best represented his life, which he described in reply as "unfortunately, almost completely void of placid periods." He noted that he and his wife were beginning divorce proceedings. Empathizing with Geller's difficulties, Kent replied, "At the very least [divorce] can be distracting, and at the most, heartbreaking," and graciously accepted his preference:

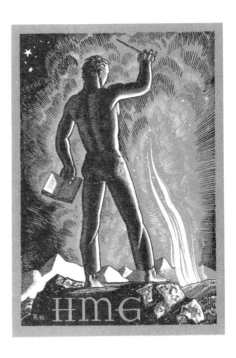

I am convinced from what you have written me that drawing No. 5 is the one that should be made your bookplate. But, if you don't mind, I think I will put it more decidedly in the category of mythology by divesting it, or him, of the last vestige of present-day reality—his pants—and make him, if you please, Apollo. A baton is actually more appropriate to Apollo than the traditional lyre.

For whatever reason, Kent's imagined Apollo never materialized and the final design replicates his fifth sketch. Geller requested two sizes, with one presumably large enough for pasting in his oversized musical scores. Colish printed two thousand of each, using a gray plate and a black plate, and they were delivered in April 1962. "The finished bookplates have arrived," Geller wrote, "and I am truly delighted with the results. To some they may appear flamboyant and overdramatic, but they suit my taste and have great personal meaning." (By year's end, he resumed his Hollywood career.)

Bookplate for Harry M. Geller, 1962.

Rockwell and Sally left for Moscow a month later. Coinciding with his 80th birthday, the sojourn they planned would allow time for seeing more of the country as well as painting it. But after four months, he suddenly collapsed from fatigue, curtailing their visit. Then, in November, while painting alone in his studio, he suffered a stroke that paralyzed his left side. Recovery would come, given his will power, and if he felt resentment, it was reserved for the stroke's effect on his speech.

By 1964, he had overcome the worst effects of the stroke and returned to painting his Asgaard landscapes. Aware of his illness, the Soviet government invited him to return, specifically to rest in their resort facilities. Once again the Kents stayed for four months, and Rockwell returned home exhausted. Weakened by a slow heartbeat that sapped his strength, he welcomed the

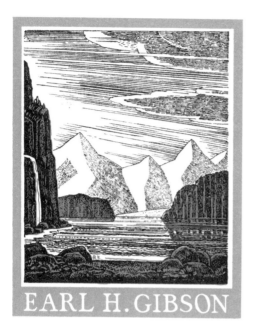

*Bookplate for
Earl H. Gibson, 1966.*

pacemaker that was implanted in Montreal in December. It helped restore some of his energy, but the irritability that resulted from infirmity was only heightened by the "shameful mess" in Vietnam: "We are thoroughly appalled and frightened by the war's steady escalation and by the dictatorship that shows itself only increasingly impervious to public remonstrances. If God knows what is going to happen he gives no signs of caring." But he applauded what he termed "the most hopeful movement of my whole lifetime in America—the participation at long last of our young people in political affairs."

Earl H. Gibson, a book collector in Seattle, wrote to Kent in February 1966 to say that, if the artist was still "in business," he wished to purchase "a small bookplate depicting sunrise on Resurrection Bay with the mountains outlined against a morning sky. This was my first impression of Alaska in 1942 and one I'm sure you will remember." He had prefaced his inquiry with a description of his collection of Kent's books. In reply, Kent wrote:

> *I have devoted myself almost exclusively to painting for the last fifteen or twenty years and have done very little work in black and white and only an occasional bookplate. However, I would like to do one for you if the price I used to charge ($200 to $250) meets your pocketbook. For such an Alaska scene as you describe to me I will call the price $200.*
>
> *If you have all my books in first editions, you are in that respect more fortunate than I am, for I have been a bit careless about keeping copies of my own books....I am almost sorry to hear that you have all my books, for I would like to have had something to give you.*

Gibson shared Kent's anger over the escalating war in Vietnam, and with every communication regarding the bookplate they also exchanged books and newspaper clippings that reinforced their view. About the copy of Mark Twain's *War Prayer* that Gibson sent, Kent wrote, "We are quite overwhelmed by it and are sending to its publishers…to ask if copies of it are obtainable. But I don't think much of Ben Shahn's picture at the top of it, seeing no connection whatever between a lot of men with walking sticks and the deeply moving text of the prayer." Through their correspondence, the

artist quickly came to regard Gibson as "a most thoughtful friend in everything that concerns me."

Kent provided two sketches from which Gibson selected the design, but when Kent got around to inking the final drawing, he discovered that his sable brushes would have to first be replaced. Moths had devoured their points, underscoring how long it had been since he had drawn with ink. Using a set of new brushes, he completed Gibson's drawing in August. Louis Colish, who had taken the reins at A. Colish, after his father's death in 1963, accepted the small job, and four hundred bookplates were printed in black and gray from copper plates.

Gibson's bookplate only hinted at the artist's failing eyesight and unsteady hand. The one he made for Vladimir Orlov, at the same time, amplified his physical decline. With Orlov's name in Cyrillic lettering, it depicted a nude figure sailing through the night sky on an open book. The graceless, impossible posture of the kneeling man with arms stretched wide toward a distant star was an expression of futility rather than aspiration.

Bookplate for Vladimir Orlov, 1966. In his correspondence with Kent, Dan Jones mentioned "the Russian bookplate." It was most likely printed in the Soviet Union.

In April 1967, Kent was named one of six recipients of that year's Lenin Peace Prize, the Soviet counterpart to the Nobel Peace Prize. Among the other honorees were a West Berlin evangelical pastor and an imprisoned South African attorney. (Pablo Picasso had received the prize in 1950.) The awards committee praised Kent as an "artist whose works are permeated with warmth and respect for man—the toiler and fighter," and cited his efforts against the "dirty war" in Vietnam. He and Sally traveled to the Soviet Union for the ceremony. When asked several months later how he would use the accompanying cash award, Kent let slip his having donated ten thousand dollars of the prize toward the purchase of medical supplies for the women and children of the South Vietnamese Liberation front. He called it "a token of my shame and sorrow," while U.S. Treasury officials called it a violation of the Trading with the Enemy Act and promised an investigation.

With Au Sable Forks so near to Montreal, a letter bearing a Canadian stamp was no more surprising than the Canadian currency that occasionally ended up in Kent's pocket change, but in the winter of 1967, he received a letter from Canada that astonished him. Joseph R. Smallwood, the premier of Labrador and Newfoundland, wrote that, in reading through the papers of a former premier, he had discovered details of Kent's banishment from the colony as a supposed German spy fifty years before. He continued:

I hardly knew whether to laugh or cry, and I resolved then that I would try to do something to re-establish Newfoundland in your books. I certainly would not blame you if you felt nothing but revulsion at the thought of Newfoundland, and yet from all I have read of yours, and heard about you from mutual friends, I would truly be surprised if you had not taken it all with good humor.

How can Newfoundland show her regard for you?…Would you come back here? Would you be this Government's guest on a visit back to Newfoundland, including Brigus?…Please forgive us for past injuries, and please be magnanimous enough to be our guest some time at your convenience.

That ancient episode, known as the "Tragedy of Newfoundland" in the Kent family lore, would finally be resolved, put to rest through what Rockwell appreciated as an atoning act. "Had wishes but been jet planes," he said, "I'd have been there within hours!"

IN APRIL 1968, KENT RECEIVED A LETTER FROM PETER DIRLAM. HIS NEIGHBOR, Robert Gross, had written to the artist in 1937 about "a matter which has been a long desired wish of mine; that of possessing a personal bookplate designed by you." Gross was at that time a steel-mill foreman for Ford Motors in Detroit. He explained to Kent that, although the Depression had halted his studies at Stanford University, he continued to read Shakespeare and Walt Whitman. Kent's illustrated editions of their works had led him to begin collecting the artist's books, most recently *Later Bookplates & Marks*. In describing his small personal library, he said, "I am learning to gain a whole lot from a little good, rather than very little from a whole lot of not much." In responding, Kent said, "This is a fine letter that you have written me and one that makes me eager to design a mark for your books. Sometime I will do it but not right now for I am snowed under with work.…Liking your letter, I feel that I may leave the price to you. If you tell me that I should, I will make it for a fraction of my regular charge."

Gross failed to follow up on Kent's promise, but thirty-one years later, he encouraged his young neighbor to write to the artist about designing a bookplate for his collection of books about polar culture and exploration. Peter Dirlam wrote:

I am a man of the Arctic, bitten heart and soul. My interest was aroused at Cornell in 1956 by a course in Old Norse literature. Two years later, I visited Iceland to explore Viking remains. The long summer days captured my

imagination. Then on to Lapland, Greenland, and the Arctic Institute in Leningrad. I imported sperm whale teeth to America, expanding the business to include Eskimo Art.

He went on to explain that, despite having sold his import business, "the seeds of academic interest had already been sown to bear later fruit" through his establishment and support of Arctic book collections in three libraries. It was for these volumes that he hoped Kent would design a bookplate. He enclosed sample bookplates from two of the libraries. Kent responded without delay:

> *Perhaps I ought to admit that my conscience has been troubling me for the past thirty years about my non-fulfillment of a promise made to Mr. Gross—now that you remind me of it—I do regret not having kept my word, I must admit that the details of the matter have completely left my memory—and it is now too late for me to do anything about it.*
>
> *And too late for me to now undertake the making of any bookplates. However, I am too appreciative of the importance of the collections that you are subsidizing to not want you to have an appropriate bookplate—more appropriate, that is, than either of those you sent me samples of. The Cornell bookplate is, to be sure, a dignified conventional institutional label; but the other one is in my judgment just plain horrible. But the best I can do now is to suggest that you look over drawings of mine reproduced in my autobiography,* It's Me, O Lord. *You may be able to find a copy in a good library.*

Although Kent was then completing the painting he called *Lilacs,* he knew better than to trust his failing eyesight to a small drawing. He suggested two illustrations from *It's Me, O Lord* that might be appropriate, then continued: "Should you want to use a drawing of mine I would like to lay out the bookplate and have charge of having it printed, for good design in bookplates lies in more than just the picture used." It was the best he could do, certainly more than he had intended, and Dirlam chose the image of an Eskimo woman that Kent had drawn for the jacket of *Land of the Good Shadows,* a 1940 book by Heluiz Chandler Washburne.

The Dartmouth College Library was one of the recipients of Dirlam's generous endowments, but Edward Lathem, the librarian, had reservations about the chosen image. Although he appreciated the coup of Kent's involvement, he argued that its detail would "reduce to a mere blob of black and white" when sized to fit a bookplate:

Your resurrection of Rockwell Kent (and I must put it that way, for I would have guessed that he would have been dead for years) startles me most agreeably. What a shame he is not able to take on the creation of a wholly new design for a bookplate, but I have enthusiasm for the idea of adapting one of his existing illustrations.

As I look through his Moby-Dick, *the one that strikes me as most suitable to our purposes is a piece of scrimshaw that might be used in the manner I have sketched on the enclosed sheet.*

Dirlam forwarded Lathem's letter to Kent, who was indifferent about using his scrimshaw illustration from Chapter 58 of *Moby-Dick*.

Unknown to Kent, the distinguished book designer-typographer Lester Douglas had borrowed the scrimshaw drawing for a bookplate he designed for himself.

It is clear from your letter and Mr. Lathem's letter that you two have quite different tastes in the field of bookplate design. If you hold him to be the arbiter in the matter there is nothing for it but that you use the scrimshaw sperm whale tooth—though of all the drawings in any of my books it is to me of least significance and so far removed from being in any sense a work of art... I give you and him full permission to use the drawing, together with the sans serif type that Mr. Lathem prefers, leaving it to him and his printer to arrange it typographically as they please. But the bookplate should not be considered, or even spoken of, as designed by me. However, I assure you I haven't the least objection to the drawing being used in that way. But I do suggest that the printer send the linecut that he makes of the drawing, and a proof of it, to me, for I would want to do a bit of hand tooling on the plate to clean up some of the lines.

Undaunted, he described how his own choice, the illustration of the Eskimo woman, would be printed with gray as the second color, how the type would be positioned and printed, and how he would make the color separation himself in order to reduce Dirlam's expenses. Then, in one short paragraph, he put the question of his imagined demise to rest:

I am as amused at Mr. Lathem's having thought that I was dead as he might be unamused at learning that I had never heard that he had lived. But of course don't tell him that.

Dirlam enjoyed Kent's comment and wrote to assure him that there was no question in his mind of the artist's vitality, and with that he directed Kent to proceed with the bookplate as he envisioned it:

Librarians will come and go, but I hope that my collections will have some degree of permanency. I am sure that a departure from "simplicity" in Dartmouth's bookplates will please many, quite probably Mr. Lathem himself when he sees the completed work and knows that this is how I want it. Then, too, this is not to be for Dartmouth alone but also for Cornell, Jacob Edwards Memorial Library (Southbridge), and my own personal collection. Our librarian in town is just delighted with a "Kent by Kent" plate.

Kent was pleased with Dirlam's decision: "I recall that past experiences with committees compelled me occasionally to refuse to attempt bookplates that were to be carried out under [their] auspices," an obvious reference to his three-year ordeal with the Mallinckrodt memorial bookplate. There would be four versions. Kent wrote to the book publisher for permission to use the image, designed the layout, took charge of the typography and color separations, wrote the printer's specifications and contracted the printing. And he provided his services free of charge:

It has been only a pleasure to have done this little job for you, and I have been particularly glad to have been allowed to have it done by the Colish Press, for I had years of happy, close association with Louis Colish's father.

Colish, on the retirement of Elmer Adler of Pynson Printers fame, succeeded to all of Adler's printing of my work. Elmer Adler died a few years ago in Puerto Rico where, under governmental patronage, he had established in San Juan a beautiful museum of books and other notable Puerto Rican printed records.

At eighty-five, Kent had thought it too late to take on another commission, but the Dirlam job helped to restore his vigor and sense of usefulness. Also, there were signs of renewed interest in his illustrated books. That summer he learned that a copy of *It's Me, O Lord* had sold at auction for $22.50. "The highest price yet paid for a twentieth-century autobiography," he boasted. It was a small bit of recognition that he found gratifying, whether or not the bidder realized he was still alive. *Voyaging* was about to be reprinted, and his *Moby-Dick* had recently been published in Prague, and in his opinion: "It, like the Moscow edition, is far superior to the trade edition issued by Random House." As for his painting, the Richard Larcada Gallery in New York was representing his work, with preparations underway for a retrospective at Bowdoin College, his first American exhibition in decades.

Peter Dirlam's bookplates were briefly put aside in July for Kent's return

visit to Newfoundland. Fifty-eight years had passed since he first arrived there—a haphazard two-week journey by railroad and steamer, as well as on foot—but after the three-hour flight from Montreal, Rockwell and Sally received a warm welcome in St. John's, the bustling provincial capital. Only the beauty of the country's rugged geography remained the same. No longer a remote outpost, modern Newfoundland called itself the "happy province," and Kent was impressed by the government's vision and devotion to serving its citizenry. Their itinerary included an introduction to the country's growing community of artists, whom he recognized as "fellow picture-painters happily at work, *at home* in Newfoundland."

And as Smallwood promised, they visited the coastal town where Rockwell had settled with Kathleen and their children:

> *Brigus, where half a century ago I'd lived, seemed to my eyes little changed— but for the absence of its harbor of those sailing vessels that in former days had been its pride and glory....But the event that was to me the most deeply moving experience was my revisitation of the house that, in those earlier years, I had all but actually* built, *in the fond hope—no, more than that,* belief— *that it should be our family home for years to come.*

He wept at the sight of the shingled house that still bore his handiwork: "What hopes of happiness had been built into that house!" When he and Sally departed at week's end, he realized that they were leaving as "but tourists in a foreign land" and recalled the closing lines of Byron's "When We Two Parted":

> *If I should meet thee*
> *After long years,*
> *How should I greet thee?—*
> *With silence and tears.*

Work resumed on Peter Dirlam's bookplate, and in September the layout of what would be Kent's final bookplate was delivered to the printer. Two thousand of each version were ordered. When Dirlam noticed that the artist had failed to include his signature, Kent confessed that it was "an oversight I am often guilty of" and asked Louis Colish to engrave "a tiny RK on the lower right-hand corner of the black plate."

After his bookplates were delivered in December, Dirlam wrote to Kent that "Ed Lathem at Dartmouth, who originally threw cold water on the

idea, wrote a most enthusiastic letter about them when he finally saw the finished project." He asked the artist to interpret the illustration, and Kent replied:

I think of the woman as expressing, with her outspread arms, her joy at the return of the sun in spring—an event that is received joyously by all the people living north of the Arctic Circle.

Kent once said that "much though we admire Frank Lloyd Wright as an architect, he could only build a house. It is the people who live in houses who can make them homes." He had built and rebuilt houses from Monhegan and Brigus to County Donegal; and each had stubbornly denied him more than temporary shelter. It was only the house at Asgaard that became an enduring home for him, first with Frances and then Sally. But in April 1969, as the couple slept, a bolt of lightning set it ablaze. Managing to escape, they watched from his old station wagon as the Au Sable volunteer firemen arrived to find the structure engulfed in flames. Despite a downpour of rain, they realized the impossibility of saving the house and set about pitching paintings and books out onto the snow-covered ground. The *New York Times* reported the loss of "at least 20,000 books, many of them first editions." Fortunately, many of Rockwell's paintings had been shipped to Bowdoin College in Maine for the upcoming exhibition. His letters and papers, already packed in cartons for transfer to the Archive of American Art, were also rescued.

At daylight, two walls stood over the water-filled cellar, a black pool that hid fragments of priceless mementos as well as the pots and pans of everyday life. Sally compared the snow that began falling to a funeral shroud. It was Carl Zigrosser who understood, perhaps better than anyone, why that same morning Kent retired to his studio to begin sketching the plans for a new house that would rise from the old foundation:

His immediate response was to rebuild it in the same form and shape as it formerly had been. To be sure, it was not an exact replica: the second story was missing, which was used exclusively for guests. He could live and function on the first floor and not be aware of much difference. He wanted to blot out the memory of the calamity and live as before. The intensity of his determination could be revealed by asking how many men at the age

DIRLAM FUND
THE FISKE ICELANDIC COLLECTION
CORNELL UNIVERSITY

Bookplate for Peter B. Dirlam, 1968. One of four versions.

of eighty-six years would start rebuilding a home as he did. He had terrific will power and an unshakable belief that he could accomplish anything that he decided to do. This feeling of invincibility carried him successfully through most of his life. Whatever he could not meet and overcome—he was very competitive—he would obliterate and act as if it had never existed. Had he lost his faith, the whole structure of his life would have crumbled.

As one neighbor recalled, "He was excited about the prospect of a new house. It wasn't like it was the end of the world for them at all." Rockwell and Sally moved into the reconstructed house in September, and the daily rituals of their life resumed. Although he made the short hike to his studio less frequently and with increasing effort, he returned to his painting and began writing a sequel to *It's Me O Lord*. When a publisher proposed a new, limited edition of *Wilderness,* he readily approved the project and agreed to sign each of the fifteen hundred numbered copies. In 1970, he completed two canvases, *Whiteface Sunset* and *Woodsman,* before his morning walks to the studio ceased.

Only his legs had surrendered. When Bennett Cerf sent him copies of *My Lai 4,* an account of American atrocities in Vietnam, Rockwell replied:

Your publication of it at just this moment is an act that should prove, like virtue, its own reward to Random House, for Nixon's invasion of Cambodia should give the book a shocking impact on the now fully aroused public mind and conscience.... Only a few days ago you may have read, as we have, in an authoritative article in the New York Times, *that in science we have become a second-rate power—due, of course, mainly to our preoccupation with killing (and being killed by) the faraway people of Vietnam.*

THEN IN HER LATE FIFTIES, SALLY HAD JOINED ROCKWELL ON HIS DOWNWARD slope three decades earlier. Being unable to bear children had been a cause for sorrow in the early years, but destiny had given her "an artist to love around the clock without interruption." It had never been dull:

The turbulent years of anxiety in World War II, the coming of the Cold War that crushed the hopes of a rational society, the vicious McCarthy era, the almost retirement to our own little "principality" as Rockwell would call our peaceful farm acres; and then the almost rebirth of having found a land and people, the USSR, where his life and work were loved.

He demanded perfection, and she gave her best. He had taught her to bake bread; she had learned to knit the cable-stitched socks he preferred; and they lived on the produce from her garden. "Things to wear," she recalled, "had long since been reduced to Montgomery Ward jeans and overalls, and a couple of sets of store clothes for city wear." Through it all, the stars had never faded; she remained bewitched by her artist.

On a chilly March evening in 1971, as he sat by the fireplace laboriously signing copies of the new edition of *Wilderness,* Sally watched as he leaned forward, then righted himself in the big chair, his favorite chair, and lost consciousness forever. His lifetime of almost eighty-nine years ended in a Plattsburgh hospital eleven days later. News of his death made the front page of the next morning's *New York Times* under the headline "Rockwell Kent, Artist, Is Dead; Championed Left-Wing Causes." Of his life, Sally would later write:

What is a book but just so many pages, so many hours of life. Or a painting but a day or two or three out of doors and some hours in the studio. What is a bookplate but a neat little drawing done to someone's fancy. Or a house but something that the local carpenter can build you any day. What is a handcarved mirror frame but some evenings of recreation with a piece of wood and a tool. What is a voyage in a small boat but something that fishermen do every day. What is a love letter but the finding of words that speak the heart. But if those are multiplied by hundreds and the days and hours span seas and continents, the houses built are multiple, the books illustrated legion, the canvases hundreds, the causes served numberless— pamphlets, speeches, lectures, photographs developed and printed at home, commercial drawings, murals, tableware, silverware, fabrics, letterhead devices. Add it all up and it is hard to conceive that one single human being, with no more than the twenty-four hours a day allotted to all of us, the same two hands and working almost single-handedly could accomplish so infinitely much.

APPENDIXES

I. By Way of Preface: On Symbols

by Rockwell Kent

DMITTING, to begin with, all that may be said for bookplates as an ingenious way to forestall the borrower's carelessness or thief's intention, and against bookplates as of no use whatever toward that end; for them as a proud and pretty way of marking books, and against them as so great a nuisance that few people ever paste them in; admitting that the trouble of them nowadays outweighs their questionable usefulness, we still may venture to pronounce with no uncertainty that bookplates, labels, letterheads, seals, pennants and whatever may be made to bear, proclaim and blazon to the world or to one's self a motto, crest or personal device, may influence and determine the course of civilization and the destiny of nations and of man. It is upon the romantic belief that heroes do make history, and that the conduct of ourselves and those we know does touch the problem of our happiness, that we depend our argument. And against the protest of one's right to that belief we urge its usefulness.

Published in 1937 as the preface to *The Bookplates & Marks of Rockwell Kent*, "On Symbols" was decorated with Kent's personal mark.

All men conduct themselves in life exactly, or as nearly as they may, as they want to; yet in the determination of those wants they are so subtly led, cajoled and played upon by the seductive whisperings of manner and custom, that, with the most splendid intentions in the world, they emerge, for the most part, merely civilized. Of all the means of the persuasive forces of tradition none is so fairly a refinement of idea—and by refinement pointed to its purpose, none so insidiously potent for the domination and enslavement of the mind—as that abstraction of a thought, the symbol. And with the symbol we are here concerned.

What was the idol but the symbol of a deity? How well the Christians knew that to destroy it was to kill the faith! What was the crescent to the faithful and the cross to true believers? The arms and crest of chivalry to those who wore them? How many a device of heraldry has transmitted its emblazoned thought through successive generations of its bearers—to mould and make what men have called at last that family character? All that those symbols were, in more believing times, the personal and chosen

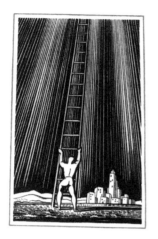

*Bookplate for Henry
Lewis Batterman Jr.,
ca. 1929.*

In *The Bookplates &
Marks of Rockwell Kent,*
it was identified as
6642 with the client's
name deleted. Here,
Kent jokingly refers to
it as the bookplate he
made for a boy who
climbed the ladder of
success—as a burglar.

symbol now may be to those who want to fix some thought or principle unto themselves, to make it theirs, to live toward it, for it, by it; to let it be the visual reminder of a faith or aim or of a mood experienced and reinvoked. It may lend imagination to prosaic minds or wake the dreamer; strengthen the weak and urge a personality toward genius. Yet accept with caution; for so unrelenting is the authority of the symbol that, like such potent medicines as need physicians to administer them, the prescribing of a symbol is a true function of the psychiatrist.

Toward the appreciation of the dangers of ill advised symbol taking I may, with some reluctance, give a tragic example from my own early experience, when, in response to a mother's request for such a bookplate as would make her son the President of the United States, I made him the device…and he became a second story man.

It is therefore with much reluctance, in my own practice of bookplate designing, that I have applied the science of psycho symbolism; and in the devices for my children and my friends I have, through incomprehension of the former and, for the latter, unconcern, done little except try by gentle flattery to please. Yet, in the design for Gordon Kent, I have ventured (and I may write it in these pages which he may not read) to determine his becoming a good horseman. That is enough.

R. K.
Ausable Forks, New York
January, nineteen twenty-nine

II. Again: By Way of Preface

by Rockwell Kent

O N the western foothills of Mt. Mansfield in Vermont is a region so devastated by the improvidence of human generations that only a few families still cling to what may once have been called farms: cling, weep or grin, endure, and propagate. And call it life. They vote as Maine.

Green Mountains? Where? Gone are the spruces and the hemlocks, the yellow, silver, and black birches, the black cherry trees of the wilderness, the oaks and beeches; and going—all but gone—the maple groves, the sugar orchards of the north. The ax has reached the heart.

On the once fir-clad mountain side the ground snow glares through stubble growth; the unobstructed north wind rakes the hills. It rakes the houses standing naked there, and whistles through their seamed, dilapidated walls. Old cellar holes are filled with drifted snow; drifts choke the dooryards, block the road. God, it can blow on these stark foothills of Mt. Mansfield! Blow, and snow. And it is just November.

"Come in! don't knock!" I stamp my feet on the doorstep, push open the flimsy door, brush the snow from my boots, go in: and there's a dirty smoke-begrimed, grease-spattered, tatter-papered, patch-plastered old kitchen; there's a shiny oilcloth on the table, a lamp on that, and lamp light shining on a lot of faces: good! It's warm in there, and friendly-like.

"Set down!" the woman says. I do. These are my neighbors, and I've come for milk. And while I'm waiting for it, while I'm saying: "Well, I guess we're in for a real one this time with the wind blackened to the norwest and no hope of a clearup till she works clear round to west again"; and him sayin': "That's right"; and her sayin': "I wish 'twould warm up so's I could patch the walls," and "We can't keep no fire goin' with that wet stuff *he* brings in, and "*He* ain't banked the house yet, and it's no wonder we're froze," and "I sometimes wish the old thing would burn up—only we haven't got no insurance," and—oh, plenty more along these general lines; while all this time I'm waiting, something or other has been going on around the stove and table. And before I know it there's a dish of beans, a plate of cold pork, a cup of

Kent wrote "Again: By Way of Preface" for *Later Bookplates & Marks of Rockwell Kent,* published in 1937. It was written in the isolation of his Asgaard studio, with references to Vermont, where he had taken an active role in the marble workers' strike that year, and to Minnesota, where he and his family had lived in an abandoned schoolhouse many years earlier. He was most likely reading a biography of Marx. His "voluntary seclusion" and loneliness were real, and the references to romantic literary couples allude to the frustration of his waning marriage.

coffee, bread and butter, a dish of stewed raspberries and a lot of other things, and a plate, knife, fork and spoon in front of me. "Now set right there and eat," says the woman. "You ain't had your supper yet; we know that." I do exactly as I'm told.

"But ain't you lonely down there by yourself?" my hostess asks me as I pat my full belly and get up to go. "A little bit," I answer her; and lie.

More isolated, lonely, uninhabitable than the ramshackle four room residence of my neighbors was the "abandoned" one room school house which for a few weeks past I've made my home. It had four walls, a roof, a windy floor; six windows furnished light—and *air! "Welcome,"* my thoughts read on the snow-drift door mat. A chunk-stove was its hearth and fireside: none better. But, as I had learned by peering in through battened windows on my first discovery of the place, it was furnished. School desks and seats had been removed, and in their place were proper chairs and tables and such added embellishments as fitted the summer evening picnic camp that the old school house had in fact become. No matter how I tracked the owner down; great matter what he said. Before in my eagerness I could even frame my plea to rent the house, his hand had found the key. "There," said the professor, "the house is yours." And with these words we come suddenly and quite unexpectedly to the very subject of this preface: *Bookplates* (marks of ownership) *and*—but wait, the narrative! "But ain't you lonely down there by yourself?" the woman asks. "A little bit," I say; and *lie*.

Ha! waiting for me in that abandoned house, that misanthrope's retreat, waiting for my return with patience that mocked the passage of time, waiting there—but incidentally, no more heeding the draughts of my chunk-stove than King Alfred did the pancakes—was a being with whose past life and thought I had recently become familiar to a rare and privileged degree, by whose tragic circumstances I had been deeply moved, to whose doctrines I responded as to the voice of God within myself, and at whose destiny in the eventual memory and institutions of mankind I could but dimly yet impressively surmise. Familiar to all the world as were the name and achievements of my distinguished guest, and deeply humanitarian as was the underlying purpose of his work, it was of so severely impersonal and uncompromisingly logical a nature as to exclude all conjecture as to the quality of man behind the thought. That human quality, there in the uninterrupted seclusion of my school house, I had come to know.

How, indeed, without knowing it, without applying to his doctrines, as he himself repeatedly and consistently enunciated them, that *reasonable* interpretation which the mind seeks, could I have persisted in that work of

designing labels of ownership for which—aside from entertaining of my guest—I had gone into voluntary seclusion? "The abolition of private property?" I cry at him, quoting his very words. "Of the right to own, for instance, books? Are books no more than *things?* Are they not, rather, Life, its multiple reincarnation? The re-creation, wholesale and for everyone, forever, of beings that a parsimonious God made mortal and unique? Tristam and Iseult through books live on; and Héloise and Abélard; and Romeo and Juliet; and Faust and Gretchen ('Verweile doch, du bist so schön!'): as long as mankind loves, its lovers shall live on. And books shall endure as long as the love of beauty lasts. And until happiness becomes as common and forgotten as the air we breathe, the men who led the fight for it shall live. They *live,* these leaders of mankind, in books. *You* live, bearded and shaggy-maned iconoclast, my guest; and with an intimacy more privileged and penetrating than friendship in the flesh may ever have achieved, I and a million others—through your published letters, works, your 'Life' that I am reading—know you. Might it not have been in Prospero's library that Miranda cried:

From Goethe's *Faust,* the line is translated "Stay nevertheless, you are so beautiful."

> 'O wonder!
> How many goodly creatures are there here!
> How beauteous mankind is! O brave new world
> That has such people in't!'

Kent quotes William Shakespeare, from *The Tempest,* Act V, Scene 1.

Books are not things, they're people multiplied; their friendships are as inexhaustible as Shelley's love: "that to divide is not to take away." And the possession of them, Karl, far from conflicting with your doctrine is— if we will only think of books as friends toward whose cultivation we must cultivate ourselves and for whose enjoyment we must have leisure—the possession of books is both the promise of a richer life and, in degree, the sign of its fulfillment. Ah, there is much, thank God, to be desired in life! And books stand high. For leisure, education, books, "Workingmen of the world unite! You have nothing…"

The Percy Shelley line is from his 1821 poem "Epipsychidion."

"Look here!" interposes my long suffering publisher, "What's all this about? Get to the subject I assigned to you: *Bookplates and—*"

"Yes, Yes, I know:" I interrupt him, *"Marx!"*

R. K.
Vermont
November 1936

III / The Bookplates of Rockwell Kent

Katherine Abbott, 1920 *(page 35)*

Katherine Abbott, 1927 *(35)*

Frederick Baldwin Adams Jr., 1936 *(88)*

Elmer Adler, 1927 *(48)*

Nicolai Alexeevich, 1960

Albright Art Gallery, 1934

Arthur S. Allen Jr., 1928 *(67)*

Arthur G. Altschul, 1940 *(106)*

C. A. (Charles Amiguet), ca. 1920 *(32)*

Antioch Press, 1950–57

 Y-51 Pegasus *(145)*

 Y-52 hangman *(145)*

 Y-53 seated man *(145)*

 Y-54 open book *(145)*

 Y-55 tree stump *(146)*

 Y-56 actress *(Pauline Lord) (146)*

 Y-57 waterfall and trees *(146)*

 Y-58 Alaska *(Anne Rosenberg) (146)*

 Y-59 man and woman *(149)*

 Y-50 seated woman *(149)*

Merle Armitage, 1929 *(63)*

George Edwin Avery, 1936 *(88)*

Bangor Public Library, 1949 *(157)*

Henry Lewis Batterman Jr.
 (known as 6642), 1929 *(192)*

Leod Daw Becker, 1937 *(93)*

Gordon A. Block Jr., 1938 *(162)*

Henry S. Borneman, 1942 *(120)*

Byron O. Brewster, 1936 *(94)*

Briarcombe Farm, 1913 *(23)*

Ruth S. Brokaw, 1937 *(93)*

Katharine Brush, 1934 *(79)*

H. C. (unidentified), 1923 *(32)*

Bennett A. Cerf, 1928 *(48)*

Chicago Latin School, 1928 *(50)*

Eleanor B. Church, 1945 *(128)*

Jeanette Clarke, 1958 *(167)*

Bruce David Colen, 1948 *(133)*

College of Preachers, 1928 *(49)*

Dexter G. Cook, 1937 *(93)*

George Henry Corey, 1941 *(119)*

O.D.D. (Olga Drexel Dahlgren), 1927 *(41)*

Marjorie & Richard Dammann, 1936 *(97)*

Martha B. Willson Day, 1945 *(128)*

Charles & Rosamond Denby, ca. 1929

Gregory Desjardins, 1941 *(119)*

Peter B. Dirlam (four versions), 1968 *(185)*

Monroe Franklin Dreher, 1934 *(76)*

Carl W. Drepperd, 1931 *(75)*

Edward Price Ehrich, ca. 1929 *(63)*

Elizabethan Club, Yale University,
 ca. 1929 *(49)*

Elnita Straus Library, 1936 *(80)*

Burton Emmett, 1928 *(49)*

Stephen Morgan Etnier, ca. 1933 *(75)*

Charles Ewing, date unknown *(11)*

George R. M. Ewing Jr., 1928 *(60)*

Kathleen Kent Finney, ca. 1940 *(105)*

J. Whiting & Helen Otillie Friel, 1953 *(158)*

H. M. G. (Harry M. Geller), 1962 *(177)*

The basis for this list is a checklist compiled by Dan Burne Jones in 1976. Works that were most likely intended to serve as trademarks or letterheads are not included. Completion dates are taken from Kent's correspondence with his clients and printers, as well as his own several attempts to date the early bookplates for collectors.

Earl H. Gibson, 1966 *(178)*

Burns Gillam, 1943 *(127)*

Greenland Press, 1941

 A woman embracing book *(137)*

 B running man *(Merle Armitage)*

 C boy and dove *(137)*

 D ship's figurehead *(137)*

 E nude woman *(Helen Lowry) (137)*

 F charioteers *(Gilbert H. Doane) (138)*

 G bird cage *(H. C.)*

 H nude man on rock *(138)*

 J waterfall *(Gerald Kelly)*

 K *Reader (138)*

 L Artemis *(Ruth Porter Sackett) (138)*

 M Greenlander *(A. C. Rasmussen)*

 O book and flower *(Katherine Abbott)*

David Grutman, 1956 *(167)*

Robert J. Hamershlag, ca. 1929 *(60)*

Ray Baker Harris, 1937 *(97)*

Leo Hart, 1934 *(76)*

Hazel & Richard Harwell, 1936 *(87)*

Raymond Dexter Havens, 1931

G. M. H. (Gertrude Morgan Hawley),
 ca. 1937

Edward W. Hickey, 1940 *(106)*

Marie Luise Hinrichs, 1942 *(120)*

G. E. H. Jr. (George E. Hite Jr.), 1936 *(80)*

E. Josephine Holgate, 1923 *(11)*

Lucille Holt, 1933 *(76)*

N. G. H. (Nathan G. Horwitt),1925 *(61)*

Nathan G. Horwitt, 1929 *(61)*

Joseph O. Jackson, 1956 *(168)*

Edmund Johnstone, after 1940 *(105)*

Jacquie & Dan Burne Jones, 1956 *(168)*

Blanche Kednay, 1936

Gerald Kelly, 1920 *(35)*

Alan Horace Kempner, 1937

Joe E. Kennedy, ca. 1937 *(88)*

Frances & Rockwell Kent, 1928 *(59)*

Gordon Kent, 1928 *(59)*

Kathleen & Rockwell Kent, ca. 1920 *(31)*

R. L. K. (Richard Lee Kent), 1928 *(59)*

Rockwell Kent III, 1928 *(59)*

Sally & Rockwell Kent, 1947 *(105)*

S & R Kent (Sally & Rockwell Kent),
 1955 *(186)*

LeRoy Elwood Kimball, 1937 *(87)*

Florence King, ca. 1920 *(31)*

William A. Kittredge, 1929 *(62)*

Blanche & Alfred Knopf, 1928 *(47)*

Emily Milliken Lambert, 1928 *(48)*

Louise & Gilbert Lang, 1926 *(41)*

N. L. (Nancy Lee), ca. 1920 *(32)*

Leonard L.Levinson, 1941 *(119)*

Library of Congress, Rare Book
 Collection, 1936 *(87)*

Literary Guild of America, 1947 *(143)*

 A mountain climber

 B Sally

 C flower and open book

 D standing woman

Pauline Lord, 1937 *(94)*

H. L. (Helen Lowry), 1928

Edmond Lyon Memorial, University
 of Rochester Library, 1928

Helen & George Macy, ca. 1938

Edward Mallinckrodt Memorial, Lamont
 Library Harvard University, 1953 *(157)*

Billie & Stanley Marcus, 1936 *(87)*

S. M. (Somerset Maugham), ca. 1929 *(63)*

Paul Mayo, 1933

Albert Alexander Mendez, 1923

George Milburn, ca. 1928 *(62)*

Elizabeth Miller, ca. 1923 *(32)*

Perry A. Molstad, ca. 1929

Ray Slater Murphy, ca. 1926 *(62)*

J. B. Neumann, 1929 *(63)*

Northrop, 1933 *(79)*

Vladimir Orlov, 1966 *(179)*

H. P. (Helen Pearce), 1928 *(60)*

Marjorie & Duncan Phillips, 1926 *(44)*

Loring Pickering, 1946 *(128)*

Samuel Loomis Prentiss, 1913 *(23)*

Margaret & Ralph Pulitzer, 1928 *(64)*

P. R. (unidentified), 1920

A. C. Rasmussen, 1933 *(76)*

Lucie Rosen, 1922 *(41)*

Anne Rosenberg, 1927

A. M. R. (Arthur M. Rosenbloom), 1942
 (120)

M. & J. S. (unidentified), ca. 1929

Margaret Sanger, 1944 *(23)*

Charles Gebner Schreiber, 1928 *(60)*

Anne & Morris Slemons, 1934 *(79)*

Juliet K. Smith, 1937 *(97)*

Donald Snedden Memorial, Stamford
 University Library, 1938 *(98)*

Society of Jesus, 1957 *(168)*

G. Hamilton Southam, 1935 *(80)*

Maxwell Steinhardt, 1928 *(47)*

Iphigene Ochs & Arthur Hays Sulzberger,
 1928 *(47)*

George & Alma Tatum, 1941 *(111)*

L. U. (Louis Untermeyer), 1937 *(94)*

Irene von Horvath, 1955 *(167)*

E. F. & T. C. v S. (Elizabeth F. &
 Theo. C. von Storch), 1930 *(70)*

Warner Library, 1947 *(133)*

Estelle & Edwin Weiss, 1934 *(79)*

Mary C. Wheelwright, ca. 1923 *(41)*

Frank H. Whitmore, 1934 *(73)*

John Hay Whitney, ca. 1925

Arthur Wiesenberger, "Security," 1948 *(133)*

Lucius Wilmerding, 1937 *(93)*

Carl Zigrosser, ca. 1920 *(31)*

Carola Zigrosser, 1933 *(75)*

Projects

Lydia Ancker

Roy Dikeman Chapin

Gilbert H. Doane *(Greenland Press, F)*

Barbara Kent, 1928

The Lawrenceville School, 1939

Stanley Marcus, 1936 *(LeRoy E. Kimball)*

Harry McGuire, 1943

Harry J. O'Neil

John R. Palmer *(George Edwin Avery)*

Austin Riggs

Ione Robinson, 1928 *(50)*

Mary Ryan & Marion L. J. Lambert

E. A. Rodgers, 1945

Ruth Porter Sackett *(Greenland Press, L)*

David Sarnoff, 1933

Charles Schwarz, 1927

John J. Smith, ca. 1928 *(George Milburn)*

Mai Elmendorf Walker

Sketches exist for a number of bookplates that are not known to have been completed and printed for the original client. In several cases, they were transferred to another client or adapted for use as commercial bookplates.

Notes

References to the Rockwell Kent Papers of the Archives of American Art are cited as RKP; to Kent's autobiography *It's Me O Lord*, as IMOL.

• **Preface, xi:** "nothing that could...," Rockwell Kent, *N by E*, 38–39; "My master's name...," Hardy, *Book-Plates,* 163; "He who would...," Scott, *Book-plates of To-day*, p. 56. **xii:** "a personal matter," RK to Harry M. Geller, 7 Oct. 1961, RKP; "the store should...," RK to Manny Greenwald, 17 Sept. 1941, RKP; "I am...," Traxel, p. 117; "The theft of..., RK to JOJ, 19 Nov. 1955, RKP; "Books are not...," Kent, "Again: By Way of Preface," *Later Marks and Bookplates of Rockwell Kent.*

• **Chapter One, 3:** "I began, like...," Kent, "Rockwell Kent," RKP; "a niggardly patroness...," IMOL, 26; "I [was] brought...," Kent, "Rockwell Kent," RKP. **4:** "widow's household," IMOL, 43; "Besides being a...," ibid.; "square-bearded silhouette...," ibid., 23; "a species of...," ibid., 53–54; "Since in all...," ibid., 62; "That, upon reading...," ibid., 323. **5:** "Quite obviously...," IMOL, 43; "The two little...," ibid., 44; "I have no...," ibid., 51. **6:** "a career at...," IMOL, 65; "to conform to...," ibid., 72; "revolutioniser," Homer, *Robert Henri and His Circle*, 27. **7:** "All will be...," IMOL, 54. **8:** "If he showed...," IMOL, 82; "Henri was in...," ibid.; "They lived for...," Kent, "Feild-Kent Manuscript," RKP. **9:** "Books began to...," IMOL, 90; "It's funny, I...," ibid., 92–93; "I was as...," ibid., 90–91. **10:** "The time had...," ibid., 93. **12:** "the active companionship...," IMOL, 95; "a wonderful place...," Homer, op. cit., 12; "Probably for no...," Zigrosser, *The Artist in America*, 46; "It was enough...," IMOL, 120; "I worked as...," Kent, "Rockwell Kent," RKP. **13:** "all stewed up...," Brooks, *John Sloan: A Painter's Life*, 126; "Far the most...," IMOL, 150; "Went over to...," Sloan, *John Sloan's New York Scene*, 408. **14:** "Plain, alluring little...," IMOL, 155; "This Sunday night...," ibid., 156; "Why do you...," ibid., 159.

• **Chapter Two, 15:** "never won entire...," IMOL, 101; "Kathleen, a tall...," ibid., 169; "marriage to someone...," ibid., 160; "Kathleen, however much...," ibid., 179; "good people, people...," ibid., 181. **16:** "pretty generally disliked," RK to KW, 6 Sept. 1908, RKP; "It is almost...," RK to KW, 29 Oct. 1908, RKP; "darling, darling little...," RK to KW, 1 Nov. 1908, RKP; "The Whiting family's...," IMOL, 181; "I had never...," ibid., 186; "Our long winter...," ibid., 186–187. **17:** "not so far...," IMOL, 322; "the reverence of...," ibid., 186; "If the enjoyment...," ibid., 258; "as my young...," ibid., 199; "that most stupendous...," ibid., 194. **18:** "in the scheme," Sloan, op. cit., 397; "a pale willowy...," ibid., 407; "The Kents arrived...," ibid., 414; "went into raptures...," Brooks, *John Sloan: A Painter's Life,* 126. **20–21:** Entries from John Sloan journal, 6 Oct. to 4 Nov., 1910, Sloan, *John Sloan's New York Scene*, 462-73. **20:** "that rumored, stern...," IMOL, 205. **21:** "Dear wife, dear...," ibid., 218; "Jennie—

all that...," RK to Jennie Sterling, 14 Dec. 1910, RKP; "Poor Rockwell Kent...," Sloan, op. cit., 517. **22:** "When five o'clock...," IMOL, 250; "a constant visitor...," ibid., 246; "friendship at first...," Zigrosser, *A World of Art and Museums,* 28; "as angelically beautiful...," ibid., 250; "Greenwich Village seemed...," Zigrosser, op. cit., 28; "It was somewhat...," IMOL, 258. **24:** "the chain gang," IMOL, 274; "As the steamer...," ibid., 282; "Not for a...," ibid., 284. **25:** "A man's clambering...," Kent, *After Long Years,* 7; "What in fact...," ibid. **26:** "I was so...," Margaret Sanger to RK, 29 Dec. 1915, RKP; "fortunes reached their...," IMOL, 321; "This last affair...," KWK to RK, 26 July 1917, RKP; "where men are...," Rockwell Kent, *Wilderness: A Journal of Quiet Adventure in Alaska,* xxvii; "Do stop for...," KWK to RK, Sept. 1917, RKP. **27–28:** "a husky lad...," IMOL, 326; Journal entries, 25 Sept. to 13 Dec. 1918, *Wilderness.* **28:** "Paradise is far...," RK to Carl Zigrosser, 13 Dec. 1918, RKP; "I told [Rocky]...," Kent, *Wilderness,* 163; "the end of...," ibid., 181.

• **Chapter Three, 29:** "of numbered streets...," IMOL, 339; "a ridiculous figure...," RK to CZ, 23 Nov. 1918, RKP; "isolation—not from...," Kent, *Wilderness,* 106; "It's more beautiful...," RK to CZ, 20 June 1919, RKP. **30:** "I was a...," Zigrosser, op. cit., 131; "Tonight I've made...," Kent, *Wilderness,* 61; "Into the smooth...," Kent, "Text for 'The Lovers,'" RKP; "Engraving in my...," IMOL, 353–354. **33:** "The introduction of...," Zigrosser, op. cit., 38; "a democratic art," Kent, *How I Make a Woodcut;* "in every sense...," ibid.; "Often I wish...," RK to CZ, 23 Aug. 1950, RKP; "Our differences, such...," Zigrosser, op. cit., 147; "Gerald, a man...," IMOL, 379. **34:** "On the whole...," GK to RK, undated, RKP; "the most remarkable...," *New Statesman,* 31 July 1920. **36:** "fine houses, pretty...," IMOL, 355; "They had good...," ibid., 89; "He often went...," Zigrosser, op. cit., 134; "One didn't look...," IMOL, 355; "emotional mess," ibid., 357; "a somewhat desperate...," ibid., 356.

• **Chapter Four, 37:** "From the 20th...," Bennett, *Elmer Adler in the World of Books,* 60. **38:** "an instigator...," (Frederick Baldwin Adams), Bennett, op. cit., 8; "the most uncommercial...," ibid., 92; "the last place...," *New York Times,* 12 Jan. 1962, 35. **39:** "We had to...," IMOL, 372; "the craziest man...," John V. A. Weaver to RK, 29 Aug. 1921, RKP; "I am a...," Traxel, p. 117; "If I had...," IMOL, 397. **40:** "had come to...," IMOL, 384; "And now I...," ibid., 380; "a problem child," ibid., 401. **42:** "When a coarse...," Kent, "There is no such thing as Commercial Art," *Professional Art Quarterly,* vol. 2, no. 4, June 1936, 6; "Carl Zigrosser, either...," IMOL, 430–31; "Of all the...," ibid., 413; "The moment that...," ibid. **43:** "learned that Frances...," from Cazenove G. Lee Jr. to RK, 12 Feb. 1936, RKP; "As you know...," Duncan Phillips to RK, 25 Feb. 1927, RKP; "He had volunteered...," from DP to RK, 12 June 26, RKP; "Your generous...," ibid. **44:** "first adventure in...," IMOL, 414; "a nice young...," Elmer Adler to RK, 8 Sept. 1926, RKP. **45:** "In an effort to...," William A. Kittredge to RK, 16 Sept. 1926, RKP; "Believe me, Mr....," ibid., 30 Dec. 1926, RKP. **46:** "I never thought...," BC to RK, 11 Dec. 1928, RKP; "One day Rockwell...," Cerf, *At Random,* 65; "He would later...," from RK to Anne Colen, 11 Feb. 1948, RKP. **51:** "the leading commercial...," Cerf, op. cit., 65; "a beautiful and...," Kent, *This Is My Own,* 67; "I am learning...," Robinson, *A Wall to Paint On,* 31–32; "I have finally...," ibid., 33-34. **52:** "It was my great...," IMOL, 430.

• **Chapter Five, 53:** "a lovely child," IMOL, 409; "We had the...," ibid., 426; "the John Singer...," ibid., 84. **54:** "While Kent flaunted...," from Levin, *Edward Hopper: An Intimate Biography,* 210; "contribute an editorial...," Albert Boni to RK, 23 Sept. 1927, RKP; "a machine for...," Traxel, *An American Saga,* 143; "all day and...," IMOL, 432; "a bit of...," Robinson, op. cit., 46; "When I was...," Kent,

"Rockwell Kent," RKP. **55:** "So when you...," RK to FLK, 27 Feb. 1928, RKP; "a spendthrift's place...," Kent, *This Is My Own,* 352; "level land for...," Welsh, *The View from Asgaard,* 11; "At first glance...," IMOL, 434; "And there are...," Kent, *This Is My Own,* 80. **56:** "I suppose that...," WK to RK, 8 Sept. 1927, RKP; "The expressions of...," WK to RK, 16 April 1927, RKP. **57:** "I shall be...," RK to WK, 19 April 1927, RKP; "give (eventually) my...," RK to FLK, 20 March 1928, RKP; "my book-loving...," RK to EA, 25 June 1936. **58:** "This evening I...," Rockwell Kent III to RK, 9 Jan. 1927, RKP. **65:** "unassumed naturalness...," IMOL, 355; "the gentle, noble...," ibid.; "As you know...," RP to RK, 11 Aug. 1929, RKP; "I entered the...," MA to RK, 3 May 1929, RKP. **66:** "It is difficult...," *Saturday Review,* 6 July 1929. **67:** "I have had...," AA to RK, 28 Jan. 1929, RKP; "He was a...," IMOL, Kent, *N by E,* 4; "Father has the...," SA to RK, 5 Feb. 29, RKP; "something forbidding about...," Kent, *N by E,* 8; "In such wind...," ibid., 28; "We have encountered...," SA to AA, 3 July 1929, RKP. **68:** "lost ship on...," SA to AA, 17 July 1929, RKP; "Her mission well...," IMOL, 440; "No explanation of...," *New York Times,* 24 July 1929, 13; "a very triumphal...," AA to N. Winship, American Consul General, Copenhagen, 27 Sept. 1929, RKP.

• **Chapter Six, 69:** "I had come...," IMOL, 441. **70:** "This is my...," Theo. von Storch to RK, undated 1928, RKP; "I have only...," RK to TvS, 6 Jan. 1930, RKP; "I haven't much...," TvS to RK, 11 Jan. 1930, RKP. **71:** "I am permitting...," 30 June 1930, RKP; "very serious burden...," IMOL, 473; "greatest, deepest pleasure...," ibid., 437; "kept the pot boiling...," RK to CZ, 21 Oct. 1930, RKP; "Occasionally I need...," ibid; "the mainstay of...," IMOL, 398. **72:** "When it comes...," RK to AE, 23 Dec. 1954, RKP; "We were so...," Cerf, op. cit., 71–72; "it was the...," from Reese, "Collecting Herman Melville." **73:** "In every way...," H. S. Canby, *Saturday Review,* 6 Dec. 1930, 413; "Maybe the most...," RK to Florence Rosengren, 11 April 1936, RKP; "The sack containing...," Kent, *N by E,* 139; "It was one...," RK to Carl Drepperd, 2 Jan. 1930, RKP; "six-shelf, two-trunk...," CD to RK, 17 March 1941, RKP; "I feel as...," ibid., 2 Nov. 1930. **74:** "spend a winter...," IMOL, 452; "Eskimo wife," CZ to RK, April 1932, RKP; "Frances can tell...," ibid.; "My own remaining...," IMOL, 465. **77:** "In pursuance of...," IMOL, 609; "It was sort...," Stephen Morgan Etnier, interview by Robert Brown, Archives of American Art, 22 Feb. 1973; "So Steve and...," IMOL, 609; "The mood...," CZ to Frances Kent, undated 1933, RKP; "Adler delivered Carola's...," CZ to RK, 23 June 1933, RKP. **78:** "I found it...," RK to Leo Hart, 21 Jan. 1933, RKP; "We said the...," CZ to RK, 16 Oct. 1933, RKP; "Unfortunately I am...," RK to CZ, 25 Oct. 1933, RKP; "the thought of...," IMOL, 474. **81:** "I am only...," RK to CZ, 21 Dec. 1933, RKP; "Because modern life...," *New York Times,* 12 July 1934, 19; "It was an...," IMOL, 478; "the most poignant...," ibid., 481; "Gordon went there...," *New York Times,* 27 July 1935, 15. **82:** "You may trust...," Fridolf Johnson, *Rockwell Kent: An Anthology of His Works,* 56; "If ever I...," IMOL, 234; "Four a month...," EA to RK, 15 Jan. 1936, RKP; "I apparently couldn't...," RK to 3 Jan. 1936, RKP. **83:** "a rough dark...," James F. Drake to RK, 13 Dec. 1935, RKP; "in fear and...," GEH to RK, undated 1936, RKP; "it can't merely...," RK to EA, 8 April 1936, RKP; "I hope it...," EA to RK, 13 Dec. 1935, RKP; "a settlement for...," ibid., 5 Jan. 1936. **84:** "if they were...," EA to RK, 27 Jan. 1936, RKP; "would be a...," ibid.; "I have made...," RK to EA, 12 Oct. 1936, RKP; "Wilmerding is very...," EA to RK, 11 Feb. 1936, RKP. **85:** "as graduation from...," Stanley Marcus, *Minding the Store,* 39; "I am awfully...," SM to RK, 11 May 1936, RKP; "I hate to...," ibid., 26 June 1936; "I hate like...," ibid., undated 1936. **86:** "If you knew...," SK to EA, 6 June 1936, RKP; "The

scenes!...," Kent, *This Is My Own,* 267; "The bookplate drawing...," RK to SM, 28 Aug. 1936, RKP. **89:** "I know that...," EA to RK, 27 Aug. 1936, RKP; "Maybe this one...," RK to EA, 28 Aug. 1936, RKP; "I hope that...," RK to SM, 16 Oct. 1936, RKP. **90:** "A design made...," RK to EA, 20 Oct. 1936, RKP.

• **Chapter Seven, 91:** "There were, after...," IMOL, 496; "The record says...," Leod Daw Becker to EA, undated, Elmer Adler Papers, Princeton University Library; "A Philadelphia Art...," Charles Sessler to RK, 23 Oct. 1937, RKP. **92:** "Dexter Cook who...," CZ to RK, 25 May 1936, RKP; "Inasmuch as...," Cook to RK, 16 Sept. 1936, RKP; "Ruth, who went...," ibid., 29 Dec. 1936, RKP; "a man of...," Sally Kent to Richard Day, 30 Oct. 1942, RKP; "I have a...," RK to EA, 1936, RKP. **95:** "stridency and violent...," Untermeyer, *Bygones,* 117; "ask for art...," LU to RK, 6 June 1933, RKP. **96:** "As I stammered...," LU to RK, , 2 Nov. 1927; "in consideration of...," IMOL, 526; "to half-time...," ibid., 529. **99:** "Rockwell Kent has...," from Dexter Cook to CZ, 31 Jan. 1938, RKP; "hampered in earning...," RK to Leonard Levinson, 20 April 1941, RKP; "charity case," RK to EA, 26 Oct. 1938, RKP. **100:** "There was little...," IMOL, 515; "The slow oxidation...," ibid., 529.

• **Chapter Eight, 101:** "Here's a notice...," EA to RK, 13 Feb. 1940, RKP; "it is but...," *New York Times,* 25 Feb. 1940, VI 23; "He had grown...," (Lawrence Thompson) Bennett, *Elmer Adler in the World of Books,* 24; "He turned out...," Cerf, op. cit., 61. **102:** "when Pynson Printers...," *New York Times,* 25 January 1962, 35; "turning out pages...," IMOL, 529; "the rotten, leaky...," Kent, *This Is My Own,* 156; "Though the Colophon...," *New York Times,* 14 April 1940, 19; "I would like...," Sally Kent, "Memoirs," RKP; "At present I...," Shirley Johnstone to RK, 8 Dec. 1939, RKP. **103:** "easy, good, clear...," IMOL, 530; "The friendly...," Sally Kent, "Memoirs," RKP; "should be lovely...," IMOL, 529–30; "Please be glad...," FLK to RK, 17 Jan. 1940, RKP; "on having taken...," Zigrosser, op. cit., 140. **104:** "I went to...," FLK to RK, 5 March 1940, RKP; "Darling, our lives...," ibid., 30 April 1940, RKP; "From July...," EA to RK, 3 June 1940, RKP. **107:** "An article in...," *New York Times,* 27 Sept. 1940, 20; "I showed some...," EA to RK, 10 Dec. 1940, RKP; "Do realize that...," RK to Laurel (Miss.) Public Library, 18 Feb. 1941, RKP; "Probably I'll be...," RK to EA, 18 Dec. 1940, RKP; "Here is Tatum's...," ibid., 21 Dec. 1940, RKP. **108:** "Under separate cover...," RK to EA, 18 March 1941, RKP; "I am still...," RK to EA, 30 April 1941, RKP. **109:** "So it's a...," RK to EA, 6 May 1941, RKP; "Doubtlessly I'm all...," RK to EA, 8 May 1941, RKP. **110:** "I am not...," RK to EA, 21 May 1941, RKP; "Mr. Adler has...," George Tatum to RK, 19 June 1941, RKP. **112:** "I am sending...," RK to GT, 18 June 1941, RKP; "Alma is here...," GT to RK, undated 1941, RKP; "I think it...," EA to RK, 10 July 1941, RKP; "I suppose the...," RK to GT, undated 1941, RKP.

• **Chapter Nine, 113:** "latent ambitions to...," Zigrosser, op. cit., 55; "Don't ask me...," CZ to RK, 30 Jan. 1941, RKP; "I, this year...," RK to EA, 20 March 1941, RKP; "In urgent need...," from RK to EA, 1 Oct. 1941, RKP. **114:** Rockwell Kent-George H. Corey letters, Jan. 1941 to April 1941, RKP. **115–18:** Rockwell Kent-Leonard L. Levinson letters, April 1941 to Oct. 1941, RKP. **118:** Rockwell Kent-Gregory Desjardins letters, Aug. 1941 to Dec. 1941, RKP. **121:** "a revelation of...," IMOL, 548; "the grueling grinds...," Sally Kent, "Memoirs," RKP; "about 37 years...," Harry A. Levinson to RK, 22 Nov. 1941, RKP; "Here in America...," Kent, *This Is My Own,* 393; "We have gone...," LU to RK, 2 June 1941, RKP. **122:** "Apparently, the only...," IMOL, 560; "I will neither...," RK to MS, 29 April 1942. **123:** Rockwell Kent-Marie Luise Hinrichs letters, June 1942 to Jan. 1943, RKP. **124–25:** "a booklover, mystic...," Rockwell Kent-Charles Sessler letters, June 1942 to Jan. 1943, RKP; Rockwell

Kent-Dorothy Gillam letters, July 1942 to Jan. 1943, RKP. **126:** "Instantly there came...," Burns Gillam to RK, 10 Feb. 1943, RKP; "I like the..." RK to BG, 16 Feb. 1943, RKP; "Send the bill...," RK to AC, April 1943, RKP. **128:** "leisure to paste...," RK to EC, 8 April 1945, RKP. **129:** Rockwell Kent-Loring Pickering letters, July 1946 to Dec. 1946, RKP; "It was only...," Zigrosser, op. cit., 140. **130:** "We are receiving....," Frances H. Warner to RK, 16 July 1946, RKP; "By the way...," EA to RK, 14 March 1947, RKP; "*the* final-for....," RK to BC, 5 June 1947, RKP. **131–32:** Rockwell Kent-Anne Colen letters, Nov. 1947 to Aug. 1948, RKP; "It was a....," RK to Beatrice Colen, 4 Feb. 1948, RKP. **134:** Rockwell Kent-Arthur Wiesenberger letters, March 1948 to July 1948, RKP.

• **Chapter Ten, 136:** "yours for a...," RK to Manny Greenwald, 21 May 1941, RKP; "The whole enterprise...," RK to MG, 17 Sept. 1941, RKP; "To those of...," Kent, "Introduction to Book-Plate Catalog," RKP. **139:** "a particularly crude...," MG to RK, 18 Oct. 1941, RKP; "I have been...," RK to MG, 21 Oct. 1941, RKP; "always been soft...," SK to MG, 6 Nov. 1941, RKP. **140:** "checks for $50...," RK to MG, 6 May 1942, RKP; "My only feeling..., ibid., 9 Jan. 1942, RKP; "having been found...," MG to RK, 26 Aug. 1943, RKP; "pride in knowing...," Gertrude Greenwald to RK, 22 Nov. 1943, RKP; "In order to....," Ernest Morgan to RK, 30 June 1943, RKP; "I think that...," ibid., 19 Nov. 1943. **141:** Morgan then wrote...," from EM to GG, 18 Nov. 1943, RKP; "Knowing of your....," EM to RK, 26 Feb. 1945, RKP; "to accommodate...," MG to RK, 23 Aug. 1947, RKP; "I must confess...," ibid., 31 Oct. 1947, RKP; "personal accessories...," Greenland Press Studios letterhead, 1948; "We were somewhat...," RK to MG, 25 Nov. 1948, RKP. **142:** "one of those...," GG to RK, 26 Nov. 1951, RKP; "His approach...," Literary Guild promotional brochure, 1947, RKP. **144:** "Over the years...," RK to Nilo Sutliff, 27 Aug. 1949, RKP; "We feel...," Milton Runyon to RK, 29 Aug. 1949, RKP; "It was a...," EM to GG, 18 Dec. 1943; "our bookplate sales...," EM to RK, 24 April 1950, RKP. **147:** "The only concession....," RK to EM, 15 May 1950, RKP; "working out very...," EM to RK, 20 Aug. 1951, RKP; "The public...," RK to EM, 27 Aug. 1951, RKP; "cultural morality," EM to RK, 30 Aug. 1951, RKP. **148:** "Obviously we can't...," EM to RK, 30 Dec. 1953, RKP; "I have all...," RK to EM, 22 Jan. 1954, RKP; "It is the...," ibid., 12 Jan. 1956, RKP; "Most of the...," EM to RK, 20 Jan. 1958, RKP. **150:** "I had hardly....," RK to EM, 31 Jan. 1966, RKP.

• **Chapter Eleven, 151:** "something quite simple...," Felix Ranlett to RK, 3 May 1949, RKP; "Most people do...," ibid., 12 Aug. 1949. **152:** "I am sending...," RK to FR, 12 Sept. 1949, RKP; "The new tree...," FR to RK, 15 Sept. 1949, RKP; "It came as...," IMOL, 580. **153:** "Rockwell Kent said...," *New York Times,* 8 March 1950, 2; "The department...," IMOL, 608; "We would like...," LeRoy Provins to RK, 13 Nov. 1950, RKP; The idea of...," Edward Mallinckrodt to LP, 3 Feb. 1951, RKP. **154:** "The Tree of...," RK to LP, 3 Jan. 1951, RKP; "the present sketches...," EM to LP, 3 Feb. 1951, RKP; "If I had...," RK to LP, 29 March 1951, RKP. **155:** "He still is...," LP to RK, 21 Dec. 1951, RKP; "for the sun's...," RK to LP, 14 Jan. 1952, RKP; "It seems that...," LP to RK, 2 June 1952, RKP. **156:** "At last, after...," RK to LP, 9 June 1952, RKP; "I spent a....," ibid., 16 Jan. 1953; "There was more...," RK to Fred Smith, 27 Nov. 1953, RKP. **159:** "too palely pink," IMOL, 589; "did not believe...," *New York Times,* 4 April 1951, 20; "mostly hall," J. Whiting Friel to RK, 6 Aug. 1952, RKP. **160:** "I will try....," RK to JWF, 14 Aug. 1952, RKP; "a slight correction...," ibid., 5 March 1953, RKP. **161:** "The Arthur-Daniels...," AP to RK, 24 Sept. 1954, RKP; "We do encounter...," EM to RK, 18 Dec. 1952, RKP; "Our satisfaction...," RK to EM, 23 Dec. 1952, RKP; "in sincerity...,"

Hans Hinrichs to RK, 31 Aug. 1950, RKP. **162:** "Rockwell was one...," Zigrosser, op. cit. 149; "I have gotten...," RK to Molly Tallentire, 5 March 1953, RKP; "the cultural counterpart...," IMOL, 412. **163:** "there is no...," Kent, "The Artist and World Friendship," *The World Tomorrow,* Feb. 1924; "I find that...," RK to EM, 15 Jan. 1954, RKP; "the sketch of...," Irene von Horvath to RK, undated 1954, RKP; "she would visit...,"Irene von Horvath from an interview with the author; "I should think...," RK to George Chappell, 9 Sept. 1943, RKP. **164:** "A certain human....," IvH to RK, undated 1951, RKP; "the most beautiful...," ibid., Dec. 1954; "most satisfying work...," Jeanette Clarke to RK, 27 April 1957, RKP; "one of the...," RK to Dan Burne Jones, 17 July 1961, RKP; "unknown to her...," Eliot Stanley; "That it was...," JC to RK, 22 March 1958, RKP; "On finishing...," Orville Prescott, *New York Times,* 13 May 1955, 23. **165:** "I have made...," RK to EM, 21 Nov. 1955, RKP; "I am not...," *New York Times,* 9 July 1955, 31; "It is not...," EM to Passport Division, U.S. State Dept., 17 Nov. 1955, RKP; "the undertaker and...," RK to David Grutman, 16 Nov. 1955, RKP. **166:** "I would like...," David Grutman-Rockwell Kent letters, Nov. to Dec. 1955, RKP. **169:** "I have always...," Joseph O. Jackson to RK, 15 Nov. 1955, RKP; "I would love...," RK to JOJ, 19 Nov. 1955, RKP. **170:** "I got so...," RK to JOJ, 24 Jan. 1956, RKP; "It pleases me...," JOJ to RK, 5 Feb. 1956, RKP; "This can only...," RK to AC, 17 Feb. 1956, RKP; "rather mediocre example...," JOJ to RK, 16 March 1956, RKP; "I hope that...," RK to JOJ, 30 April 1956, RKP; "I'd like to...," DBJ to RK, 9 Oct. 1941, RKP. **171:** "Your own disappointment...," RK to DBJ, 30 Jan. 1957, RKP; "to the Society...," JWF to RK, 11 Dec. 1956, RKP; "The commission...," RK to JWF, 30 Jan. 1957, RKP; "Because of both...," RK to EA, 28 June 1956, RKP. **172:** "The inscription...," RK to AC, 8 Aug. 1957, RKP; "My wife and...," RK to EM, 11 May 1957, RKP.

• **Chapter Twelve, 173:** "My pictures...," RK to DBJ, 27 April 1960, RKP; "My situation at...," ibid., 7 April 1960, RKP; "Well, dammit...," DBJ to RK, 20 April 1960, RKP. **174:** "pitiably small," *New York Times,* 17 Nov. 1961, 13; "In the course of...," RK to DBJ, 27 April 1960, RKP; "I read in...," CZ to RK, 14 Dec. 1960, RKP; "There is nothing...," IMOL, 250; "wanted to lead...," ibid., 305; "the ordinary, regular...," ibid., 192. **175:** "my official biographer," RK to DBJ, 19 March 1963, RKP; "It happens that...," RK to Philip J. More, 1 June 1945, RKP. **175–77:** RK-Harry M. Geller letters, May 1961 to March 1962, RKP. **178-79:** RK-Earl H. Gibson letters, Feb. 1966 to Aug. 1966, RKP. **179:** "the Russian bookplate" RK to DBJ, 22 Aug. 1966, RKP; "artist whose works...," *New York Times,* 1 May 1967, 1; "a token of...," *New York Times,* 12. **180:** "I hardly knew...," Kent, *After Long Years,* 11–12; "Had wishes but...," ibid., 12; "a matter which...," Robert C. Gross to RK, June 1937, RKP. "This is a...," RK to RCG, 1 July 1937, RKP. **180–85:** Rockwell Kent-Peter B. Dirlam letters, April 1968 to Feb. 1969, RKP. **182:** "Your resurrection...," Edward C. Lathem to PBD, 21 May 1968, RKP. **183:** "The highest price...," RK to PBD, 15 June 1968, RKP; "It, like the...," ibid., 3 March 1969. **184:** "fellow picture-painters," Kent, *After Long Years,* 19; "Brigus, where half...," ibid., 17; "What hopes...," ibid., 18; "but tourists in...," ibid., 19; "an oversight I...," RK to PD, 13 Sept. 1968. **185:** "much though we...," RK to DBJ, 29 May 1963, RKP; "His immediate response...," Zigrosser, op. cit., 144. **186:** "He was excited...," Godine, *Adirondack Life,* 74; "Your publication...," RK to BC, 15 May 1970, RKP; "an artist to...," Sally Kent, "Memoirs," RKP; "The turbulent years...," ibid. **187:** "Things to wear...," ibid; "What is a...," ibid.

Selected Bibliography

Adams, Frederick Baldwin. 1942. *Elmer Adler: Apostle of Good Taste.* New York: Typophiles.

Armitage, Merle. 1932. *Rockwell Kent.* New York: Alfred A. Knopf.

Bennett, Paul A. 1964. *Elmer Adler in the World of Books.* New York: Grolier Club.

Bowdoin, W. G. 1901. *The Rise of the Book-Plate.* New York: A. Wessels.

Brooks, Van Wyck. 1955. *John Sloan: A Painter's Life.* New York: E. P. Dutton.

Cerf, Bennett. 1977. *At Random: The Reminiscences of Bennett Cerf.* New York: Random House.

Elmer Adler Papers. Graphic Arts Collection, Princeton University Library.

Etnier, Stephen Morgan, interview by Robert Brown, Archives of American Art, 22 Feb. 1973.

Ferris, Scott R., and Ellen Pearce. 1998. *Rockwell Kent's Forgotten Landscapes.* Camden, Maine: Down East Books.

Godine, Amy. 1990. The Sally Kent legacy: a reminiscence of a life with Rockwell Kent. *Adirondack Life* 21 (Nov./Dec.): 30–35, 74.

Hardy, W. J. 1897. *Book-Plates.* London: Kegan, Paul, Trench, Tribner and Co.

Homer, William Innes, and Violet Organ. 1969. *Robert Henri and His Circle.* Ithaca: Cornell University Press.

Horning, Clarence P., and Fridolf Johnson. 1976. *200 Years of American Graphic Art.* New York: George Braziller.

Johnson, Fridolf, ed. 1982. *Rockwell Kent: An Anthology of His Works.* New York: Alfred A. Knopf.

Johnson, Fridolf, and John F. H. Groton. 1976. *The Illustrations of Rockwell Kent.* New York: Dover.

Jones, Dan Burne. 1976. Rockwell Kent: his bookplate designs. *American Society of Bookplate Collectors and Designers Yearbook 1976:* 53–74.

———. 2002. *The Prints of Rockwell Kent: New Edition of the Catalogue Raisonné.* Revised by Robert Rightmire. San Francisco: Alan Wofsey Fine Arts.

Kent, Rockwell. 1929. *Bookplates and Marks of Rockwell Kent. The.* New York: Random House.

———. 1930. "Alias Kent, by Hogarth, Jr." *Colophon,* Spring: 6.

———. 1934. *How I Make a Woodcut.* Pasadena, Calif.: Esto Publishing Co.

———. 1936. On being famous. *Colophon,* new series 1, no. 4: 580–583.

———. 1937. *Later Bookplates and Marks of Rockwell Kent.* New York: Pynson Printers.

———. 1937. A short autobiography. *Demcourier* 6, no. 10: 4–5.

———. 1940. *This Is My Own.* New York: Duell, Sloan and Pearce.

———. 1955. *It's Me O Lord.* New York: Dodd, Meade.

———. 1968. *After Long Years.* Au Sable Forks, N.Y.: Asgaard Press.

———. 1978. *N by E.* Middletown, Conn.: Wesleyan University Press edition.

———. 1996. *Wilderness: A Journal of Quiet Adventure in Alaska.* Hanover, N.H.: Wesleyan University Press edition.

———. Undated. Rockwell Kent. Autobiographical manuscript. Rockwell Kent Collection, Archives of American Art.

———. Undated. Feild-Kent Manuscript. Autobiographical manuscript. Rockwell Kent Collection, Archives of American Art.

Kent, Rockwell, and Carl Zigrosser. 1933. *Rockwellkentiana: Few Words and Many Pictures.* New York: Harcourt, Brace.

Kent, Sally. Undated. Memoirs. Manuscript. Rockwell Kent Collection, Archives of American Art.

Levin, Gail. 1980. *Edward Hopper.* New York: W. W. Norton.

———. 1995. *Edward Hopper: An Intimate Biography.* New York: Alfred A. Knopf.

Lewis, John. 1967. *The Twentieth Century Book: Its Illustration and Design.* New York: Van Nostrand Reinhold.

Marcus, Stanley. 1974. *Minding the Store.* New York: Little Brown and Co.

Perlman, Bernard B. 1999. *The Lives, Loves, and Art of Arthur B. Davies.* Albany: State University of New York Press.

Reese, William S., Collecting Herman Melville. 1993. *The Gazette of the Grolier Club.*

Robinson, Ione. 1946. *A Wall to Paint On.* New York: E. P. Dutton.

Rockwell Kent Collection. Feinberg Library, Plattsburgh State University.

Rockwell Kent Papers, ca. 1840–1993. Archives of American Art, Smithsonian Institute.

Rockwell Kent Collection. Rare Book and Manuscript Library, Columbia University.

Ross, Will. 1999. The eternal struggle: Rockwell Kent and advertising. *The Kent Collector* 15, no. 2: 5–14.

———. 1999. The great debate. *The Kent Collector* 25, no. 2: 20–23.

Schroeter, Joan G. 2002. Rockwell Kent in 'Egypt.' *The Kent Collector* 28, no. 1: 20–23.

Scott, Temple. 1902. *Book-plates of To-day.* New York: Tonnelé and Co.

Sloan, John. 1965. *John Sloan's New York Scene.* Edited by Bruce St. John. New York: Harper and Row.

Traxel, David. 1980. *An American Saga: The Life and Times of Rockwell Kent.* New York: Harper and Row.

Untermeyer, Louis. 1928. *Burning Bush.* New York: Harcourt, Brace.

———. 1965. *Bygones: The Recollections of Louis Untermeyer.* New York: Harcourt, Brace and World

Welsh, Caroline, and Scott R. Ferris. 1999. *The View from Asgaard: Rockwell Kent's Adirondack Legacy.* Blue Mountain Lake, NY: Adirondack Museum.

West, Richard, ed. 1972. *Rockwell Kent: The Early Years.* Brunswick, Maine: Bowdoin College Museum of Art.

West, Richard V., Fridolf Johnson and Dan Burne Jones. 1985. *An Enkindled Eye: The Paintings of Rockwell Kent.* Santa Barbara, Calif.: Santa Barbara Museum of Art.

Zigrosser, Carl. 1942. *The Artist in America.* New York: Alfred A. Knopf.

———. 1975. *A World of Art and Museums.* Philadelphia: Art Alliance Press.

Acknowledgments

THIS WAS INTENDED TO BE A BOOK OF PRETTY PICTURES, WITH SO LITTLE text that there would be no author's name to crowd the cover and hardly anyone to acknowledge. But as Rockwell Kent said, "Whatever is less good than something that is better is not good enough." If the result is indeed good enough, it is largely because of the people named here.

Sally Kent Gorton kept her husband's flame burning the rest of her days, and upon her death in 2000, it was passed to Plattsburgh State University. Edward Brohel, Cecilia Esposito, Marguerite Eisinger and Wayne Miller are among the faithful stewards of the treasure know there as the Rockwell Kent Collection. They've been generous and supportive in every way possible, and my gratitude knows no bounds. The days I spent in Plattsburgh and the drive to Asgaard with Ceil will never be forgotten.

A great deal of the research was accomplished through the Archives of American Art of the Smithsonian Institution, an amazing resource; it was Jane Glover at the American Art Study Center of the DeYoung Museum in San Francisco who so admirably facilitated its use day after day. I am also indebted to Rebecca Davidson, Margaret Sherry Rich and Linda Bogue of the Graphic Arts and Rare Books and Special Collections at the Firestone Library at Princeton University, and to Jane Siegel of the Rare Book and Manuscript Library at Columbia University. They made it immeasurably easy to search through haystacks for golden needles. Although less was asked of Roger Moss at the Athenaeum of Philadelphia and John Mustain at the Stanford University Library, their interest and willingness are also appreciated.

Jim Keenan, Lewis Jaffe, Eliot Stanley, Jake Wien, Frederick Lewis and, especially, Robert Rightmire are dedicated authorities on bookplates and/or Kent's life and work. They took me under their wings, offering good advice and fielding questions that I hope grew progressively more intelligent. Some may never be answered, but there was always someone willing to try: My friend Faith Bell of Bell's Books in Palo Alto put everything aside to resolve the mystery of the Snedden bookplate; Linda Duffield was a great

help in translating German text; Anita Brown searched the archives at Antioch Publishing; and Leatrice Armstrong of the Mary C. Wheelwright Museum was able to shed light on the museum's namesake.

It was my pleasure to be in touch with George Tatum, Irene von Horvath, Peter Dirlam, Tony Grutman (the son of David Grutman), Lee Morgan (the son of Ernest Morgan), Chris Kent (the son of Rockwell Kent III) and, finally, the remarkable Gordon Kent. As living links to Rockwell Kent and his bookplates, they brought this project to life.

Every effort was made to produce a physical book that would meet Elmer Adler's standards. Julie Churchill worked miracles in making antique bookplates look as good as new; Kathy McNicholas was the calligrapher; and Dotty Hardberger graciously coped with my unwavering indecision on all things aesthetic. We relied on Dave Fleming, Jeff Kause and Karl Frauhammer of McNaughton and Gunn, our printer, for technical advice.

Taylor Teegarden, the mentor of my career as an editor, agreed to edit these pages. Manuscript reached her wherever she happened to be at the time, and she promptly responded to every word, and to what lay between each line, with care, insight and welcome fussiness. Finally, Sharilyn Hovind proofread the final manuscript and discovered an unimagined number of errors. The outcome is infinitely better for their help.

Will Ross has been my collaborator in every sense of the word. He wrote a fine foreword, which I appreciate, but hardly a week has gone by without his volunteering assistance and assurance. The resulting friendship with Will and his wife Kathy is one of the highest rewards of this endeavor.

My personal thanks to Maoma Yessick who forty years ago taught me *Moby-Dick,* which eventually marked my introduction to Rockwell Kent, and to Ann Spivack, who was present at the moment of this book's inception. Ann Altman, Elaine Anderson, Kris Balloun, Karen Bornstein, the late Brian Buchanan, Jodi Curtis, Gail Friedlander, David Garst, Fred Marett, Kathryn Maeropol, Charlene Moser and Penni Wisner are among the friends who provided nurturance, always through their loving encouragement—and sometimes with good food. I'm especially grateful to my dear Pam Utz for her endless enthusiasm for this book as well as her editorial insight. And always, there was Gary Jones.

DON ROBERTS
San Francisco
December 13, 2002

Index